Against the Odds

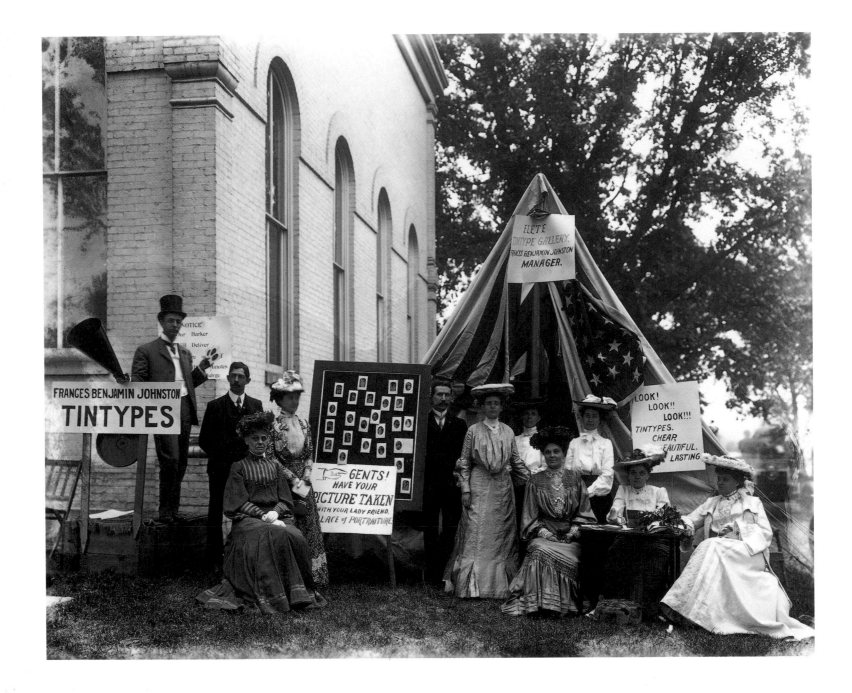

Against the Odds WOMEN PIONEERS IN THE FIRST HUNDRED YEARS OF PHOTOGRAPHY

Martin W. Sandler

Rizzoli International Publications, Inc.

NEW YORK · 2002

Designed by Jerry Kelly

Printed in Singapore

Library of Congress Cataloging–in–Publication Data

Sandler, Martin W.
Against the odds : women pioneers in the first hundred years of photography /
Martin W. Sandler.
p. cm.
Includes bibliographical references.
ISBN 0-8478-2304-0 (hc. : alk. paper)
1. Women photographers–United States–Biography. 2. Photography–United
States–History–20th century. 3. Photography, Artistic.
I. Title.
TR139.S27 2002
770'.92'273–dc21
[b]

Frontispiece: Frances Benjamin Johnston, *Selling Tintypes at County Fair* (1903)

For Carol, whose patience, energy, and support have, as always, been invaluable.

CONTENTS

ACKNOWLEDGMENTS

THE AUTHOR IS DEEPLY INDEBTED to the curators and staff members of the scores of museums, libraries, and other institutions where research for this book was conducted. While space limitations prohibit the naming of all these people, acknowledgment is gratefully given to the following individuals whose assistance went well beyond the call of duty: Walt Burton, Walt Burton Galleries; Lorna Congdon, Society for the Preservation of New England Antiquities; Paula Fleming, National Anthropological Archives; Olivia Gonzalez, St. Louis Art Museum; Steve Massingale, North Carolina Department of Archives and History; Pamela Morris, Portland Art Museum; Gary Sampson, University of New Hampshire; Todd Strand, State Historical Society of North Dakota; Shannon Thomas, Museum of American History.

Acknowledgment is also given to Niall Dunne, Carol Weiss, Ann Hobart, Ulrich Figge, and John Thornton for their vital contributions to this book. A special expression of gratitude is given to Ray Roberts for his masterful editorial skills, and to Thurman Naylor for generously sharing both photographs and insights.

PREFACE

THE WOMEN YOU ARE ABOUT TO MEET were all pioneers. Pursuing careers either as amateurs or professionals, they took up the camera in photography's earliest and most formative years and not only produced images that rank among the greatest ever taken but, through their work, exerted an influence on every field of the medium far greater than has been revealed thus far.

The standard histories of photography are notable for the lack of recognition given to women photographers. Even recent works on camerawomen have focused in large measure on those women whose names are generally known. What has been left out are the major accomplishments of little-known or totally unknown women photographers whose contributions have long gone neglected or ignored. The personal stories of these women have also been sadly lacking, stories that enlighten our understanding of their accomplishments and give us a deeper appreciation of the work they produced.

Added to these personal oversights have been the misconceptions that have surrounded women's role in photography. For example, the notion is still put forth that because of the arduous nature of landscape photography, early camerawomen were not significantly represented in this field. The truth of the matter is that a host of pioneer women photographers, some almost exclusively, were involved in capturing landscape photographs. Similarly, while scores of early male photographers have been justifiably celebrated for their accomplishments in capturing the likenesses and ways of life of early Native Americans, far too little recognition has been given to female photographers who focused on the same subject. As this book will reveal, the countless images that early camerawomen captured of the first Americans not only rival but often exceed those taken by their more recognized male counterparts.

The women in this book come from varying backgrounds and were driven to their work by motivations as diverse as the images they produced. Aside from their photographic talent, what is most remarkable about their achievements was their ability to succeed in the face of extraordinary societal and professional odds. They operated at a time when women's place was truly regarded as being in the home, tending house, children, and husband. They sought to build careers at a time when such an ambition for a woman was not only frowned upon but often condemned. Many pursued photographic subjects that required them to travel significant distances alone and to stay in unfamiliar places, another taboo for women of their day. The physical hardships and the dangers that many of them endured while capturing their images, and the fact that many sought, through their photographs, to express their deepest personal feelings were also regarded by many of their time as outside the purview of members of their sex.

Added to all these obstacles was the fact that, whether amateur or professional, these photographers were forced to operate in a male-dominated medium, one in which the decision makers, whether gallery owners, publishers, corporate managers, or government and private agency heads, were all men. Many of these women paid a real price for their undertakings. The number of divorces or marital separations among them was significantly greater than the national average of their day. Many of them, even those who received the highest professional acclaim, were forced to struggle financially far more than their male counterparts.

Yet they succeeded, and in the process helped change the face of photography. That they did so can be attributed to the various ways

Martin W. Sandler

they overcame the barriers they faced, obstacles which in many ways are still confronted by women today. More specifically, their achievements were due to their often passionate desire, as some pointedly expressed it, to "pursue their own destiny." For above all else, it was their sense of independence that best characterized these photographic pioneers, a quality that shone through not only in their personal lives but in the photographs they produced.

The goal of this book is to fill in important gaps in the adventure that is photography, gaps created by the absence in photography's story of many pioneer camerawomen. The purpose is to present the human side of this saga, revealing, often in their own words, what drove these photographers to their work, what they sought to achieve through their images, techniques, and approaches, and to show the scope of their contributions.

It is important to state that the contention herein is that the work of these photographers should be assessed and their contributions recognized not because they were women photographers, but because they were *masterful* photographers. Their talents and their contributions stand on their own. That they accomplished so much is one of the most inspiring stories in all the creative arts.

AGAINST THE ODDS

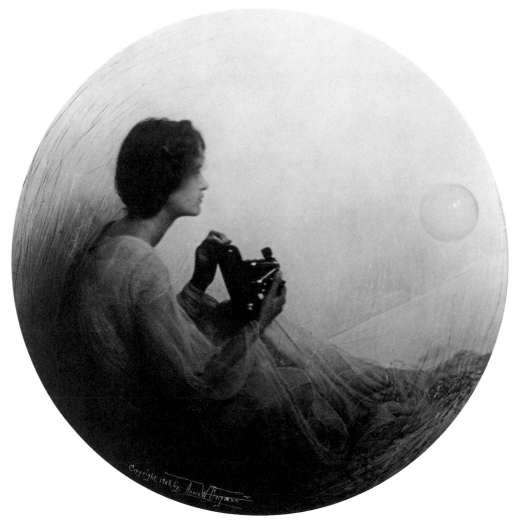

Anne W. Brigman *The Spirit of Photography* (c. 1905)

1 · Beginnings

"FROM THIS MOMENT FORTH PAINTING IS DEAD." This is how the artist Paul Delaroche reacted upon encountering his first photographic image. His assessment of the future of art and artists was, of course, far off the mark, but he was correct in his assumption that the miraculous new development would transform the way people around the globe would be able to view their world.

Almost as remarkable as the introduction of photography itself was the extraordinary speed with which technological advancements took place that would put the camera in the hands of millions everywhere. In 1839, the Frenchman Louis Jacques Mandé Daguerre astounded the world by providing proof that he had captured a permanent photographic image. His silver plate positives were soon improved upon by the Englishman William Henry Fox Talbot whose paper negatives allowed for the making of countless copies of a single image.

In 1851, both of these early processes were rendered obsolete by the collodion–glass plate negative process introduced by English sculptor Frederick Scott Archer. Although these wet plates, as they were called, had to be developed almost immediately and were extremely messy to work with, they resulted in images clearer than ever before possible. Archer's innovation spawned a variety of early photographic forms including the ambrotype, the calotype, the tintype, and the stereograph.

In the 1870s and 1880s, two further advancements took place that revolutionized a medium that was still less than fifty years old. In 1873, a British physician, Richard Leach Maddox, introduced gelatin-coated glass negatives. These so-called dry plates

could be developed at any time after the image was captured. And in 1888, the American George Eastman launched the simple Kodak camera with its self-contained roll of flexible film. It is because of these innovations that photography was on its way to becoming the most democratic form of visual expression the world has ever known.

There had been women involved in photography from its beginnings, but cumbersome equipment and the difficulty of preparing and developing wet plates had restricted their participation. The dry plate process not only made negatives easier to develop but launched a whole new photo-finishing industry that gave photographers the option of removing themselves entirely from the developing process. The Kodak camera was easy to handle and, like the dry plates, provided its owner with the freedom to concentrate solely on taking pictures. Once the roll of film was taken, the camera was sent to the Kodak factory where prints were made and then shipped to the owner along with the camera containing a new roll of film. None of this is to say that all female or male photographers gravitated to the Kodak camera once it was available or removed themselves from the developing process. Indeed, many of the most successful camerawomen would never consider using anything but a large format camera or allow anyone other than themselves to develop their prints.

Aside from the new technology, other factors made it easier for women throughout the nation to embrace the new medium. Whereas art academics had always discriminated against women, photography required little formal training and in fact many of the most successful women photographers would be self-taught. The early advancements in photography took place at a time of great social change in America, a time when inventions such as

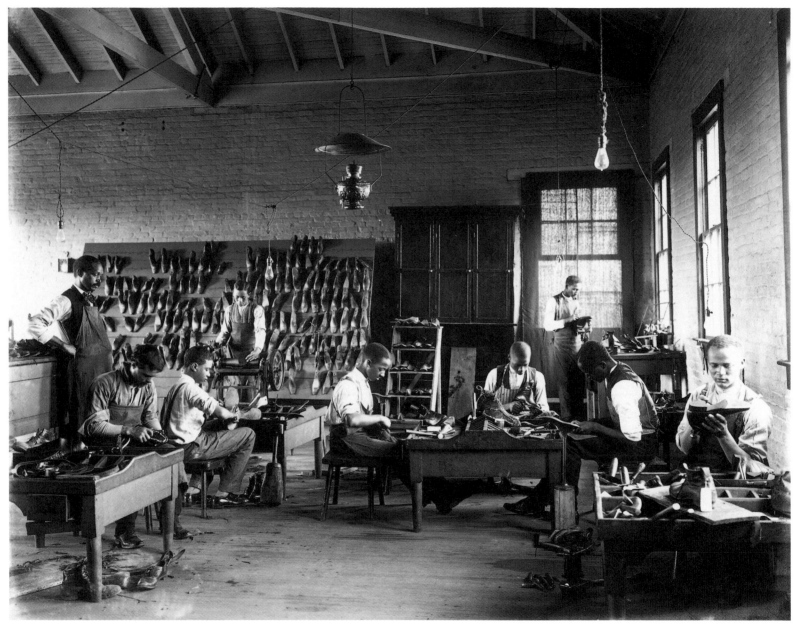

Frances Benjamin Johnston *Cobblers Class* (1902)

Against the Odds

the typewriter and the sewing machine freed women from the confines of the home as never before. Of all the inventions in a great age of innovation, it was the camera that offered women the best opportunity for creative expression.

We begin our consideration of early women photographers with two stories, the first that of a photographer whose life and images have only recently been revealed; the second that of a woman whose photographic contributions are shrouded in mystery.

Evelyn Jephson Flower was born on an enormous country estate outside of London in 1868. Her father, an East India merchant, headed a household that boasted fifteen servants, including a governess and two nurses who cared for her and her ten siblings. Thanks to her father's wealth and influence and that of an older stepbrother who rose to the title of Lord Battersea, she would spend her privileged childhood surrounded by many of England's leading political, artistic, and social figures.

When she was twenty-one, however, she shocked her parents by marrying Ewen Cameron, a poor Scotsman fifteen years her senior, who shared her love of wildlife and the outdoors. Partly in search of a hunting adventure and partly to get away from her disapproving parents, the newlyweds chose the Badlands of America's eastern Montana as their honeymoon site.

It took only a few days in Montana for the couple to decide that they would never leave. For two people in love with the wilderness it seemed the ideal place. Wherever they looked there were miles of open, unsettled land covered with grass. The landscape of the Badlands was replete with wild and weird formations of sandstone and clay. For Cameron, who had run away from what she had regarded as a stifling existence in England, it was a paradise.

The question was, how would they earn their living? They answered it by deciding to raise horses. Perhaps they would have been successful had Evelyn's husband paid more attention to business, or if he had not made so many bad business decisions, such as a bizarre and costly attempt to raise polo ponies. In an attempt to improve their situation, the Camerons over the years established three different ranches, but none would prove profitable. The couple's relationship grew strained as she assumed the lion's share of the work. Although Evelyn kept a detailed diary of her life in Montana, there is nothing in her writings to explain how this woman, raised with servants and all the trappings of wealth, could have prepared herself for such an arduous existence. What her diaries do reveal is that she worked from sunup to sundown carrying out the work usually assigned to a ranch hand: she broke wild horses, roped and branded cattle, and removed the horns from calves.

Throughout all of the hardships and the financial setbacks, Cameron remained determined to make a success of her life in the West. Even after her husband died in 1915, she continued to ranch until her own death in 1928. As early as 1894, conscious of the need to find an additional source of income, she began, with the aid of a boarder that she and her husband had taken in, to teach herself photography. She was convinced that she could make herself proficient enough with the camera to be able to sell her pictures to the pioneers and immigrant groups that were increasingly making Montana their home.

For the better part of the next twenty years she traveled the vast territory, lugging her heavy camera and glass plate negatives, photographing individuals, families, social gatherings, farming activities, railroad workers, cowboys, and sheepherders. Before her work with the camera was done, she would chronicle

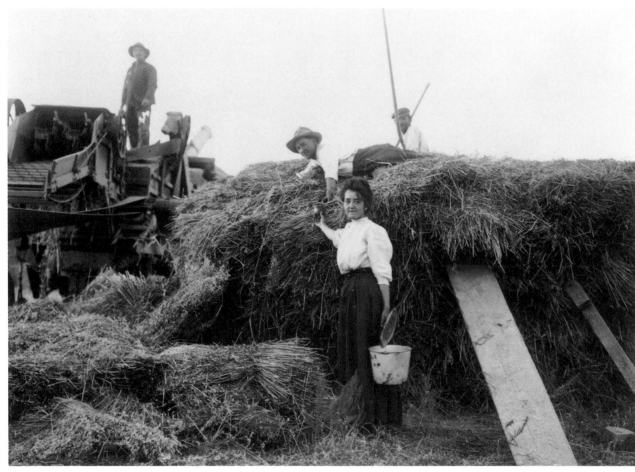

Evelyn Cameron *Bringing Water to the Threshing Crew* (1909)

cooking for the various work crews. She felt particularly akin to three young ranching sisters—May, Mabel, and Myrtle Buckley—and took many pictures of them roping cattle and horses. In some of these pictures the sisters are seen wearing the split skirts that enabled them to ride comfortably astride their mounts, an innovation introduced into the West by none other than Evelyn Cameron.

Although Cameron captured scores of images of the cowboys who roamed the open grasslands, her favorite subject seemed to be the sheepherders. Perhaps this was because she was fascinated with the men whose occupation was so lowly regarded by the cattlemen and other frontiersmen. Undoubtedly it

the frontier experience and the setting in which it took place as it had rarely been portrayed.

Her photographs of various frontier types reveal her personal understanding of the challenges of pioneer life. This is particularly true of the women she recorded. She captured images of them riding, roping, looking after animals, working in the fields,

was also because the many pictures they asked her to take proved to be a regular source of income. A photograph she took of two of the sheepherders in a boxing match, the ropes held by fellow herders, reveals the simple honesty that marks all of her pictures, the result of the obvious connection between her and her subjects.

Hers was a remarkable story: of a woman carrying heavy photographic equipment enormous distances on horseback; of a woman standing at an outdoor pump washing her negatives and prints during a blizzard; of a woman continuing to carry out all the demanding chores of ranching while pursuing her photographic career. A pioneer photographer in the truest sense of the word, Evelyn Cameron was as authentic a part of the settling of the West as those whose images she froze in time.

At the same time that Cameron was confronting the hardships of life in an untamed land, another woman was facing many of the same challenges in an adjacent territory. Elizabeth Ellen Roberts was born in Waterloo, Iowa, in 1873 to immigrant parents–her mother from Ireland, her father from Wales. When Roberts was four years old, the family moved to Bismarck, North Dakota. A short time later, like so many pioneers continually on the move seeking greater opportunities, they relocated again, this time to Deadwood, South Dakota, making the entire journey by stagecoach. Two years later, they were back in North Dakota where Roberts's father, a cattle buyer, established a modest ranch near a small town called Medora. She would live in the area for the rest of her life.

In the fall of 1886, with his family now grown to include five girls, Roberts's father left on a cattle-buying trip. Since checks were not in use in the region, he carried gold in his pockets. His last letter to the family, accompanied by a twenty-dollar bill, came from Wyoming. They never heard from him again. Mrs. Roberts sent dozens of letters seeking news of her husband to no avail. Years later, a Cheyenne, Wyoming, police record was discovered describing a man's body that had been found in the Cheyenne stockyards at the very time that Lloyd Roberts would have

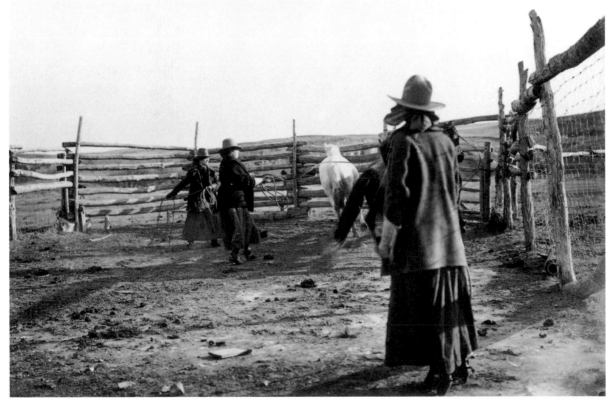

Evelyn Cameron *The Buckley Sisters in Their Corral* (c. 1905)

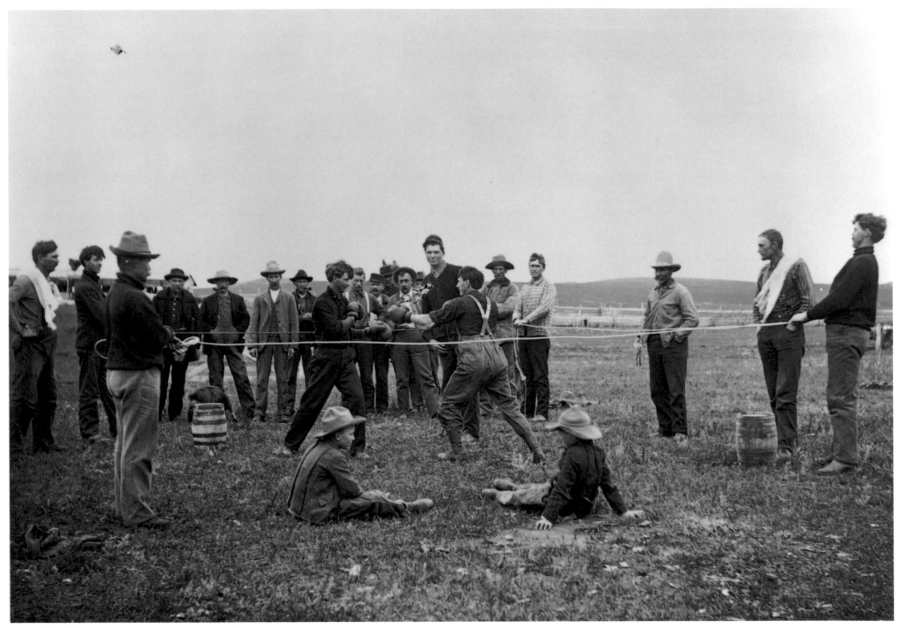

Evelyn Cameron *Sheepherders' Boxing Match* (1905)

been there. Since the description fit him perfectly, it was assumed that it was he, killed for the gold he carried on his person.

With Mr. Roberts gone, the challenge of life in the still wild cow country fell to Mrs. Roberts and her five young daughters. One night a wolf killed most of their sheep. They were witness to numerous gunfights and were continually warned of Indian raids. In the same year that Lloyd Roberts disappeared, they were forced to endure the fiercest winter North Dakota had ever experienced. Tens of thousands of cattle throughout the region died, a tragedy that would eventually signal the end of the glory days of the American cowboy.

But they were determined to carry on. Roberts's mother, Margaret, knitted mittens and socks that she sold to the cowboys. The children did sewing for people in the area, and grew flowers and picked wild fruit that they sold to a hotel in Medora. Mrs. Roberts also earned money by taking in washing from an already famous "up and coming" neighbor of theirs, an easterner who came to his ranch as often as possible to hunt, ride, and revel in the untamed beauty of the Dakota Territory. His name was Theodore Roosevelt and Roberts would always remember how, as a young child, her neighbor "Teddy" would bounce her on his knee.

The scant records of the family that exist show that Roberts and her sisters all married and raised families of their own. Their mother, whom Teddy Roosevelt called "the most wonderful woman in North Dakota," moved to Medora where she was able to keep a big house by taking in students. The records also show that for more than thirty years, Elizabeth Ellen Roberts served as North Dakota's first woman game warden.

What the records don't reveal, however, is Roberts' exceptional skill as a photographer. In the obituaries that marked her death, there is commentary about her pioneering experiences and her time served as game warden, but not a word about her having taken a single photograph. Yet housed in the State Historical Society of North Dakota are hundreds of negatives of extraordinary images that were captured by this very same Elizabeth Ellen Roberts. It is a great mystery. How did she learn her photographic skills? When did she take these photographs? Obviously, such an extensive photographic record would have required years of picture-taking. Most importantly, how could any frontier photographer, particularly a woman, have traveled throughout the region photographing so many people and capturing so many aspects of pioneer life without attracting attention?

The Historical Society does hold one important piece of evidence. They have one of her cameras, one of the earliest swing-lens devices, which enabled her to capture the spectacular panoramic images that highlight her work. But that's all; nothing else exists but the photographs themselves—and they are extraordinary. The panoramic images reveal the vastness of the still-open prairie as rarely captured in photographs. Her image of an enormous herd of sheep with the endless prairie in the background, framed by two sheepherders to the right and two longhorn steers to the left, reveals her sophisticated sense of composition. So, too, does the farming scene with the huge mechanical thresher in the foreground and the fieldhands silhouetted in the distance. These were no photographic accidents. In image after image she captured scenes that were dramatically and artistically composed. Her work also discloses that her mastery of the camera was not confined to images on a grand scale. Her photograph of a young girl standing at a pump is nothing less than a quintessential picture of life on the American frontier.

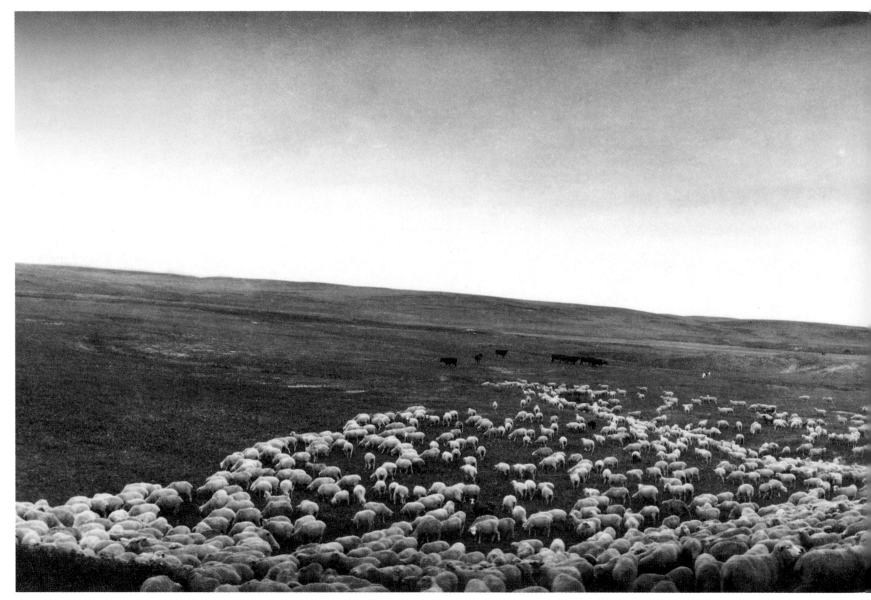

Elizabeth Ellen Roberts *Sheep* (c. 1905)

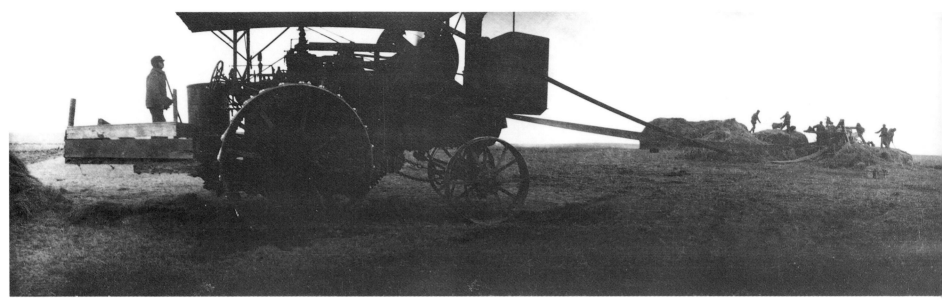

Elizabeth Ellen Roberts *Threshing* (c. 1905)

We wish we knew more about her life in photography, and perhaps someday we will. For now the photographs are enough, lasting testimony to what early women photographers were able to accomplish, often far removed from recognition or renown.

The same sense of mystery surrounds America's first female image makers, those women who, as early as the 1840s, became involved in the world's initial form of photography, the daguerreotype. We know from accounts and engravings in early periodicals that there were women who worked in daguerreotype studios, covering and finishing the ornate cases in which the silver-coated, one-of-a-kind images were held. We are aware that there were those who, in one manner or another, assisted their daguerreotypist husbands. But what of women who were daguerreotypists in their own right?

Records and advertisements reveal that there were at least hundreds of these earliest camerawomen, yet little is known about them. Few of their images have been identified and, as far as we know, no full-scale history of photography or narrower study, including Beaumont Newhall's classic volume on the daguerreotype in the United States, has included a single daguerreotype image taken by an American woman. Now, thanks to the efforts of master photographic sleuth, Thurman Naylor, we have a striking, authenticated array. These discoveries include the pristine photographic depiction of an 1840s couple taken by Mrs. Warren A. Reid of Quincy, Illinois, and the lovely image of a bonnet-clad woman, captured by Lydia B. White of Providence, Rhode Island.

Vital as it was to the story of photography, the daguerreotype remained in vogue little more than twelve years, rendered obsolete by the collodion–wet plate process. Among the new types of

images made possible by this innovation was the tintype. Inexpensive to produce (plates were made by pouring collodion over a piece of varnish–coated metal), the tintype took hold almost immediately. Traveling tintype "professors" set up their portable studios at carnivals, beaches, and on boardwalks throughout America. Small tintype images were used in rings, tie pins, and cuff links. Unlike the daguerreotype, which left ample room for the photographer to identify herself inside the case that housed the image, the tintype provided no such opportunity. Diaries and journals do disclose, however, that the ranks of the tintypists included a number of women and that among them was Frances Benjamin Johnston who, before her long and varied photographic career was over, would become one of the nation's most influential and successful photographers. And we have the marvelously detailed photograph of Johnston standing proudly at the center of her tintype operation.

Thanks also to the collodion process, the world was introduced to yet another form of early photography, one which became even more popular than the tintype. In 1854, the Frenchman Adolphe Eugène Disdéri patented the *carte de visite*, a name he gave to both the camera he invented and the photographs it took. The *carte-de-visite* camera had several lenses and as many as twelve portraits could be taken on one wet plate negative. The paper print from the negative was cut up into individual prints which were then pasted on 4 by 2½-inch cards, which were used as calling cards. It became a common practice in America for people to leave *cartes de visite* whenever they went visiting and to exchange them with relatives and friends on holidays and other special occasions. From names and logos printed on the backs

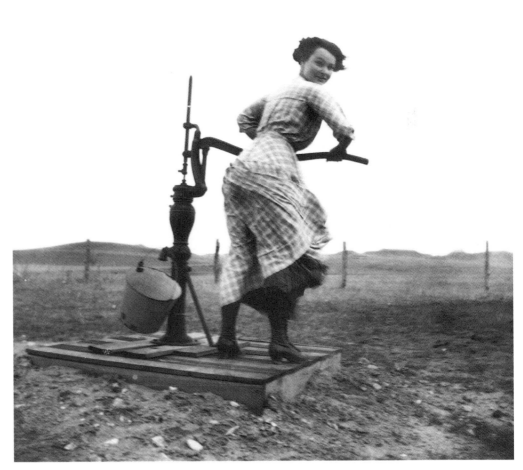

Elizabeth Ellen Roberts *Mrs. Ted Pope* (c. 1905)

of these ubiquitous cards—information often as sketchy as a simple "Mrs. Stuart"—we know that women photographers were also involved in this early form of the medium.

In the 1880s, with the advent of the dry plate and the Kodak camera, women by the thousands began to embrace photography, both as a vocation and an avocation. Although America's transformation from farm to city life was well under way, the United States was still predominately an agricultural nation of small towns and villages when these new photographers entered the field. It is not surprising that so many of them focused on rural genre themes, popular with country folk, who saw in them an affirmation of their way of life, and with many city dwellers, nostalgic for their old, simpler existence. While these genre photographers operated in every part of the nation, most shared a predilection to produce highly romanticized views of country life and a belief in the importance of photographing close to home.

Home for Frances Allen, born in 1854, and her sister Mary, born four years later, was the family farm in Wapping, Massachusetts. Trained as educators, they began teaching in 1876, but by the early 1890s both sisters, due to illnesses they had suffered as children, started to go deaf. With teaching now impossible, they turned to photography as a way of supporting themselves.

In 1895, after their father died, they and their mother moved to Deerfield, Massachusetts, where they began to take the type of pictures they felt would be most appealing to the buying public. Their photograph of two women in a doorway serves as a prime

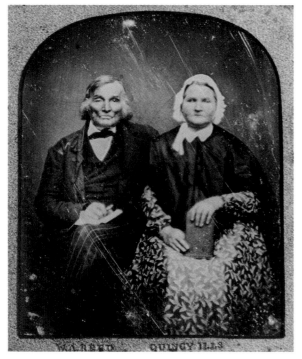

Mrs. Warren Reid
Unidentified couple
(1840s)

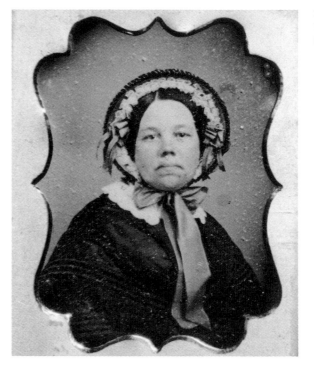

Lydia B. White
Unidentified woman
(1840s)

example of the way genre photographers strove to appeal to viewers longing to preserve a genteel way of life that was rapidly disappearing. The photograph also reveals that the Allen sisters, by so expertly framing their two subjects, possessed a natural sense of composition despite the fact that, as far as we know, they had received absolutely no training in the medium.

If there is one photograph that best serves as a prime example of the rural genre approach it is Sarah Jane Eddy's *Contentment.* A lifelong resident of Rhode Island, Eddy began photographing in the 1880s and was an influential member of several camera clubs. Almost all the elements that rural genre photographers sought to include in their images can be found in *Contentment.* The gingham-clad farm woman, her hair drawn back in a bun, serenely peels potatoes for the evening meal. At her feet sits the family cat basking in the warm sunlight that pours through open windows. The feeling of comfort that Eddy sought to evoke is intensified by the familiar country objects–rocking chair, baskets, gourds–that surround her. There is no mistaking Eddy's message: contentment is to be found in the quiet, simple existence that only life in the country could provide.

The evocation of rural values can also be seen in Mary Paschall's *Picking Geese.* In this image, an entire family works together at a simple agrarian task. They are all there–mother, father, grandmother, even the small child. Like the woman in Sarah Eddy's *Contentment,* the expressions on the faces of the family members convey serenity in the job at hand and in their way of life. And, as in Eddy's image, Paschall has posed them flanked by familiar artifacts of farm life–the handcrafted wooden wagon on the left and the whitewashed barn wall complete with hanging lantern on the right.

In portraying both the familiar and the sentimental, genre

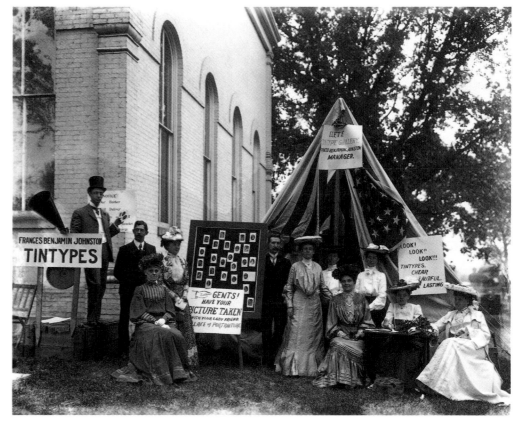

Frances Benjamin Johnston *Selling Tintypes at County Fair* (1903)

photographers continu-
ally turned to children
as subjects of their im-
ages. An Ohio farm
wife, Nancy Ford Cones,
became a master of this
approach. The daughter
of a physician, Nancy
Ford was born in Milan,
Ohio, in 1869. She was
twenty-five when she
took her first pho-
tographs, images that
so impressed her father
that he bought her an
interest in a photo-
graphic studio in
Mechanicsburg, Ohio.
When her business
partner proved to be
unscrupulous and her

Mrs. Stuart Unidentified girl (c. 1860)

sister called upon her to help nurse a sick husband, she rejoined
her family. She continued to photograph but lacked the facilities
to develop or print her pictures.

In 1897 she met James Cones, who had just opened his own
photographic studio. He began to print her images and soon
they were taking portraits together of wealthy families in near-
by Cincinnati. Three years later they were married and in 1907
moved to a twenty-five-acre farm in Loveland, eighteen miles
from Cincinnati. Here she began to focus more fully on genre
images, many of which featured her daughter, Margaret.

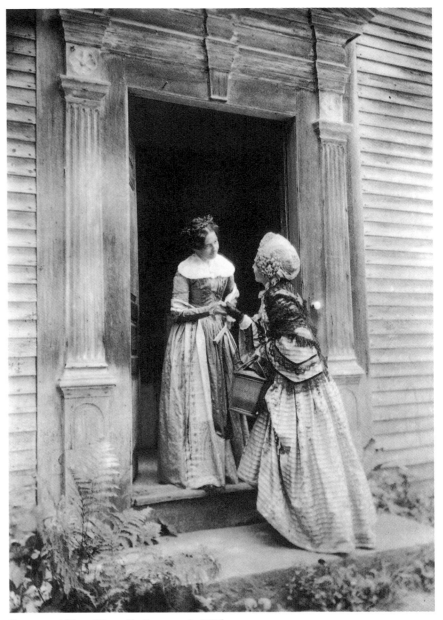

Frances and Mary Allen *The Doorway* (c. 1890)

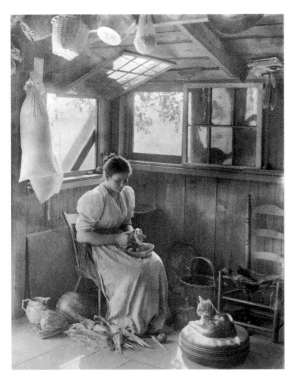

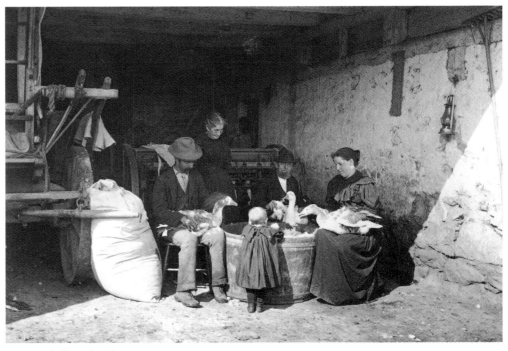

Sarah J.
Eddy
Contentment
(c. 1895)

Mary Paschall *Picking Geese*

In 1939, while she was still at the height of her photographic powers Cones's husband died. Although she would live another twenty-three years, she all but abandoned her photography. Yet the pictures she took, particularly those involving children, remain among the most compelling of all the early genre photographs. In images such as one she titled *Threading the Needle*, she demonstrated her special ability to employ light, shadow, and tone to capture the mood. Her photographic achievements reveal that in the hands of the best genre photographers the camera could go beyond that of capturing our attention through subject matter alone.

Children were also a favorite subject of West Coast photographer, Myra Albert Wiggins. Born in Salem, Oregon, in 1869,

Wiggins was a painter and a poet as well as a photographer. She would receive her greatest acclaim, however, for her genre images, which eventually earned her admission to the Photo-Secession, a group founded by Alfred Steiglitz dedicated to gaining photography recognition as a true art form.

Possessed with a flair for the dramatic, Wiggins claimed credit for having created a whole new category of early photography, which she labeled Dutch genre. She pursued this approach by dressing her subjects in antiquated Dutch clothing and posing them in settings designed to replicate the content, tone, and textures achieved by the best Dutch masters, such as Vermeer. The effects she sought were most fully realized in her photograph, *Hunger Is the Best Sauce.*

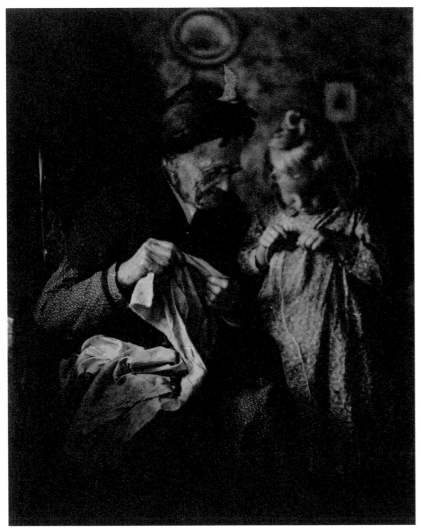

Nancy Ford Cones *Threading the Needle* (c. 1907)

While a few of the nation's earliest women photographers, such as Nancy Ford Cones, gained some recognition in their lifetime, most worked in relative anonymity. One in their ranks, however, became internationally famous. Her name was Catherine Barnes Ward, and among the accolades she received was one from early photography critic Richard Hines Jr., who in 1898 called her "the foremost woman in the ranks of photography today." Given some of the other female photographers operating by that time, it is an assessment open to serious debate, but there is no question that through her writing and lecturing as well as her photography, Ward exerted enormous influence, particularly on her fellow camerawomen.

She was born Catherine Weed Barnes in Albany, New York, in 1851. Her maternal grandfather was the famous New York politician and publisher Thurlow Weed. She attended Vassar College but was forced to withdraw to care for her ailing mother. After her mother died, the interest she had in photography accelerated and, against the advice of family and friends, she decided to become a professional photographer. By 1890 she was writing a column called "Women's Work" for the publication *American Amateur Photographer*, establishing herself as probably the nation's first woman photography columnist.

Ward was particularly outspoken on the subject of the acceptance of women into photography. Denied admission by one photographic club because of her sex, she immediately joined another and campaigned aggressively for women's acceptance in all the clubs. Perhaps her most important crusade involved her campaign to rid the photographic world of the practice of awarding separate prizes for male and female achievement.

A city dweller, Ward's photographs are very different in content from those of country photographers like Sarah Eddy and Nancy Ford Cones, but contain their own distinct charm. Her image *Five O'Clock Tea*, for example, captures a more sophisticated ritual than peeling potatoes or threading a needle, yet Ward pays the same attention to detail. She adds her own sense of mystery by capturing the young woman in the photograph with her eyes closed. Is she asleep or just pensive? We'll never know.

Nancy Ford Cones once stated that "it is a dead sure thing that if you cannot make pictures in or around the home, it is positively hopeless to go abroad to find them." It was a sentiment shared both by her fellow genre photographers and by those early camerawomen who, while not taking a sentimentalized genre approach, dedicated themselves to capturing scenes of the familiar, specifically that of the daily life around them. Their ranks ranged from those like Evelyn Cameron and Elizabeth Ellen Roberts, who trained their cameras on a section of the nation still in the making, to Chansonetta Emmons, Emma Coleman, and Margaret Morley, who documented daily rural life, to Alice Austen, who documented both the daily life of her fellow gentry and life in the teeming city.

One of the most gifted of all these photographers of daily life was a woman who in her lifetime had only one photograph published. Yet years after she passed from the scene, a far more famous women photographer, Berenice Abbott, would proclaim, "Here is living proof of a true photographer whose eye and brain

Myra Albert Wiggins *Hunger Is the Best Sauce* (c. 1900)

react naturally to the old, the familiar, the now, the importance of life under our noses."

Chansonetta Stanley was born in the small rural town of Kingfield, Maine, in 1858, the only girl in a family of six children. Two of her brothers, the twins F.E. and F.O., would eventually gain fame and fortune, first as manufacturers of the Stanley dry photographic plate and later as inventors of one the world's most fabled automobiles, the Stanley Steamer.

It was while her brothers were developing their dry plate process that Stanley (later Chansonetta Emmons) first became interested in photography. When the twins moved to the Boston

Chansonetta Emmons *Shelling Corn, Kingfield, Maine* (1901)

area to open a factory for their new product she went with them and began teaching art in the Boston schools. Soon afterward she met James Emmons, whom she married in 1887. Eleven years into their marriage tragedy struck when James died suddenly of blood poisoning. At the age of forty, Emmons found herself a widow with a seven-year-old daughter to support.

She was much luckier than most in her position, however, because her brothers, now wealthy from their dry plate venture, had both the means and desire to support her financially. But Emmons was also determined to discover something positive to do with the rest of her life. She found it in the camera. For the better part of the next thirty-five years she and her daughter traveled back and forth between a house in the Boston area that the brothers rented for them and the family homestead in Kingfield, where she found the subjects that would launch her seriously into photography.

With their lives anchored in the rocky Maine soil, the people of Kingfield and the surrounding areas were a special breed. At the time that Emmons went back there, most were living much as their ancestors had lived for generations. She knew these people well; many were friends or relatives. She took pictures of them all—farmers at work at five in the morning, women whose work never seemed to end. She captured them with all the common trappings that surrounded them—the table chair, the spinning wheel, the one-room schoolhouse, the blacksmith shop, the gristmill.

Emmons's real genius, that which distinguishes her from all early photographers, lies in the way she was able to use natural light. Her unique talent for lighting enabled her to create shapes, shadows, and forms, and to bring a special kind of beauty to the scenes she shot. This ability is seen clearly in *Shelling*

Corn, a photograph that was one of her favorites. In this marvelously composed image, she used the soft light pouring through the window to create a variety of tones and textures. The naturally illuminated window becomes a powerful addition to the scene.

The photographs *Grist Mill* and *Feeding the Hens* provide other examples of Emmons's talent for composition, her ability to let natural light flow through and around all the objects in her picture, and her patience in allowing those she was photographing to arrange themselves as she waited for just the moment to snap the shutter. The individuals and the articles portrayed in these images typify her determination to photographically preserve a way of life that was quietly disappearing.

Chansonetta Emmons *Grist Mill, West New Portland, Maine* (c. 1901)

Another relatively unheralded photographer of daily life, one who brought an added dimension to her images, was Emma Coleman. Born in Boston in 1853, her parents were wealthy, and she would have the luxury of spending a life dominated by travel and artistic and literary pursuits, including a career as a highly talented amateur photographer. It was a career influenced profoundly by two women, the painter Susan Minot Lane and the historian/teacher C. Alice Baker.

Although Lane and Baker were twenty years older than Coleman, the three developed a deep and long-lasting friendship. They vacationed together in Deerfield, Massachusetts, York, Maine, and New Hampshire's White Mountains. It was in Deerfield and York that Coleman would take many of her most compelling photographs. She was encouraged by Lane and Baker to take up the camera seriously, and Lane influenced the formal direction of her photography.

Lane had studied painting under William Morris Hunt, the nation's leading champion of the French Barbizon school of artists. She passed on her enthusiasm for the romantic style of the Barbizon painters to Coleman and encouraged her friend to emulate them through her photography. "Whatever success I have had," she later wrote, "is largely due to Miss Lane. . . . She taught me how to see a picture."

In capturing her images, Coleman pursued two related goals. One was to capture scenes as picturesquely as possible. The other, inspired by her belief in the timelessness and universality of rural life, was to record its rhythms and routines. Quiet and

Chansonetta Emmons *Feeding The Hens, West New Portland, Maine* (c. 1900)

Emma Coleman *Alice Baker* (c. 1890)

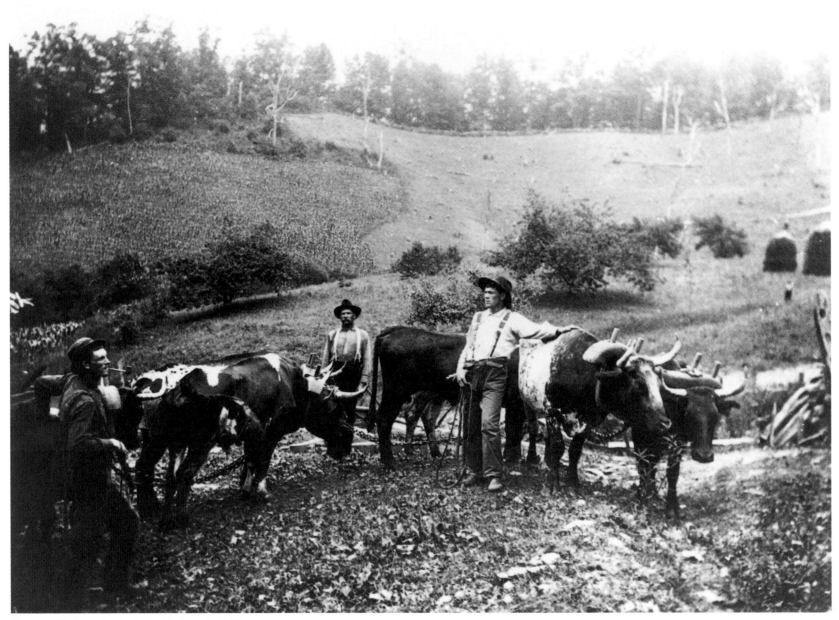

Margaret Morley *Clearing Land with Oxen* (c. 1900)

unassuming, Coleman never promoted her own work or encouraged others to do so. It is unfortunate, for she was a true pioneer in photography as well as art.

Intriguing and puzzling is the story of photographer Margaret Warner Morley, born in Montrose, Iowa, in 1858. Her family moved to Brooklyn, New York, and she attended Oswego Normal School and graduated from New York Normal College. Interested in biology, she undertook advanced studies at Chicago's Armour Institute and at the Woods Hole Marine Biological Laboratories in Massachusetts.

When her studies were completed, she began a teaching career. While preparing for her classes, the well-traveled Morley also gathered material for books she wished to write on the life of small animals, birds, and insects. From 1891 to 1915, she produced a long series of works for grade school children on these subjects. In a true pioneering endeavor, she also wrote several books designed to teach youngsters the then highly taboo facts of sex and birth.

This extraordinarily energetic and prolific woman obviously loved the outdoors and spent part of each year in Tyron, North Carolina, where she wrote two of her most popular books, *The Carolina Mountains* and *Will-o'-the-Wasps*. There she also wrote *Little Mitchell*, the story of a squirrel she found and adopted, which, according to her obituaries, she carried about in her pocket.

Unfortunately Morley suffered the same fate as Elizabeth Ellen Roberts in the historical record: the few biographical details do little to account for her relatively prolific photographic career, the products of which are housed in the collections of the North Carolina Department of Archives and History. The little that exists

about Morley in print mentions not a word about her ever having taken a single photograph.

Yet her images are exceptional in their representation of work and life in rural turn-of-the-century North Carolina, with their sophisticated sense of composition. We are left wondering when, in her seemingly nonstop schedule of teaching and writing, Morley learned to use the camera and how she developed such photographic skills. And again, why no mention of her as a photographer? It is yet another mystery housed in the world of photography.

While Emma Coleman, Margaret Morley, and others were recording images of rural life, another woman photographer was

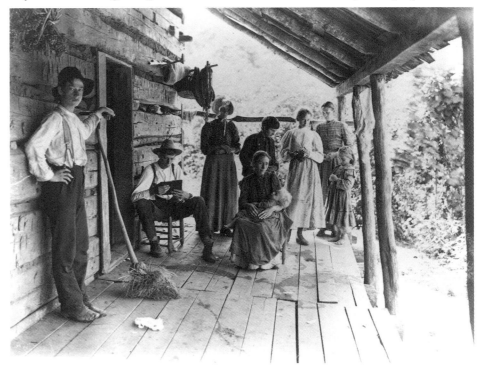

Margaret Morley *Family on Porch* (c. 1900)

Alice Austen *Trude & I Masked, Short Skirts* (1891)

Alice Austen *Hester Street Egg Stand Group* (1895)

recording a very different type of existence. Her name was Alice Austen, born Elizabeth Alice Munn in Staten Island, New York, in 1866. Before she came into the world, her father deserted his family; her mother reclaimed her maiden name for herself and her child and moved them to her parents' nearby home. The Austen homestead, Clear Comfort, was aptly named. Austen's wealthy grandparents, her two uncles and an aunt who also lived there, enjoyed a carefree, privileged existence, which they generously shared with her and her mother.

When she was ten years old, one of Austen's uncles, a Danish sea captain married to her mother's sister, brought a bulky wooden box camera home from one of his voyages. The youngster stood fascinated as Captain Müller demonstrated the device and showed her how to use it. When he left on his next journey he turned it over to Austen who immediately began to photograph everything around her. Her uncle Peter, a chemistry professor impressed with the seriousness with which she approached her picture-taking, helped build a small darkroom for her and taught her how to develop her glass plate negatives. From that time on, a camera was her constant companion, and by the time she was eighteen she knew without question that hers would be a life in photography.

Staten Island in the 1880s and 1890s was a haven for the well-to-do, filled with magnificent homes and estates. Austen captured scores of images of the people who inhabited them, their social gatherings, and their coachmen, footmen, and other servants. She found the majority of her subjects, however, in those she knew best—her family, her neighbors, and, most of all, her friends.

She had dozens of friends and, like her, they lived a fun-loving, pleasure-filled life. Their days were filled with picnics, skating and bowling parties, bicycling, and horseback riding. There were endless socials, masquerades, and musical evenings as well. Like Austen, many of her friends were pranksters and in some of the photographs we find them pretending to be intoxicated while drinking tea disguised as hard liquor. In others, the young women make believe they are smoking cigarettes or appear with their long skirts hiked up above their ankles. Simple pranks, but scandalous for their day.

Although Austen's social life was, as she put it, "larky," her approach to her picture-taking was just the opposite. Often, to the consternation of her subjects, she would spend up to an hour adjusting her equipment, positioning and repositioning those she was photographing, waiting for what she felt were the perfect postures and expressions. She was just as meticulous in recording every photograph she took. On each of the envelopes that housed her negatives she marked down the subject, the aperture, the focal distance, the weather, and the exact date, hour, and minute the picture was taken.

If Alice had trained her camera exclusively on her immediate surroundings she still would have made a lasting photographic contribution. But she did much more. In the 1890s, with New York City in the midst of the greatest influx of immigration any city had ever known, she began taking regular day trips to the metropolis of Manhattan, photographing the newcomers, native-born laborers, and a wide variety of the "street types" she encountered. The image she captured of a ragpicker posing with his cart, when compared with her Staten Island photographs, reveals how brilliantly she was able to record ways of life as far apart as one could imagine.

For the better part of the next thirty years Alice would continue to photograph—on Staten Island and in Manhattan, on

trips to cities like Boston and Annapolis, Maryland, and on journeys abroad. Then, in 1929, when she was sixty-three years old, tragedy struck. Like many of her neighbors, she was financially devastated by the stock market crash. Now mistress of Clear Comfort, she was forced first to mortgage and then to leave her beloved family homestead. During the next twenty years, with her health progressively declining, she moved first into the apartment of a friend then into two different nursing homes. In January 1950, she was evicted from the second nursing home due to an inability to pay and this proud, elegant, once affluent woman was admitted to the Staten Island poorhouse. Six months later, in a final twist of fate, an aide of photo-historian Oliver Jensen discovered her long-forgotten negatives in the basement of the Staten Island Historical Society. Jensen placed stories accompanied by some of the photographs in *Life* and *Holiday* magazines. A portion of the proceeds from these articles, given to Austen, enabled her to move to a comfortable home for the aged, where she died on June 9, 1952.

She died almost penniless, but she left a rich photographic legacy. By demonstrating that women could produce photographs that were witty and humorous as well as masterful, she was years ahead of her time. Perhaps her greatest achievement was that she gave American women some of their first unsentimentalized depictions of their fellow women. As her biographer, Ann Novotny informed us, "She photographed actual women, as young, funny, and energetic as her own friends, as plain and poor as the street vendors of the Lower East Side. . . ." It was a major achievement.

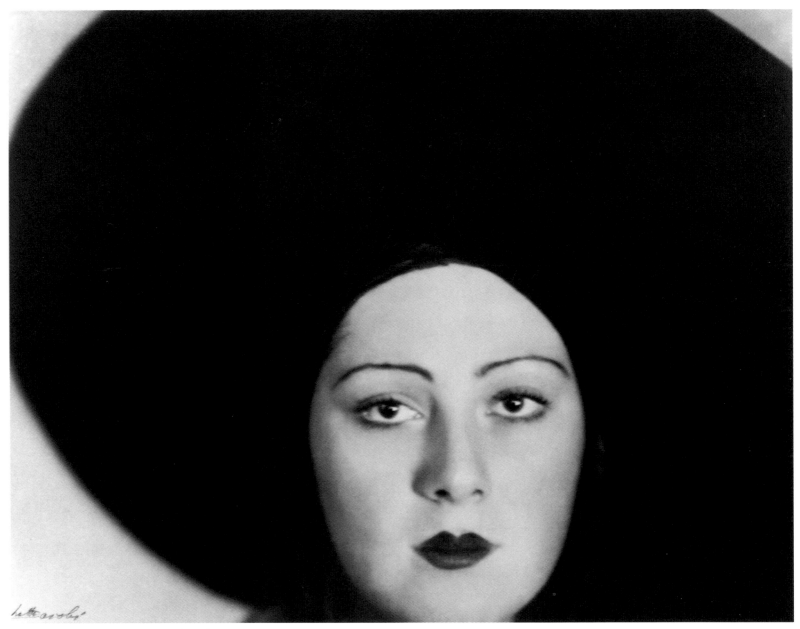

Lotte Jacobi *Head of a Dancer, Berlin* (1930s)

2 · Portraiture

ALMOST EVERY early American woman photographer began her career taking portraits. It was an excellent training ground, since capturing a likeness that satisfies both the subject and photographer is one of the most demanding of all photographic challenges.

Catherine Barnes Ward spoke for all her fellow portraitists when she observed, "Human nature takes on very odd phases, and one needs the eyes of Argus and the patience of Job to see that the work is well done." Simply stated, the basic challenge is that the person who sits for a portrait wants the likeness to be as flattering as possible. At the same time, a masterful photographer wants the image to be compelling, to convey meaning beyond the recording of physical features. Photographers through the years have identified more precise challenges. "The painter," observed Alice Boughton, "usually has several sittings, sees his subject under varying conditions in different moods, has a chance, in short, to become acquainted with the personality he is to portray. The photographer, on the other hand, has one moderately short session." What it all boils down to, in most cases, is what photo-historian Kelly Wise has termed the implicit contract between subject and portraitist. "The end of their collaboration," she has written, "will . . . be different perhaps from what either might expect, but surely not a disparagement of the subject. Probably most often without words, like strangers who choose a slow but ephemeral dance together, they grope through matters of pose, control, distance, mood, and lighting."

The style and approach that portraitists have taken has been as varied as the photographs they produced. Some photographers have sought to bring added dimension to their pictures by including props, often intended as symbols of the sitter's way of life or achievements or traits of character. Others have preferred to photograph their subjects in as plain an environment as possible. Some have deliberately chosen to remove themselves, so to speak, from the portrait, photographing only what their lens reveals. Others, through pose, lighting, and darkroom techniques have sought to bring personal interpretation to their images.

Whatever their approach or motivations, pioneer women photographers were instrumental in the development of the world of portraiture. Whether they concentrated in this area or moved on to other photographic fields, their contributions included not only the quality of the work they produced, but the key role they played in the advancement of portraiture from that of simply capturing a likeness to a recognized form of artistic expression.

"The study of the old and modern masters of Europe," wrote Charlotte Adams, one of photography's earliest critics, "is as valuable to the photographer as it is to the painter." Many of the early American portraitists, whether they had formally studied European art or not, unabashedly imitated the style of Old World painters who had long been celebrated. It was an easy approach to adopt, and one that found favor with American viewers not yet ready to accept the potential of photography as a whole new means of visual expression.

There is no clearer example of this imitative approach than Frances and Mary Allen's *A Holbein Woman.* Dressed in clothing of Holbein's time and engulfed in the same dark background favored by the Dutch artist, the Allen sisters' subject appears

Frances and Mary Allen *A Holbein Woman* (c. 1890)

exactly as she would have in one of the master's paintings.

It did not take long before there were photographers eager to break away from the bonds of imitation, determined to being their own identity to the portraits they produced. Among the earliest of these photographers was Zaida Ben-Yusuf. Born in England, she moved to the United States with her family in the early 1890s. She was a most interesting and mysterious woman. Exotic both in her dress and personal behavior, she burst on the scene like a meteor, gaining enormous recognition in photographic circles from 1897 to 1905, and then disappeared from the scene almost without a trace.

Of her portraits early photographic critic William McMurray would write, "You want a picture to seize you as forcibly as if a man seized you by the shoulder. Miss Ben-Yusuf goes a step beyond this in her photographic pictures, for some of them make you feel as if you had not only been seized by the shoulder but had also received a violent blow on the proboscis or the solar plexus. She is nothing if not original." Of all the photographs Ben-Yusuf took, *The Odor of Pomegranates* is perhaps the most striking. It is a portrait that unmistakably reflected her own theatrical personality, with its dramatic use of profile and provocative exploration of pattern in the wall covering which seductively drapes the model.

Like Ben-Yusuf, Eva Watson-Schütze was determined to bring her own identity to her portraits. She was born Eva Lawrence Watson in Jersey City, New Jersey, in 1867. When she was sixteen years old she entered the Pennsylvania Academy of Fine Arts in Philadelphia where she studied painting with Thomas Eakins. She soon began to feel that this art training left her "no outlet for creative impulses," and she turned to photography. In 1894, she opened a studio

with fellow photographer Amelia Van Buren. Four years later, she moved into her own studio in Philadelphia.

The key to Watson–Schütze's photographic approach was her passionate belief that photography, including portraiture, could be artistic without being imitative of paintings. She was particularly vocal in expressing her opinion that the artists whose work she so admired had done photography a great disservice by failing to recognize photography's own place in the world of artistic expression. It was this search for a unique artistic photographic identity that would lead her to produce portraits such as *The Rose*, distinguished by its soft, almost ethereal effects and the distinct photographic qualities that her imagination brought to the work.

"The woman who makes photography profitable," declared Frances Benjamin Johnston, "must have good common sense, unlimited patience to carry through endless failures, equally unlimited tact, good taste, a quick eye, and a talent for detail." It would be a "talent for detail" that would prove to be Johnston's greatest asset. That, and a sharp eye for business, would enable her to become one of the most financially and professionally successful of all the early women photographers. Her influence on other camerawomen would be enormous. In 1900, at the famous Paris Exposition, she lectured on the achievements of women in photography and presented an exhibition of some of their work. The following year she began writing a series of articles for *The Ladies Home Journal*, titled "The Foremost Women Photographers of America." Throughout her career she made a point of making herself available to women aspiring to enter the photographic profession.

Johnston was born in Grafton, West Virginia, in 1864, and studied drawing and printing before turning to the camera in

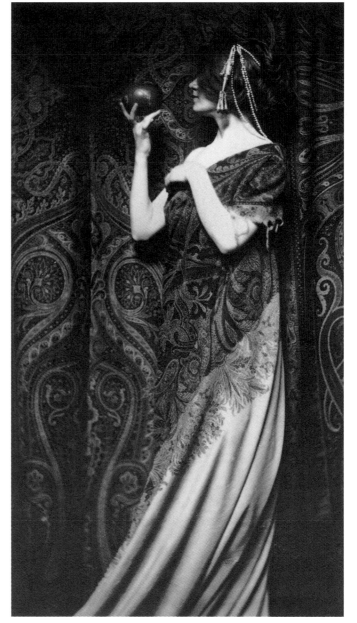

Zaida Ben-Yusuf
The Odor of Pomegranates
(c. 1899)

Eva Watson–Schütze
The Rose (c. 1903)

Frances Benjamin Johnston Self–portrait (c. 1895)

1885. In 1890, she opened her own studio in Washington, D.C. Both her life and her photographic career were characterized by the way she moved easily between two very different worlds. The niece of Mrs. Grover Cleveland, she enjoyed an exalted social position that enabled her to enter the White House during the administrations of Cleveland, Harrison, McKinley, Teddy Roosevelt, and Taft where she took portraits of all these presidents. Yet her lifestyle was characterized in her day as "Bohemian." The self-portrait she took early in her career is most revealing. In it she presents herself with beer mug in one hand, cigarette in the other, and skirt scandalously hiked up above the ankles. On one of her fingers are several rings from male suitors she had rejected. It is a photographic statement proudly defying the attitudes and conventions of the day.

Johnston would eventually earn her greatest reputation for the images she captured both as one of the nation's first documentary photographers and one of its first photojournalists. But she had a great talent for portraiture as well. It can be seen in the photograph she took of Mark Twain in 1906, just four years before his death. It is a portrait that reveals the rapport that she was able to establish between herself and those who sat for her, resulting, in this case, in one of the most natural photographic studies of the famed American humorist ever taken.

Like Johnston, Chansonetta Emmons was interested most in revealing the character of those who sat in front of her camera. But she had another agenda as well. In compiling her chronicle of daily life in her native Maine, she was motivated by the knowledge that many of the people she photographed and their ways of doing things would soon fade from the scene. One of the most masterful of all her images was that which she titled *Old Table Chair No. 2*. The photograph was one of a series of

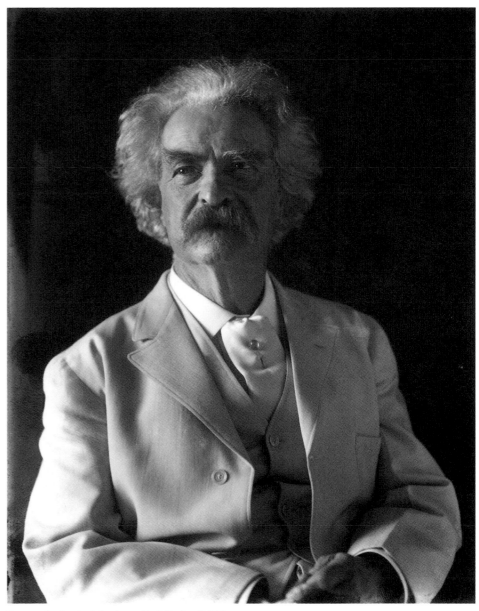

Frances Benjamin Johnston *Mark Twain* (1906)

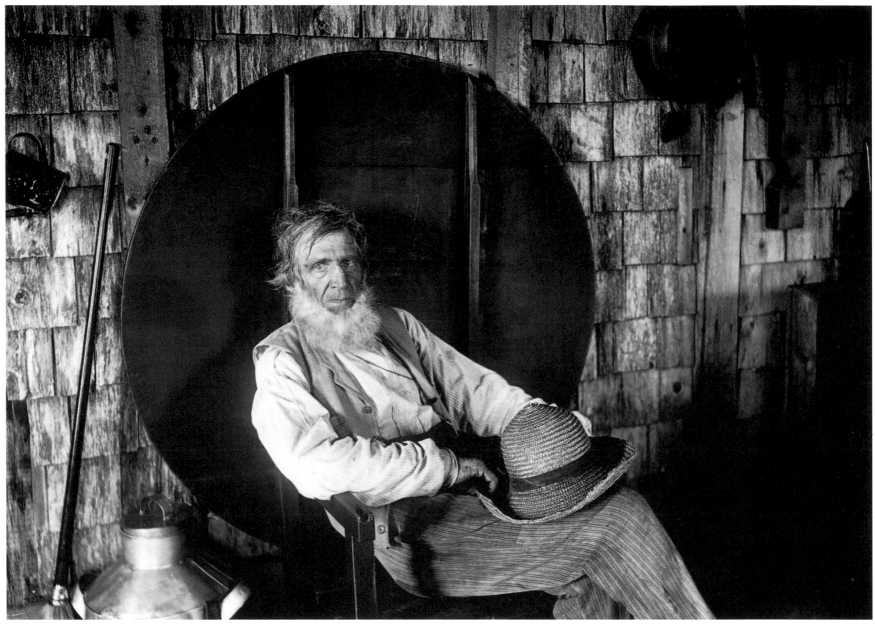

Chansonetta Emmons *Old Table Chair No. 2, West New Portland, Maine* (c. 1901)

portraits that she took using this unique piece of furniture as a backdrop.

The entire tone of *Old Table Chair No. 2* is in keeping with Emmons's goal of recording a special type of vanishing American. Indeed, not long after he posed for the picture, the Reverend Emery Butts died. But Emmons has preserved him for us. She has captured the set mouth and the determined gaze of this longtime son of the rocky Maine soil. She has made certain that he is holding his straw hat, itself an artifact of this disappearing way of life. It is impossible to study it closely without realizing that this is more than a portrait of a man—it is a deliberate evocation of the passing of an era.

Of all the women, amateur or professional, ever to pursue photography none reached greater heights than Gertrude Käsebier. Through her work she would become a role model for generations of aspiring camerawomen, motivating such future masters of the craft as Laura Gilpin and Imogen Cunningham to pursue careers in photography.

A pioneer in the American experience as well as photography, she was born Gertrude Stanton in what is now Des Moines, Iowa, in 1852. Seven years later, gold was discovered in the Colorado Territory and Käsebier's father hauled a sawmill all the way to the diggings to take advantage of what he anticipated would be a building boom. He was right, and within a year he had not only built a successful business but had been elected mayor of Golden, then the capital of the Colorado Territory. The family was reunited when Käsebier, her mother, and her infant brother made the long journey across the plains.

As a child of the frontier, Käsebier often found herself alone, amusing herself with her own imaginings. Her mother remembered coming upon her as she gazed intently on a painting that

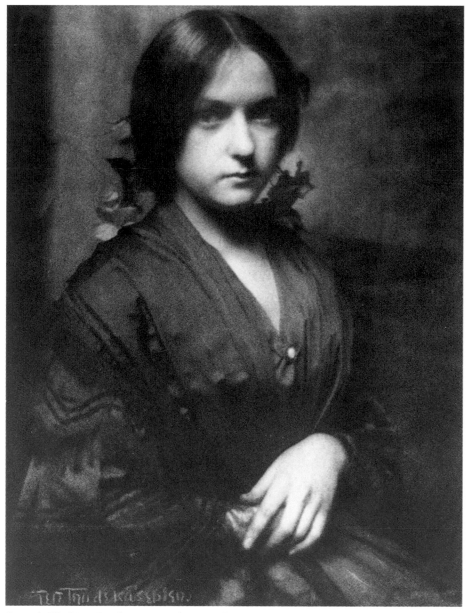

Gertrude Käsebier *Josephine (Portrait of Miss B)* (1903)

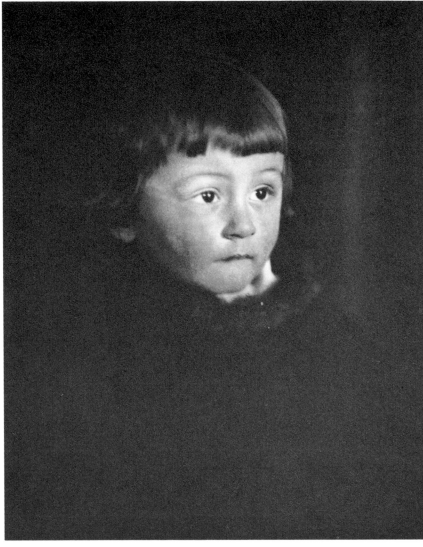

Gertrude Käsebier *Portrait of a Boy* (1897)

hung upon a wall in the Colorado home: "On one knee on the floor . . . viewing it through her small hands, telescopelike, talking to herself meanwhile, asking herself if it would ever be possible for her to make such a picture."

Although Käsebier's father continued to prosper, life in Colorado took an unexpected turn. By 1864 Civil War encounters had begun to take place in the territory. Käsebier's parents, now able to afford a much safer and more comfortable life, decided to move the family to New York.

By 1890, Käsebier had graduated from Morovian College for Women, had married Eduard Käsebier, had given birth to three children, had begun taking courses in portrait painting at Pratt Institute, and had studied photography in Germany. Upon her return home, determined to become financially as well as artistically successful, she sought out Samuel Lifshey, who ran a Brooklyn portrait studio, and convinced him to take her on as an apprentice so that she could learn the business as well as the technical side of portrait photography. In 1897 she opened her own studio. Her goal, she said, was "to make pictures of people, not maps of faces, but pictures of real men and women as they know themselves, to make likenesses that are biographies, to bring out in each photograph the essential personality that is variously called temperament, soul, humanity." In pursuing this goal, she was extremely demanding of herself and those who sat for her camera. When Thomas Edison's daughter complained that, after having sat for more than a quarter hour and having changed into several outfits, not a single picture had been taken, Käsebier replied, "I know, there's nothing there."

Time and again, however, it *was* there and in less than a half-decade Käsebier would produce scores of photographs of

both the famous and unknown, which would lead Alfred Stieglitz to label her as "beyond dispute the leading portrait photographer in this country." The qualities that Stieglitz discerned can be seen in portraits such as *Josephine* (which Käsebier sometimes titled *Portrait of Miss B*) and in the photograph of a young boy, which she titled simply *A Portrait*. Among the most interesting of her subjects was the French sculptor Auguste Rodin, the most famous of all living artists. Bombastic in his personal life, Rodin was extremely shy and uncooperative in front of a camera. Käsebier waited patiently until the sculptor became lost in thought, oblivious to being photographed. The result was an image that captures the energy and intensity of the man, along with his imposing physical presence. As in many of her portraits, Käsebier surrounded Rodin with shadow, intensifying our focus on his facial features, capturing the visual biography she constantly sought to attain.

In capturing her photograph of Rodin, Käsebier encountered many of the same challenges faced by all photographers who deal with celebrities. Famous people often come equipped with both huge egos and a stake in having their portraits present them in the most flattering light. Producing a meaningful portrait while operating under these conditions is a difficult task.

Few photographers ever handled this task better than Lotte Jacobi. Her roots in photography went as far back as the very birth of the medium. Her great grandfather had received photographic instruction from Louis Daguerre himself, and Jacobi was the fourth generation in her family to become a professional photographer. She was born in Thorn, Germany, and at the age of twelve while helping her father

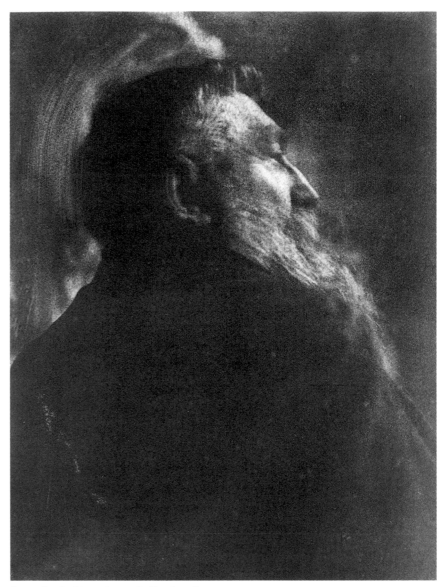

Gertrude Käsebier *Auguste Rodin* (1905)

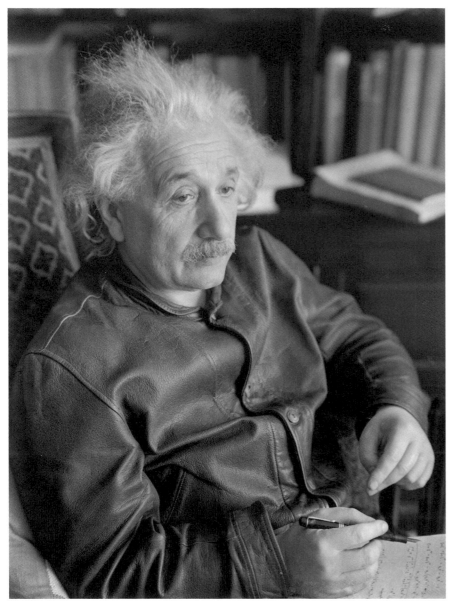

Lotte Jacobi *Albert Einstein, Princeton, N.J.* (1938)

make wet plates, became interested in photography. By 1927, she had married, given birth to two children, moved to Berlin, been divorced, and had taken over her father's photographic studio.

Once she was on her own, Jacobi began to photograph Germany's leading political figures, artists, and scientists. In less than a decade she became the nation's best-known and most successful portrait photographer. In 1935, when it was becoming obvious that Jews were not safe in Nazi Germany, she fled to America, leaving behind thousands of glass plates, negatives, and prints that despite many efforts were never retrieved.

Almost immediately after arriving in New York City, Jacobi opened the first of what was to be a succession of portrait studios. In 1938 she also became the first woman to photograph on the floor of the New York Stock Exchange while trading was in progress. She would later recall with no small amount of pleasure, the turmoil that was caused by the appearance of a woman in this male bastion.

What sets Jacobi's portraits apart is what her biographer Kelly Wise has termed "her willingness to observe rather than to direct." There is an elegant informality to her images. This quality is perhaps most clearly seen in her portrait of Albert Einstein. She has captured the genius off guard, lost in thought, hair askew. There are no fancy props, no tricky camera angles, a total lack of pretense. This is Einstein the person and the thinker as no other photographer had been able to portray him. It is an image that gives life to Jacobi's own explanation of her approach to portraiture. "I only photograph what I see," she said. "My style is the style of the people I photograph. In my portraits I refuse to photograph myself, as do many photographers."

While Doris Ulmann also took many photographs of the well known and powerful, she would attain her greatest heights

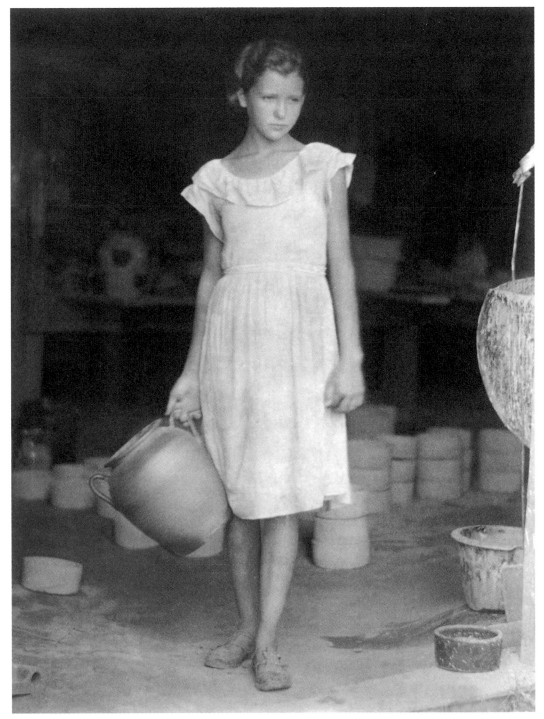

Doris Ulmann *Girl with Jug* (c. 1930)

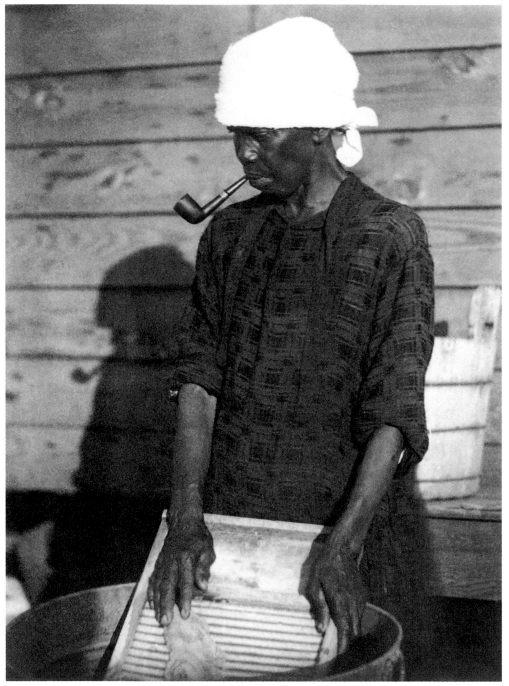

Against the Odds Doris Ulmann *Woman with Scrubboard* (1930)

operating much as a sociologist, capturing images of a much different class of people. Born to wealthy parents in 1884, she spent most of her days attended to by a host of servants. She suffered from poor health all her life and did not live beyond her fiftieth year. Yet she left an indelible mark on photography by traveling through Appalachia and the South (in a chauffeured limousine, no less) taking portraits and recording scenes of the daily life of a people whose experiences and conditions were worlds apart from any that she had ever known.

Intending to become a teacher, Ulmann attended Columbia Teachers College. While there, she took a course taught by Clarence H. White. Already recognized as one of America's premier photographers, White was making an even greater contribution to the medium as its most influential teacher. Inspired by him, Ulmann turned to photography as a career and at first, like many of the female photographers before her, concentrated on producing genre images. Sometime before 1917 she married Dr. Charles H. Jaeger, a professor at Columbia University Medical School and a highly respected orthopedic surgeon. With her own considerable social standing enhanced by her marriage, she came in contact with many of the leading celebrities and literary figures of the day, many of whom came to her apartment to pose for her camera.

Eventually she tired of taking portraits of the rich and famous. She yearned, she told a friend, to find more interesting subjects, more intriguing faces. In the mid–1920s she began to take photographic trips to rural areas close to New York City. Several of the photographs of the people she encountered were published in *Pictorial Photography In America* and in other leading journals and magazines. In 1925, Ulmann and Dr. Jaeger were divorced. Freed from the social commitments to which her mar–

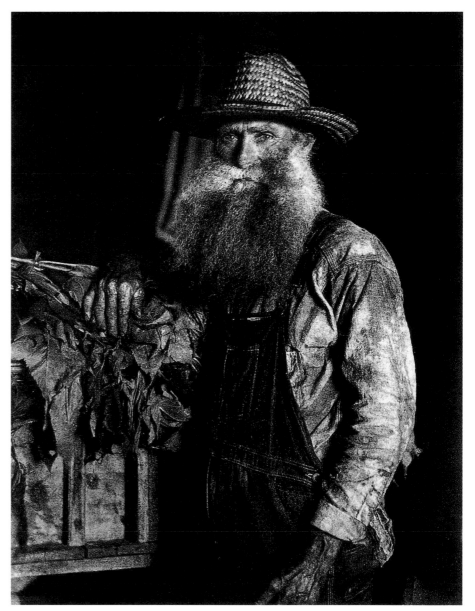

Doris Ulmann *William Campbell* (c. 1930)

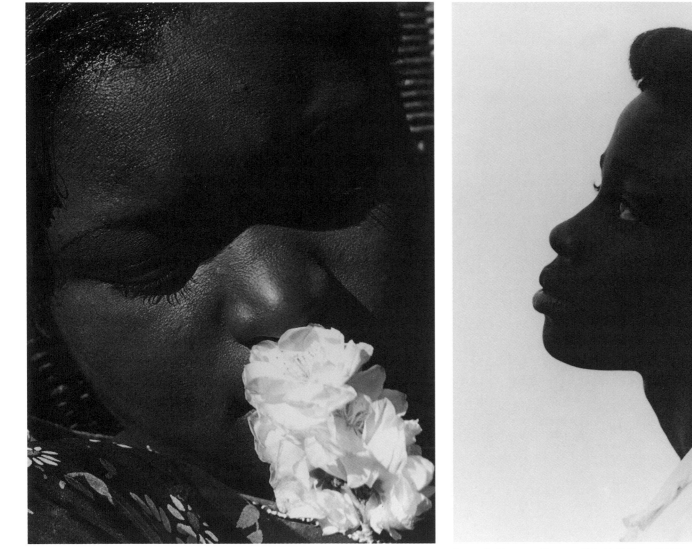

Consuelo Kanaga *Frances with a Flower* (c. 1930)

Consuelo Kanaga *Tennessee Girl with Ribbon* (1948)

44 *Against the Odds*

riage had bound her and buoyed by the success of the rural New York photographs, she made a bold decision. She would travel to the heart of rural America, to the Appalachian region, to document a people and a way of life that had long fascinated yet mystified her. It was a venture that would consume her for the rest of her life.

On her many trips throughout Appalachia, and later in the Deep South, Ulmann was accompanied not only by her maid and chauffeur but by John Jacob Niles, an accomplished folk singer, composer, and collector of American traditional music. In exchange for introducing her to the mountain folk he knew and helping her with her photography, Ulmann agreed to financially support Niles's career.

It must have been quite a sight: Ulmann driving up in her limousine to a mountain cabin or farm, attired in her fashionable hat, long gloves, and freshly laundered, floor-length white dress. Yet, she had an extraordinary knack for looking people in the eye and putting them at ease. Today as we look at the portraits she took, we are taken by the sensitivity of her work. The poverty is inescapable. It is seen in her subjects' clothing and in their surroundings. Yet there is a humanity attached to these photographs that uplifts both subject and viewer. It is a unique portrayal complied by a woman who was the personification of the word *unique.*

Like Ulmann, Consuelo Kanaga was fascinated with the character revealed in people's faces. Highly versatile, she became a masterful news photographer. She also produced compelling, thought-provoking abstract images. It was through portraiture, however, that she made her greatest mark.

Kanaga was born in Astoria, Oregon, in 1894 and grew up in California. Most of her adult life was spent in New York City, where she produced imaginative images. The power and beauty of her work was due not just to her talent with a camera but to her print-making ability. To her, the making of the print was as important, sometimes even more important, than the taking of the picture itself. It was her patience, as well as her artistry that led her to the results she sought. "I found," she wrote in later life, "that my portraits really stand on their own because I put a lot into them and wanted them to be beautiful. I had to make fifty prints to get one that I liked, so that's why I never did get rich."

Just as Ulmann found her most rewarding subjects in the people of Appalachia, Kanaga discovered her greatest satisfaction in photographing African-Americans. "I love to photograph black people," she stated, "to try to capture the strength and dignity I so often find in their faces."

One of the most compelling of all Kanaga's photographs is *Frances with a Flower,* a portrait that epitomizes her fascination with the beauty and texture of black facial features. The image also reveals her genius in achieving dramatic effects by contrasting deep shades of black with brilliant whites.

Although teachers of photography have commonly advised their students to avoid photographing faces too close up, Kanaga often preferred to do just that. The dramatic results she achieved can be seen in her portrait, *Tennessee Girl with Ribbon.* Here she has created what amounts to a silhouette by contrasting the dark skin and hair of the girl with the stark whiteness of her hair ribbon and blouse. Kanaga enhanced her contrast by having light fall upon the girl's lower lip and ear. As you study *Tennessee Girl with Ribbon* and *Frances with a Flower* you come to appreciate the assessment of photographer and writer Margaretta Mitchell. To Mitchell, Consuelo Kanaga was nothing less than "a humanitarian with a camera."

Like Lotte Jacobi, Toni Frissell was particularly adept at putting famous subjects at ease while they sat for her camera. Frissell was born in New York City in 1907. Marked by an adventurous spirit, she became known for her willingness to go anywhere and risk almost anything to get the shot she wanted. It was a trait that came naturally. Her grandparents had crossed the continent to settle in Oregon. Her uncle had gone to Alaska to search for gold and her brother was both an explorer and a documentary filmmaker.

Although Frissell eventually became an important World War II camerawoman, she gained her greatest fame for her pioneering work in the field of fashion photography. Along the way, she took portraits of many of the most well-known people of her day. Of these none is more powerful than her photograph of Winston Churchill, taken in 1950.

Of her experience in photographing the man she called "that glorious bulldog," Frissell wrote, "In repose he had two sides to his face. The right-hand corner of his mouth turned up slightly; on the left he looked dour. Most powerful men have two sides to their face." When Frissell began to photograph Churchill he appeared to be totally disinterested. "First," recalled Frissell, "he made a series of V for victory signs as if I was in a crowd of newspaper photographers. Presently an impatient look came over his face. I hadn't accomplished anything. . . . Finally I burst out with what was on my mind. 'Mr. Churchill,' I said desperately, 'You are not thinking the right thoughts'–this to one of the greatest thinkers of the country!

"I went on," recalled Frissell. " 'You are thinking how tiresome this woman is who's detaining you when you want to go out for a walk with Mrs. Churchill,' I said. 'Are those the right thoughts for this struggling photographer who wants to record a great picture of you?' I said this with a broad smile and in my most persuasive voice. At those bold words the boredom and impatience left Churchill's face. He looked gentle with just a quiver of a smile on the right side of his mouth."

When Lady Churchill saw the picture, she said to Frissell, "I don't know how you got that photograph, because Karsh took the rudest picture of my husband ever and I'll never have his portrait in my house." Frissell's photograph was so admired by Sir Winston that he made it his official portrait.

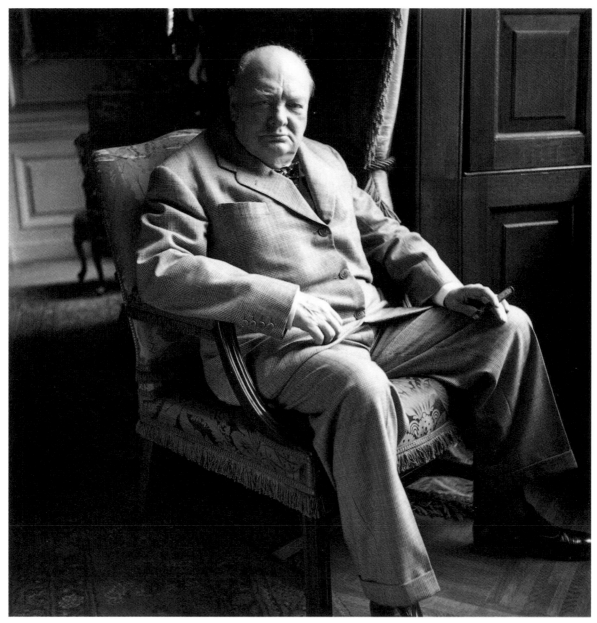

Toni Frissell *Sir Winston Churchill at Blenheim* (1950)

Gertrude Käsebier *The Picture Book* (1903)

3 · Photography as Art

IN capturing portraits, photographers such as Eva Watson-Schütze and Gertrude Käsebier had gone beyond that of simply recording likenesses and had consciously brought artistic effects to their images. Beginning as early as the 1850s, with the work of such photographers as Oscar G. Rejlander and Henry Peach Robinson in England, a movement had begun to produce photographs noteworthy for their aesthetic qualities. This movement, which came to be known as pictorialism, would gain momentum through the work of British photographer Peter Henry Emerson and the formation in England of The Linked Ring, an organization devoted to photography as art. In the United States, pictorialism would come to full flower through the contributions and influence of the group known as the Photo-Secession.

Central to the pictorialists' approach was the desire to release themselves from the shackles of subject matter by producing images based on their own imaginations and artistic techniques. At the heart of the movement was the determination to gain photography full acceptance as a legitimate form of art.

To achieve their artistic goals, pictorialists used a variety of techniques. Some achieved the effects they sought by photographing their subjects through a piece of gauze, which they placed on the lens of their camera. Others employed a process called gum-bichromate that allowed them to work much like a painter. They exposed their negatives to a surface coated with an emulsion consisting of gum arabic, potassium chromate, and pigment. They then washed away any part of the negative they wished to eliminate. Through these and other manipulations, both in their picture-taking and printmaking, pictorialists sought to enter the artistic world.

Pictorialist images were also characterized by their soft focus, their intense whites and dark shadows, the highly textured papers upon which they were printed, and their simplified composition and subject matter. As photo-historian Marion Fulton Margolis has noted, "With simplicity as their language, pictorialists emptied their pictures of material and filled them with meaning."

As pictorialism began to take hold in America, the Photo-Secession group attained such prominence and exerted such profound influence that it became synonymous with the concept of pictorialism itself. Founded in 1902 by America's premier photographer, Alfred Stieglitz, Photo-Secession drew inspiration from The Linked Ring. To Stieglitz and those who would follow his lead, the term *secession* meant a breaking away from what had been the factual, subject-oriented photographic approach.

Stieglitz wielded his greatest influence through the photographs he chose to exhibit at his Little Galleries of the Photo-Secession in New York City and through two publications, *Camera Notes* and its successor, *Camera Work*. The importance of these two photographic journals to the acceptance of photography as an art form cannot be overestimated. For pictorialist photographers, whether they were official members of Photo-Secession or not, publication in either of these journals was the height of achievement.

No early field of American photography was more influenced by the contributions of women photographers than pictorialism. In 1902, writer-critic Helen Davie proclaimed that photography's acceptance as art "can be ascribed to the influence of women." Given the contributions of male pictorialists such as Stieglitz, Edward Steichen, Clarence White, Alvin Langdon Coburn, and others, it was doubtless an overstatement. But the vital role that female pictorialist photographers played in

Gertrude Käsebier
Blessed Art Thou
Among Women
(1899)

enhancing their medium's place in the creative world is clear.

In many ways Gertrude Käsebier was the epitome of the pictorialist photographer. In her pictures we find all the attributes that characterized the movement. What set her apart was not only the artistry with which she employed pictorialist techniques but the manner in which she conveyed deeply felt emotions through her images. Many of Käsebier's photographs reflect her progressive attitudes toward marriage and child-raising. One of her most passionate beliefs was that parents should grant as much independence to their children as possible. This conviction, due undoubtedly to her own childhood experience on the frontier, characterized much of her work and marked much of the way she lived and acted.

Particularly revealing is the photograph *Blessed Art Thou Among Women*, which ultimately became Käsebier's most widely reproduced image. The subject of mother and child has always been one of the most common themes in both painting and photography. Many depictions show the child clinging to its mother, but this is not the case in Käsebier's photographs. There is a sophistication to the elegant mother in *Blessed Art Thou Among Women*; she has placed a loving arm on her child and is offering some type of advice. But what is most important in the picture is the way that Käsebier posed and positioned the mother and daughter. The youngster stares straight ahead, absorbed in her own thoughts, contemplating perhaps her own course of action. It is a dramatic conveyance of Käsebier's conviction that while a mother must guide her child, she must also grant the child independence as well. Käsebier added to the aesthetic quality of the photograph by creating a dramatic contrast between the

child's dark dress and the mother's white garment.

Käsebier's photographic commentaries on marriage ranks among the most acerbic ever portrayed. She had married her husband on the rebound from a broken romance and it was never a happy union. Though she never divorced him, she spent much time away from him, and for most of their marriage they lived separate lives. Her own experience and the marital difficulties that one of her daughters endured shaped her views on marriage and led her to create several photographs depicting the institution in the most negative light. Of these the most telling is the image she titled *Yoked and Muzzled.*

In the picture, Käsebier depicts marriage as being similar to the yoking and gagging of oxen. She presents two youngsters holding hands, a symbol of their future married state. The children encounter the heavily burdened animals, symbolic of their matrimonial destiny. The huge size of the animals, in contrast to that of the children, also represents what to Käsebier was the overpowering and suffocating nature of matrimony.

Despite the intensity and search for perfection she brought to her work, Käsebier had a lighter side. She was an accomplished and humorous storyteller, often making herself the target of her tales. She raised many eyebrows through her habit of smoking small cigars. The photograph *Where There Is So Much Smoke There Is Always a Little Fire* is indicative of this lighter side and the way she brought the artist's touch to all her images, no matter what the subject. Never a shrinking violet, Käsebier was fully aware of the special talents she brought to her work. "You can give an idiot a diamond-studded gold pen," she wrote, "but he won't write poetry."

Like Gertrude Käsebier, Eva Watson-Schütze was both a founding member of the Photo-Secession and an elected member of The Linked Ring. Although she never reached the pinnacle of acclaim enjoyed by Käsebier, Watson-Schütze's work received considerable attention. In a 1905 article devoted to her accomplishments in *Camera Work*, for example, critic Joseph Keiley defined her as "one of the staunchest and sincerest upholders of the pictorialist movement in America."

Watson-Schütze's photographs are marked by her artistry in working in soft focus, evidenced by the picture titled *A Study Head.* The gentility of the image is achieved also by the delicacy of the bonnet in which she posed her subject and by the obvious manipulations she made in her print, creating an almost fragile, shaded effect.

More than most photographers of her day, Watson-Schütze set down in writing her motivations for taking pictures. Chief among them was her desire to establish a rapport between herself and those who viewed her images. "If, through a picture," she stated, "you can give to one other person the feeling which impelled you to make it, you have done well."

The personal feelings that those who embraced pictorialism sought to convey through their images were as diverse as the photographers themselves. To Anne W. Brigman, pictorialism presented the avenue through which she could express both her love of nature and her then-revolutionary belief in a woman's right to pursue her own destiny. Born Anne Wardrope Knott in Honolulu, Hawaii, in 1869, her mother's family were missionaries who had begun their work in Hawaii some forty years earlier. In 1886, Brigman and her parents moved to Los Gatos, California, and eight years later she married sea captain Martin Brigman. She joined her husband at sea and it was while on these voyages that her fascination with the beauty, power, and mystery of nature became intensified.

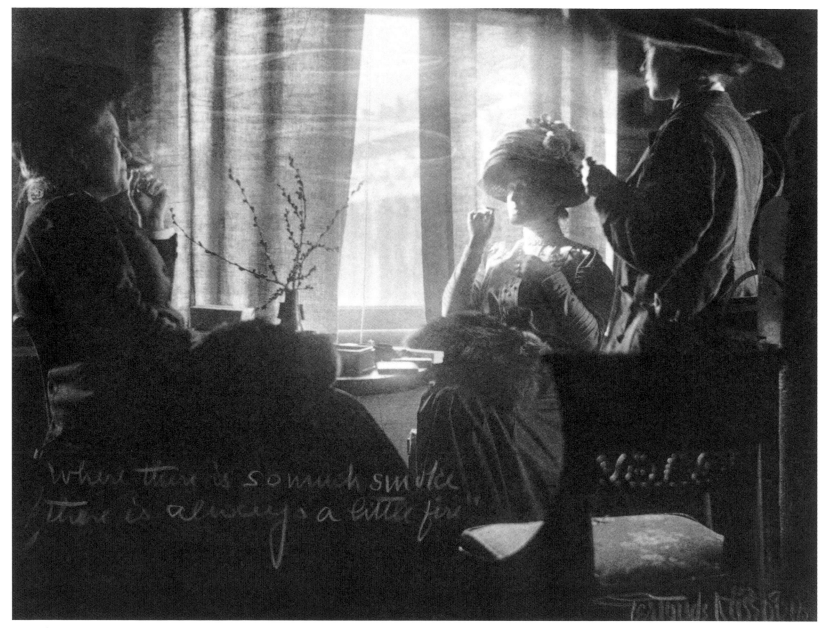

Gertrude Käsebier *Where there is so much smoke, there is always a little fire* (c. 1906)

Against the Odds

When her seafaring days were over, she occupied her time drawing impressionistic paintings and writing plays and short stories. Then she discovered photography. In 1903 she attended a salon-showing that included a number of pictorialist photographs. Inspired by what she saw, she realized that it was through the camera that she could best express her deepest passions. She began to create allegorical studies celebrating nature in general, the beauty of the human figure in particular, and women's search for freedom.

Eschewing the use of props or artificial backdrops, Brigman created many of her allegorical studies in California's Sierra Nevada. In what must have shocked many of her contemporaries, the nude figure in many of her images is Brigman herself. Her nudes represent not only her appreciation of the human figure but present a symbol of woman unfettered by the restricting female clothing of the day. Her photograph, *Soul of the Blasted Pine*, is typical of her work. The nude figure is presented as an integral part of nature, an extension of the tree upon which she is perched. Her outstretched arm symbolizes both her willingness to face whatever nature or life itself will bring and her striving to reach her fullest potential. The stark setting of the photograph also permitted Brigman to express one of her major concerns, the destruction of the nation's forests in the face of a growing commercialism.

The Wondrous Globe is typical of the sense of mystery that Brigman brought to many of her images. While it is true that a clear globe became a symbol of the pictorialist movement and that several women pictorialists employed it in some of their images, Brigman, in this photograph, leaves it to the viewer to imagine what the young child of nature is contemplating and the symbolism attached to the globe itself.

In the midst of her career Brigman separated from her hus-

Gertrude Käsebier *Yoked and Muzzled—Marriage* (c. 1915)

band to, as she explained it, "work out my destiny." She spent her later years fully engaged in the struggle for women's rights. For many years her work lay practically neglected in the pages of *Camera Work*. Increasingly we have come to appreciate her pioneering achievement in turning personal belief into artistic expression.

Like Brigman, Alice Boughton also portrayed the nude figure in many of her images. Born in Brooklyn, New York, in 1866, she studied painting in Rome and Paris. In 1902 she became one of Gertrude Käsebier's studio assistants. Embarking soon after upon her own photographic career, she became a master of the manipulated image, regularly using the gum-bichromate process.

Eva Watson-Schütze *A Study Head* (c. 1900)

Boughton's image *The Seasons* provides an example of the painterly effects she brought to many of her pictures. It is a photograph that also displays other characteristics favored by the pictorialists. Here again is the use of brilliant whites, dark shadows, and a focus on a gentle, simple subject. Evidenced also is Boughton's soft focus and her meticulous composition, also traits of those who undertook the pictorialist approach.

One of the most perceptive of early women photographers, Boughton also contributed to the pictorialist cause by clearly articulating the fine line that pictorialists had to walk–that of creating photographs that were truly artistic, while remaining unmistakably photographs. "The highest praise–supposedly praise–which is ever applied to a print," she wrote, "is that it does not look like a photograph. . . . [We] have this to guard against . . . an effort to disguise, rather than use the camera. . . . To have their productions not in the least resemble a photograph, seems to be the goal of some of the new workers, but that attitude is both forced and false. Why not avowedly use the camera? Why be ashamed because it is not something else?"

One photographer who never doubted that images could be artistic yet unmistakably the work of the camera was Myra Wiggins. Her genre pictures were from the beginning attempts to endow photographs with painterly effects. One of her most beautifully rendered photographs is that which she titled *The Babe.* The image demonstrates both her simple yet eloquent sense of composition and her special ability to contrast dark articles and backgrounds with striking white highlights.

Born in Albany, New York, and trained as an artist, Emma J. Farnsworth received her first camera as a Christmas present when she was thirty. "I did not want it," she later wrote, "but out of compliment to the donor, when summer came I tried to make

a picture, and after various attempts (following directions in books) . . . and being utterly unsuccessful, I became interested." A highly nervous type, Farnsworth's written reflections are filled with further accounts of the tensions she continually experienced in capturing the images she sought.

Yet despite her early trials and her temperament, Farnsworth obviously taught herself well; her work was eventually exhibited not only in the United States but in Canada, Europe, and India. Many of her pictures, like those of other early pictorialists, are of female subjects dressed as nymphs or goddesses in loose, free-flowing, Grecian-type garments. Like those of Anne Brigman and Alice Boughton, the images reveal a desire to be released from the heavy, tightly bound clothing that convention dictated women wear. Her photograph *Diana* is typical of the type of image that gained her international attention. There is something particularly appealing in this soft-focused, simply composed portrayal of a "goddess" at peace with herself and the world.

There is also a similar sense of a simple innocence in the im-

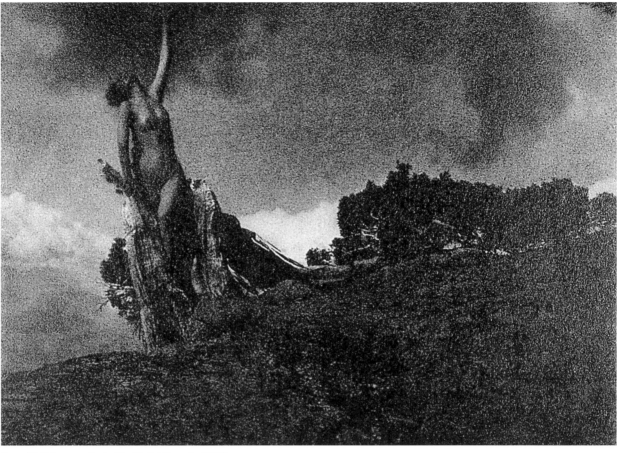

Anne W. Brigman *Soul of the Blasted Pine* (c. 1905)

ages produced by Mary Bartlett. Named the leading amateur photographer in Chicago in the 1890s, she won a grand diploma in photography at the Vienna Salon of 1891 and received many other awards. Despite these successes, she stayed close to home and concentrated on domestic subjects.

Bartlett was a pioneer in the use of platinum paper, which she sensitized herself for her prints. Her photographs are distin-

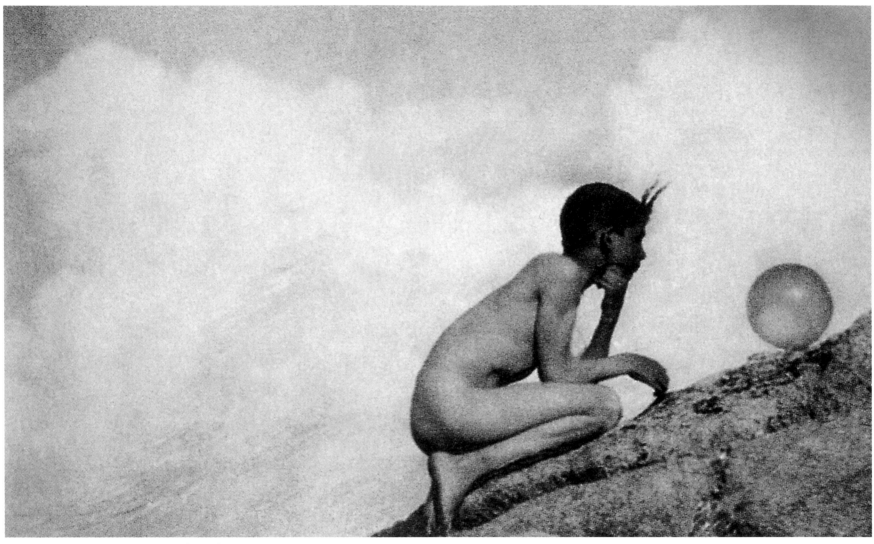

Anne W. Brigman *The Wondrous Globe* (c. 1905)

guished by the evocative poses of her subjects and by her use of natural light. There was also a special contemplative quality that she brought to many of her images, exemplified by her untitled picture of a young woman seated before a window. In the photograph, Bartlett has posed the young woman at a three-quarter angle, her hands and legs positioned in ladylike fashion. The contemplative atmosphere that pervades the image is achieved by the thoughtful expression on the subject's face as she stares out the curtained window. The outstanding feature, however, is the unique, sculptured look that Bartlett was able to bring to the woman's skirt and to the curtains through her masterful use of light and shading.

Pictorialists' styles and motivations were as diverse as the pho-

Alice Boughton *The Seasons* (c. 1905)

Myra Albert Wiggins *The Babe* (c. 1900)

Emma J. Farnsworth *Diana* (1898)

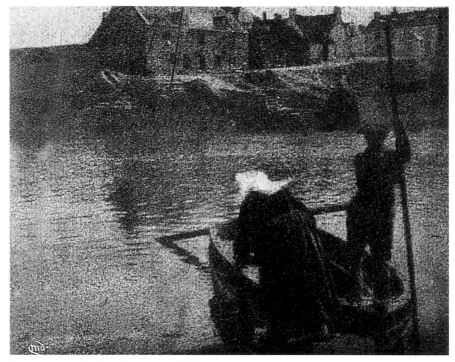

Mary Devens *The Ferry, Concarneau* (1904)

tographers themselves. Mary Devens, for example, produced im-
ages that were highly impressionistic in nature. For Jane Reece,
the romanticism that pervaded pictorialism presented the op-
portunity to express the joy she found around her. She wrote,
"In the faces of men, women, and children in nature, on land
and sea—everywhere—I saw pictures that I had to make so that
those lovely thoughts and moods could be captured and kept
forever."

Reece was born near West Jefferson, Ohio, in 1869 and stud-
ied both music and painting. In 1903, she contracted spinal

meningitis and, while recovering from this illness in North Carolina, was encouraged by her nurse to try her hand at photography. Only a year later she opened what was to become the first of five photographic studios she would successfully operate in Dayton, Ohio. In 1909, she went to New York to study Photo–Secessionist photographs before returning to Dayton to resume her studio work.

Her year in New York profoundly influenced her photographic approach. Although she never became a formal member of the Photo–Secession, her images were frequently included in the organization's exhibitions. Included among these photographs were *Interpretive Dance I* and *Takka-Takka-Yoga-Taro*. Among the most sensual of all pictorialist pictures, they reveal Reece's special ability to capture thought and mood in a photographic image.

It is often difficult to place the work of photographers into neat categories, as often the lines between them are blurred. By the time the Photo–Secession was in full swing, there were a number of portraitists, such as Eva Watson–Schütze, who had become avowed pictorialists. Among others who successfully applied pictorialist techniques to their portraits were Elizabeth Buerhmann, Sarah C. Sears, and Amelia C. Van Buren.

Elizabeth Buerhmann was only eighteen years old when she was elected an associate of the Photo–Secession. She was just twenty–one when she captured the attention of critic Sadakichi Hartmann who categorized her early portraits as representing "a further development of the Secessionist movement." Buerhmann went on to produce scores of artistically rendered portraits, among them a series of photographs she took of the aged former actress Helena Modjeská. These images, as Hartmann pointed out, went beyond common portraiture. To him, they appeared

Mary Bartlett Untitled (Young Woman at Window) (c. 1900)

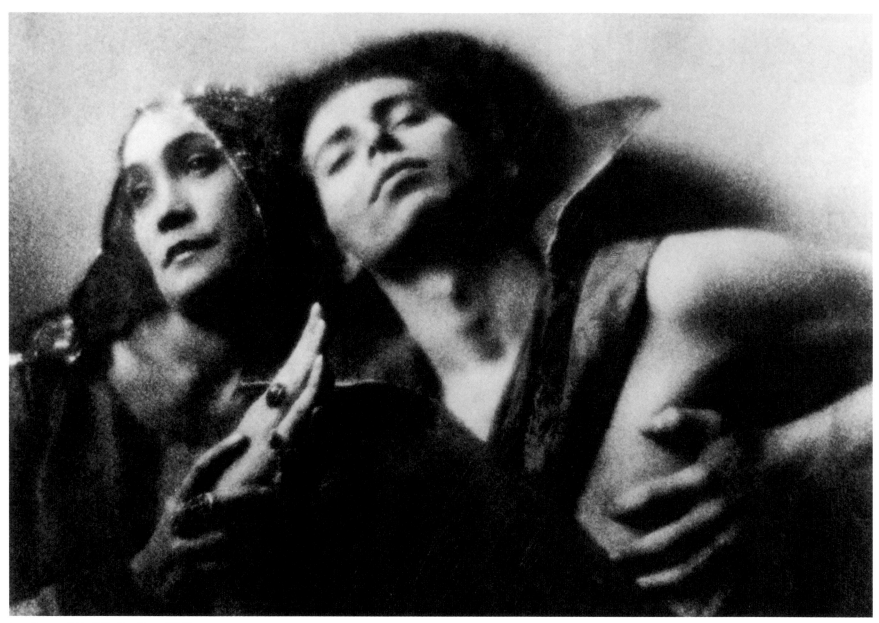

Jane Reece *Takka-Takka-Yoga-Taro* (1922)

"more like ... whimsical fantasy, a study of eccentricity."
Other early photographic critics joined in praising
Buehrmann's work, remarking upon the "exquisite taste" that
guided her approach.

Exquisite taste was also an attribute of Sarah C. Sears,
both in her personal and artistic life. She was born Sarah
Choate in 1858 in Cambridge, Massachusetts, to extremely
wealthy parents. She studied painting both at the Cowles Art
School and the Boston Museum of Fine Arts, and then began
a successful career in painting, specializing in watercolors
and oils. In the 1890s she took up photography and became
an avid pictorialist. In 1904, she was elected a fellow of the
Photo-Secession and was also selected for membership in
The Linked Ring.

Sears's photograph titled *Mary* typifies the pictorialist
qualities she brought to her portraiture. Published in *Camera
Work*, it is a masterful rendition of light and shade. The sub-
ject is bathed in shadow, save for the carefully selected high-
lights that draw us to her face, particularly her eyes. The
bright, white ring of collar accentuates the dramatic contrast
that Sears achieved.

Amelia C. Van Buren was another portraitist who used
pictorialist techniques to produce images that went well be-
yond simple likenesses. She began her artistic pursuits by
training as a painter, studying under Thomas Eakins at the
Pennsylvania Academy of Fine Arts. While there she devel-
oped a close friendship with classmate Eva Watson-Schütze.
After completing her studies, she opened an art gallery and
studio but became disenchanted when she found that she
had to lower her aesthetic standards in order to sell enough
paintings to support herself. She turned to the camera and

Jane Reece *Interpretive Dance I* (1922)

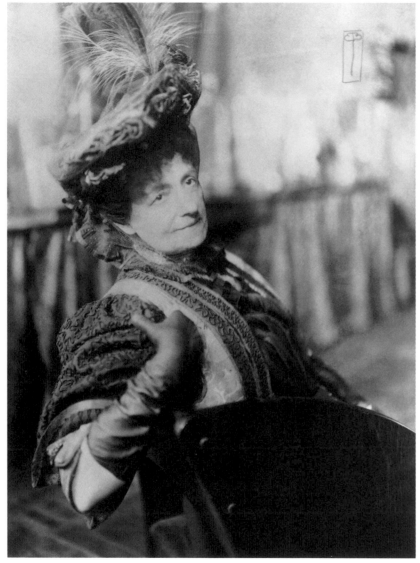

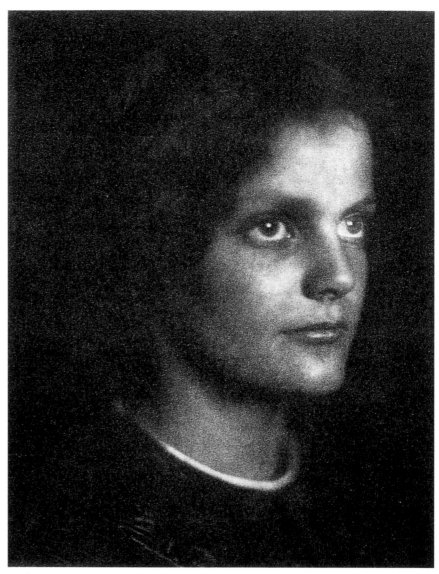

Elizabeth Buerhmann *Helena Modjeská* (c. 1909)

Sarah C. Sears *Mary* (1907)

opened a photographic studio in Atlantic City, New Jersey, in partnership with Watson–Schütze.

Van Buren never gained as much recognition as did her friend and partner, but the images she produced rank her among the most skilled of the pictorialist portraitists. Her portrait of a young woman is particularly compelling. By capturing her subject close up and in profile, and presenting her in a delicate head covering, Van Buren brought both beauty and a sense of mystery to the image. She obviously manipulated either the negative or her print or both, for the irregular patterns of shading she applied to the photograph add significantly to its artistry.

Their focus on simple and appealing subjects and their particular desire to portray innocence led many of the pictorialists to train their cameras on children. From the moment that the pictorialist approach made itself felt, American women photographers led the way in producing artistic photographs of young people. In 1903, for example, a German reviewer of Secessionist images at the Hamburg Society Jubilee Exhibition bemoaned the fact that there were no women photographers on a par with camerawomen like Gertrude Käsebier, Mathilde Weil, or Emma Spencer. "This is the main reason," he stated, "why we have no artistic photographs of children like those produced with such happy results by the American women photographers. The ladies in question are entirely independent in their work, and what appears most amazing to us in Germany, they are in no way influenced by their male colleagues."

To his list of accomplished women photographers of young people the reviewer could well have included the name Alice Austin. Unlike the Staten Island camerawoman Alice Austen whose name was so similar, we know little about this Alice.

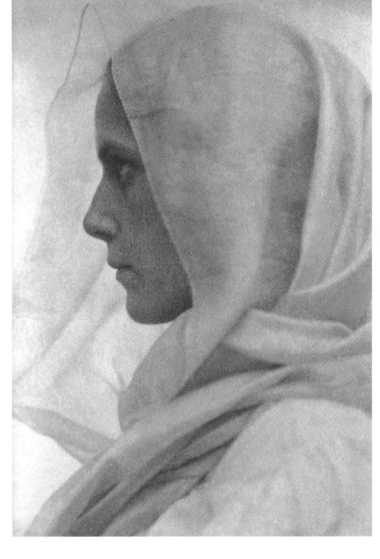

Amelia C. Van Buren
Portrait (c. 1900)

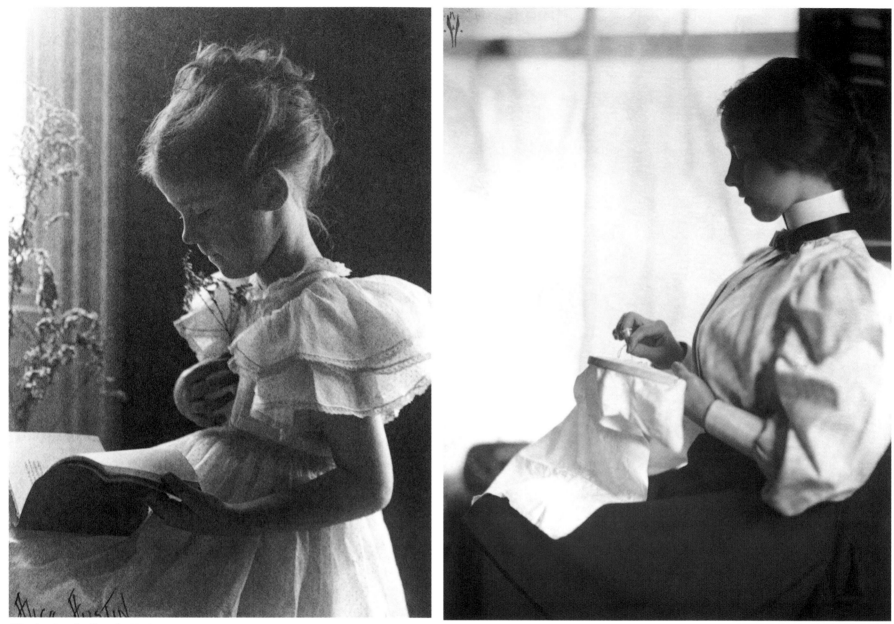

Alice Austin *Reading* (c. 1900)

Mathilde Weil *The Embroidery Frame* (1899)

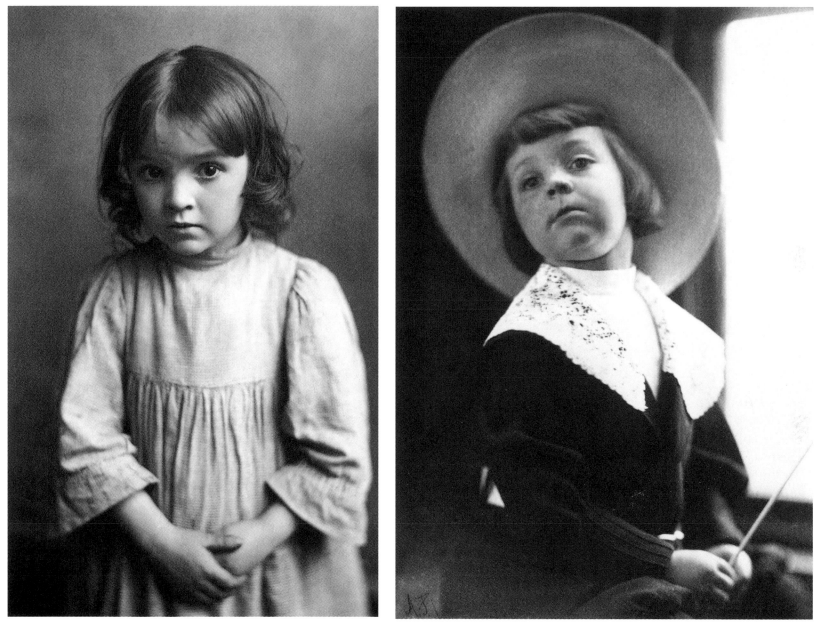

Elizabeth Brownell from *Dream Children* (c. 1890)

Anne Pillsbury *Young Girl* (c. 1890)

What we do know is that, like Sarah Sears, she studied art at the Boston Museum of Fine Arts and, like Gertrude Käsebier, also studied at the Pratt Institute in New York. We know also that in 1906 a photographic magazine rated her among the twenty most successful American women photographers. Interestingly, many of her images portray youngsters either reading or being read to. To Austin, it was obviously an activity that represented the simple pleasures of childhood. The youngsters in these photographs are elegantly dressed. Their expressions reveal both a serious approach to their activity and a contentment in what they are doing. As one studies her images, it is obvious that, rather than employing manipulation, she relied on natural light and contrasting shadows playing upon her subjects' facial features and clothing to give her images their artistic quality.

Childhood delights were also the subject of many of the images of Emma Spencer. An avowed pictorialist, Spencer was typical of the scores of early women photographers who honed their photographic skills and gained recognition for their work through local camera clubs situated throughout the nation. It was through showings of her photographs at the Newark, Ohio, club to which she belonged that her images first came to light.

The photograph she titled *A Mute Appeal* is representative of the sense of whimsy she brought to much of her work. The charmingly dressed child has completely captured her pet's attention by holding its meal tantalizingly in her hands. There is both humor and affection in the youngster's expression, and a simplicity to the image that is particularly appealing. Above all else, it is an image that epitomizes the basic tenets of the pictorialist approach–simple subjects, simply composed.

One of the most interesting women pictorialists who produced striking images of young people was Mathilde Weil. After studying painting at three different schools in her native Philadelphia, she took up photography as an amateur in 1896. Shortly thereafter she opened her own professional studio. Her reasons for turning professional so quickly and her unique strategy for surviving in a highly competitive field are revealed through her reminiscences. "I got my first camera in the winter of 1896–7, as a means of amusement and interest for myself. I practiced on friends, and my photographs became so in demand that I did not think it right to compete with professional photographers except on their terms. Accordingly, two months from the time I started I became a professional. I charged from the beginning the highest prices that obtained in the city, and have always had more work than I could do, refusing many orders unless the people could wait from a month to two months. At present, although I charge for my appointment alone what the highest-priced photographers here charge for a dozen prints, I do not find that the work pays financially for the reason that I put too much personal work on everything to be able to take in enough to cover my expenses."

Despite the financial sacrifices, Weil continued to pursue her photographic career. Her photograph *The Embroidery Frame* is typical of the work she produced. It is an elegant image, marked by its strong contrast between whites and darks and a poignant sense of serenity.

Added to the images of all these women photographers who made the pictorialist approach their calling are artistic images produced by women about whom almost nothing is known. Yet the photographs left behind by such unheralded talents as Elizabeth Brownell, Annie Pillsbury, Eva Wolbourne, and a camerawoman known to us only as Miss Libby provide further evidence of the contributions of women photographers to pictorialism.

Miss Libby *Young Woman in Garden* (1897)

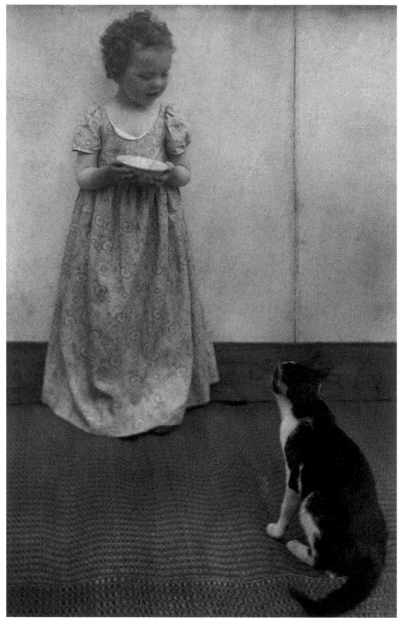

Emma Spencer *A Mute Appeal* (c. 1890)

Eva Wolbourne *Zylpha* (c. 1890)

Despite all its achievements, the glory days of the pictorialist movement were relatively short. In 1917, Alfred Stieglitz closed his Little Galleries of the Photo Secession and ceased publication of *Camera Work*. Many pictorialists, including Stieglitz, had already abandoned the artistic approach in favor of a new movement called straight photography, which eschewed the soft-focus, manipulative pictorialist techniques.

Pictorialism was also a victim of changing times. The horrors of World War I had put an end to the age of innocence in which pictorialism and its focus on simple pleasures and an uncomplicated way of life had thrived. Suddenly the approach seemed outmoded and out of touch with reality. The rise of news photography, accelerated by the events of World War I, was also a factor. For many, photographs were to be judged according to the information they imparted, not for the techniques that the photographers employed.

Still, the contributions of the pictorialist movement to photography were profound. By giving photographers the opportunity to bring their own imaginations to their images, by giving them an avenue through which they could reveal their deepest emotions, and by establishing that photography could legitimately take its place in the world of artistic expression, pictorialism earned its place as one of the most important of all photographic movements.

Marion Post Wolcott *Family on Porch* (1940)

4 · The Documentary Eye

By the year 1870, the United States had experienced the Civil War, the building of a railroad system that linked the nation from coast to coast, and the beginnings of the great government-sponsored surveys of the West. These watershed events changed the course of the nation's history and had an enormous impact on the world of photography as well. The startling images produced by the Civil War cameramen, the pictures taken by the photographers who accompanied the railroad crews on their relentless drive through the wilderness, and the images captured by the official cameramen of the Western surveys revealed as never before the camera's power to document people, places, and events.

Collectively, these images disclosed something more. Travels had taken these photographers far from home. The people they saw, the conditions they encountered, and the impact their photographs had on those who viewed them inspired a new photographic motivation. It became increasingly clear that the camera could not only make people aware, it could also be a powerful tool of persuasion. Out of this type of photographic motivation grew what became known as documentary photography. Photohistorians have commonly placed documentary images in two categories: *straight* documentary photographs, which record specific ways of life, and *social* documentary photographs, which reveal certain social conditions, often conveying the photographer's intent to inspire reform.

Women would play a vital role in the development of both of these documentary approaches. In doing so, they would join their male counterparts in introducing the world to a new breed of photographers. These documentarians would travel anywhere, endure any hardship, risk almost any danger to record a way of life before it vanished or to focus attention on a particular situation, or to make people aware of conditions they felt needed to be corrected. Beginning in the mid–1930s, a significant number of these photographers were aided in achieving their goals by government support for specific projects. Whatever their motivation or means of support, they brought new skills and new approaches to their craft. Perhaps most important, they taught the world that a truly great photograph is one which not only pleases or informs but simultaneously pulls deeply on the emotions of the viewer.

Among the first to take the documentary approach was Frances Benjamin Johnston. By the late 1800s she had decided that her photographic destiny lay beyond portraiture. Increasingly, she began to see the camera as a means of making important social statements. She began her documentary work by traveling first to the coal fields of Pennsylvania and then to the factories of Lynn, Massachusetts, to record working conditions in these places for *Demorest's Family Magazine.* Although the halftone process, which made it possible for photographs to be reproduced on the printed page, had not yet been developed, *Demorest's* presented the illustrations with engravings copied from Johnston's photographs.

The coalfield and factory pictures were so well received that Johnston was then commissioned to produce a series of photographs of the Washington, D.C., public schools to be included in the United States exhibit at the Paris Exposition of 1900. Her photographs of Washington schoolchildren provide us with our earliest examples of her special talent for detail. The pictures were, of necessity, posed, yet composed in such a way as to make

them unforgettable rather than trite. In a picture of students boarding a trolley car, for example, she framed different groups of students within the trolley's windows and doorways. As with so many of her images, many small pictures are contained within the photograph itself.

Johnston's images were one of the major triumphs of the Paris Exposition, inspiring the French government to award her the coveted Palmes Académiques. But her greatest work was yet to come. Impressed by her Paris success, two African-American schools, Hampton and Tuskegee, commissioned her to photograph life at their institutions. Both schools had been founded to provide young black men and women, most of whom were descended from slaves, with skills that would enable them to better their lives.

Johnston began her work at Hampton in December of 1899 and took more than 150 photographs of students learning to become cobblers, farmers, seamstresses, carpenters, and tradespeople of all kinds. In 1902, at Tuskegee Institute she captured hundreds of similar images. As we study these photographs today it may seem that the aspirations of these students were small. They were, for the most part, learning to be skilled laborers, not doctors or lawyers. In those days, however, the two schools represented the best hopes many young African Americans had for any advancement. Along with Johnston's ever-present attention to detail and unique style of composition, the Hampton and Tuskegee pictures are marked by the satiny quality of most of her photographs.

Like several of the women photographers who would follow her, Johnston's experiences as a woman working both in a man's world and in potentially hostile situations would not be without its dangers. While photographing at Tuskegee Institute, she took a side trip to take pictures at the Ramer Colored Industrial School, established by a former student of Tuskegee's founder, Booker T. Washington. Accompanied by George Washington Carver, who was then head of Tuskegee's agricultural department, she boarded a train for Ramer where they were met at the station by the school's principal. Aware that it was already dark and that the journey to the school by buggy was lengthy, Johnston requested that she be driven into town where she could spend the night at a hotel. When they arrived in town, two white men, incensed that a white woman would be traveling at night with two black companions, confronted them. When one of the men pulled out a pistol and fired shots at the principal, Carver helped Johnston flee to the next town.

Undaunted by the incident, Johnston returned to her work at Tuskegee. Along with her Hampton Institute images, her Tuskegee photographs presented Americans with a portrayal far removed from the negative stereotypes of lazy and lustful black men and women so common in magazines and literature of the day. Once her work at the schools was completed, she traveled the countryside photographing black families who lived in the area. Here again, it was her ability to capture the simple dignity of men, women, and children determined to rise from the shackles of the past that shone through in almost every photograph.

As in all fields of the medium, the world of documentary photography is continually enhanced by new discoveries. In 1996 library staff in Farmington, Maine, working in a remote section of the building's basement, came upon several bundles wrapped in plain brown paper. The packages contained scores of vintage prints taken in Charleston, South Carolina, in 1926 by Chansonetta Emmons. The photographs were turned over to the Stanley Museum where most of Emmons's images are housed. The curators at the museum were aware that Emmons had taken such

a trip, but were amazed at the photographic scope of the journey revealed in these images. It was clear that Emmons had consciously sought to document black life in the South in the same devoted manner she had recorded the lives of her relatives, friends, and neighbors in Kingfield, Maine, some twenty years before. As in her earlier photographs, all the Charleston images are marked by Emmons's attention to composition and her special ability in using natural light. These new discoveries provide further evidence of the scope and importance of Emmons's work.

In their documentary photographs, Frances Benjamin Johnston and Chansonetta Emmons operated with the knowledge that the people they photographed had not been suddenly thrust into their conditions but had been living under them for generations. At the beginning of the 1930s, however, millions of Americans caught up in the Great Depression came face to face with conditions with which they were hardly familiar, conditions sorely in need of remedy.

The Depression had a particularly devastating effect on farmers throughout the South and the Southwest. Severe drought had turned the soil into dust and countless families

Frances Benjamin Johnston *Students on Field Trip* (1899)

were forced to abandon their homes and farms. Tens of thousands took to the road in broken-down cars and headed for California, Oregon, or Florida hoping to find work picking crops. Those who remained behind attempted to eke out a living in any way they could.

In Washington, President Franklin D. Roosevelt spearheaded

the creation of the Farm Security Administration (FSA). Formed in 1935, the purpose of the agency was to give technical aid and financial relief to distressed farmers and their families. What no one could have imagined was that one division of that agency, the Historical Section, would produce the most acclaimed photographic collection ever compiled in the United States, a collection that would include tens of thousands of images that would eventually be labeled by Edward Steichen as "the most remarkable

human documents that were ever rendered in photographs."

To head the FSA's Historical Section, Franklin Roosevelt choose Roy Stryker, a man with great organizational ability and a keen photographic eye. Stryker, in turn, hired some of the nation's greatest photographers including Walker Evans, Jack Delano, Arthur Rothstein, and Russell Lee. Included in the photographic team were eight women—Esther Bubley, Marjory Collins, Pauline Ehrlich, Dorothea Lange, Martha McMillan Roberts, Marion Post Wolcott, Ann Rosener, and Louise Rosskam.

The administration's main goal for the Historical Section was made clear to Stryker from the beginning, which was to aid the FSA in obtaining maximum legislative and financial support from Congress. This would be achieved by capturing images of the plight of American farm families with FSA field agents providing assistance to these people. But Stryker had different ideas. He knew the "relief" pictures needed to be taken. But given the caliber of the photographers at his command, he saw the opportunity for creating nothing less than a photographic self-examination of America. He ordered his photographers to use their cameras to document as much of the nation as they could in terms of both the land and the people. They did this so brilliantly that when batch-

Frances Benjamin Johnston *Student Carpenters* (1899)

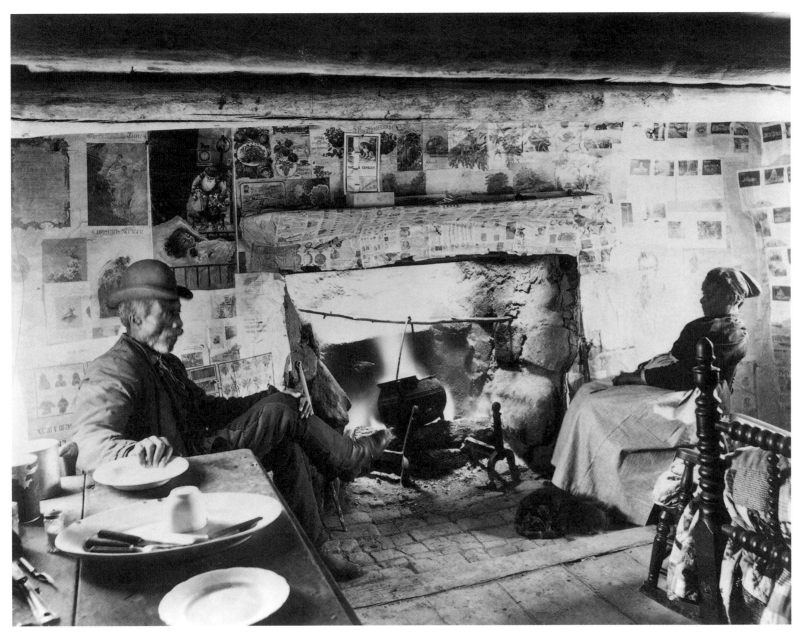

Frances Benjamin Johnston *Couple at Home* (1899)

Chansonetta Emmons *Scene in Charleston, South Carolina* (1926)

es of photographs came in from the field, Stryker punched holes in many of the obligatory relief pictures with his pen while assigning the other photographs their proper place in the ever-growing files that housed the collection. Stryker also continually prodded the photographers to capture images that revealed the unquenchable spirit of Americans even in the most desperate of times. Toward the end of the project he was asked what he felt was the greatest lesson to be learned from the photographs. "Dignity versus despair," he replied. "I believe that dignity wins out."

Of all the photographers who toiled for the FSA, none was better able to capture these qualities of despair and dignity than Dorothea Lange. Before the project was over she would take thousands of images that would establish her as one of the most renowned of all American photographers. In the process, she would arouse such compassion for those she photographed that she would earn the title, "the supreme humanist."

Lange was born Dorothea Margaretta Nutzhorn in Hoboken, New Jersey, in 1895. At the age of seven she contracted polio, which left her with a lifelong limp. Soon after, her father abandoned his family and she adopted her mother's maiden name. Upon graduation from high school she began to train for a career in teaching and then abruptly announced that she had decided to become a photographer. She was not quite twenty and had never owned a camera. Nor had she ever taken a single photograph.

She began her improbable career by talking her way into a job as a receptionist and darkroom assistant in the New York studio of the well-known photographer Arnold Genthe. In 1917 she enrolled in Clarence White's photography course at Columbia. Two years later she opened a portrait studio in San Francisco. Her

natural talent with a camera was obvious and she soon attracted some of the wealthiest clients in the city. But she became restless, dissatisfied with spending her days capturing the likenesses of the privileged. She began to wander outside her studio where increasingly she focused on capturing images of men and women caught in the early ravages of the Great Depression.

In 1935 Lange was hired by Roy Stryker and became a member of the Farm Security Administration's photographic corps. For the next five years she would bring the compassion she had demonstrated in her Depression work onto a national canvas. She would travel the nation photographing a people caught up in hard times beyond their control. She would take thousands of photographs, many of which now rank as among the most familiar ever taken in this country.

Her main focus was the farm families driven from their homes, forced to take to the road in search of survival. She photographed them in their cars, on the highway, in their tents. Perhaps more than any of the other FSA photographers' work, her photographs would create public sympathy for the relief program and would help persuade a conservative Congress to vote funds to keep the program alive.

As she relentlessly carried out her documentation, Lange discovered that certain techniques were particularly effective for her purposes. She shot many of her pictures from slightly below her subject, her camera tilted upward, producing a dramatic effect. She took many images that focused on such simple things as the bare feet of a woman sharecropper or the gnarled hands of a farmer holding his hoe. The one thing about which she was most adamant was her absolute refusal to allow anything that she was about to photograph to be changed or arranged. Throughout her documentary career she kept a quotation from

Dorothea Lange *Feet of a Sharecropper* (1937)

Dorothea Lange *Migrants on Road* (1936)

Francis Bacon pinned to her darkroom door. It read: "The contemplation of things as they are, without substitution or imposture, without error or confusion, is in itself a nobler thing than a whole harvest of invention."

Lange and Stryker did not always see eye to eye, and in fact her days at the agency would end abruptly as a result of heated arguments over the control of her negatives. But it was Lange who time and again captured images that spoke directly to Stryker's dictum that the FSA file must, along with its images of poverty and despair, contain photographs documenting the more positive side of the American people. In photographs like that of a migrant child at the back of her family's car–home, or that of a Greek migratory woman living in a cotton camp, Lange demonstrated her special gift of using posture, gesture, and expression not only to portray fear and bewilderment but to convey courage and determination.

Her accomplishments did not come without a heavy personal price. In 1920, she had married Maynard Dixon, a leading painter of the West, and had two children by him. The fact that her studio work prevented her from traveling with him caused a severe strain on their marriage and they were divorced in 1935. That same year she married the economist Paul Taylor, with whom she had three other children. The long separations from her five youngsters tormented her throughout her FSA years. How could she justify neglecting her own children, she once confided, in order to chronicle the plight of other people's youngsters? And, truth be told, she was often equally conflicted when she was home and the demands of her family life interfered with her photographic work. Late in her life she would write, "I'd like to take a year, almost ask it of myself, 'Could I have one year?' Just one when I would not have to take into ac-

count anything but my own inner demands."

Her accomplishments and her influence were enormous. By the time she left the FSA she had created a standard for all documentary photographers who would follow. And by creating a body of work that made people so deeply aware of their commonality with others, she gave new meaning to the medium itself: "The camera," she would state, "is an instrument that teaches people how to see without a camera."

Dorothea Lange's Dust Bowl images would bring her recognition as a giant of American photography. Other FSA photographers, such as Walker Evans, Russell Lee, Jack Delano, and Gordon Parks would also enjoy highly acclaimed careers, helped immeasurably by the work they produced for the agency. However, as one pours through the more than 250,000 photographs that make up the collection, it is difficult to refute the fact that the great hidden star of the entire endeavor was Marion Post Wolcott.

Hers is a fascinating story of a woman who, at an early time and in difficult and sometimes dangerous places, battled many of the challenges faced by women today and in the process helped change the way people saw their world. She took thousands of photographs for the FSA, images marked by her powers of observation, her clarity of vision, and, in many cases, her advocacy for the downtrodden. She photographed a wider range of subjects than any of her FSA colleagues, including some of the nation's poorest and some of its wealthiest citizens. Yet, after three and a half years with the agency, with her photographic skills at their zenith, she put her camera away for more than thirty-five years.

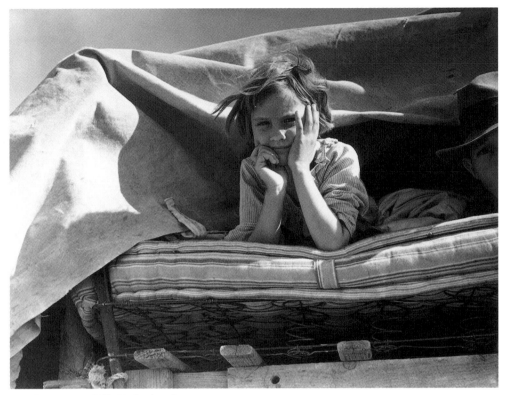

Dorothea Lange *Girl in Truck* (1936)

Marion Post was born in Montclair, New Jersey, in 1910. After studying at the New School for Social Research and New York University, she spent three years traveling in Europe, where she obtained her first camera. Her sister was the already established photographer Helen Post, and when Marion returned to the United States she enlisted her sister's aid in teaching her the fine points of photography. In 1935 she began to freelance, and two years later landed a job as a staff photographer for the *Philadelphia Evening Bulletin.*

Wolcott's mother had worked for Margaret Sanger and from her example Marion inherited a deep desire to make a social impact. She hoped that her job at the *Bulletin* would provide such an outlet, but she found herself continually assigned to photograph fashion and social events. Frustrated, she shared her feelings with her friend, the influential photographer and publisher Ralph Steiner, who told her about the FSA project and set up a meeting for her with Roy Stryker. Armed with a sample of her work, Marion met with Stryker in July of 1938. She was offered a job and given an initial assignment to photograph in the Deep South.

From the moment Wolcott arrived in the South she encountered scenes that she felt compelled to record. In Belzoni, Mississippi, she captured an image of a black man ascending an outside stairway that all blacks were required to use to enter the segregated movie house. The scene speaks for itself, but her ability to capture it from a position that highlighted dramatic shadows and angles makes it one of the most powerful photographs in the entire FSA collection.

From the beginning, Stryker was nervous about having sent a woman alone to the south. The only other woman he had sent there was Dorothea Lange, but she traveled with her second husband. Stryker's concerns were not unfounded. As she traveled through the region and later through Kentucky and North Carolina, Wolcott came face to face with the taboos and prejudices of the day, particularly regarding a woman traveling alone while performing a "man's" work. In one town she got arrested. In most others, she could not go into a coffee shop without being propositioned. And, despite her compassion for them, many of the people she sought to photograph treated her with open suspicion.

Yet she would not be deterred. For over three years she captured images of an America few of its citizens had seen. In 1941, with the work of the FSA almost completed, Wolcott fell in love with and married Lee Wolcott, a government official. An often overbearing man, he resented her photographic career, even demanding that all of the captions on the pictures she had taken as Marion Post be changed to read Marion Post Wolcott. Yet she loved him, and

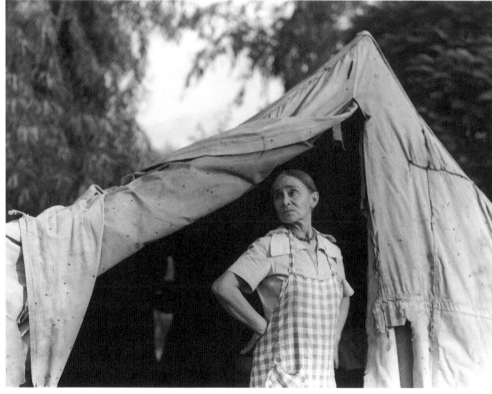

Dorothea Lange *Greek Migratory Woman in Cotton Camp* (1936)

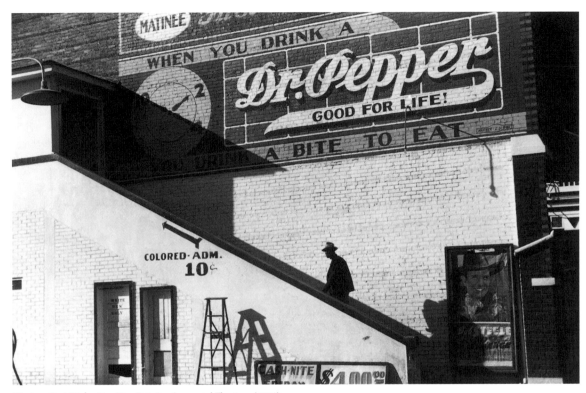

Marion Post Wolcott *Man Entering Segregated Theatre* (1939)

raphers were capturing images under the auspices of the Federal Art Project (FAP), which was part of the government's Works Progress Administration (WPA).

The WPA was a giant New Deal agency established to provide employment and boost morale during the Depression. Most of the photographers to whom it gave work took straightforward images of its many activities. In New York and California, however, FAP photographers were permitted to conceptualize their own "creative assignment," and, if approved, carry out this project almost free from supervision. Of all these "creative assignments," the most successful by far was that conducted in New York City by Berenice Abbott.

Born in Springfield, Ohio, in 1898, Abbott attended Ohio State University before moving to New York City where she studied sculpture and painting. In 1921, she traveled to Paris where she continued her studies with sculptor Emile Bourdelle. Two years later she took a job as an assistant to Man Ray who taught her photography. In 1926 she met Eugène Atget, and when he died a year later Abbott bought all his negatives and prints. She eventually printed many of these negatives and spent the next several decades introducing Atget's work to the world.

In 1929, Abbott returned to New York and opened a portrait

when she became pregnant she abruptly left the agency. She tended to Lee, raised a family and did not pick up a camera seriously until after her husband died some thirty-five years later. It was an ironic ending to the career of a woman who had triumphed over so many constraints of her day and who had compiled such an extraordinary body of work in so brief a time.

The FSA project was not the only U.S. government-supported photographic endeavor to take place in the late 1930s and early 1940s. While Dorothea Lange, Marion Post Wolcott, and their colleagues were snapping their pictures, other photog-

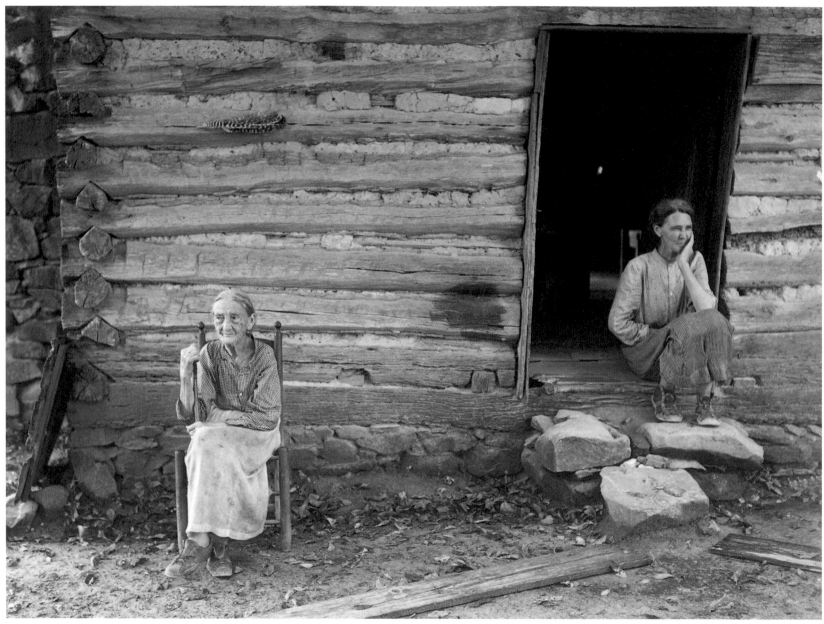

Marion Post Wolcott *Mother and Daughter* (1939)

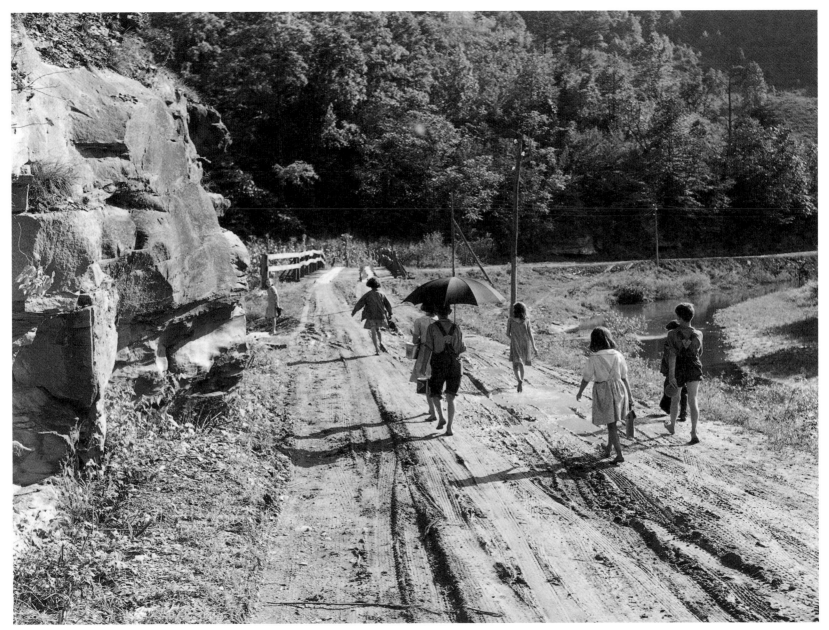

Marion Post Wolcott *Children on Way Home from School* (1940)

Berenice Abbott *Sumner Healy Antique Shop* (1936)

Against the Odds

studio. Some three decades earlier, the photographic critic Sadakichi Hartmann had written, "But who will be the first to venture on this untroden field and teach New Yorkers to love their own city as I have learned to love it, and to be proud of its beauties as the Parisians are of their great city? He will have to be a great poet and of course an expert photographer. May he soon appear!" By the time that the Federal Arts Project was in place to support the efforts of a photographer with a particular vision, there *was* an expert photographer ready to celebrate New York in photographs. But it was not a "he"; it was Berenice Abbott.

Almost from the moment that Abbott returned to New York she had been taking scores of images of the city's buildings, shops, and street activity. For her, New York presented both "the present jostling with the past" and "life at its greatest intensity." She was determined to produce a thorough photographic documentation of the rapidly changing city before all its old buildings were torn down to make room for skyscrapers. The problem was finances. The answer was the Federal Arts Project. Once her creative assignment, which she named *Changing New York*, was approved, she undertook in earnest one of the most ambitious photographic endeavors ever carried out by a single photographer.

She took countless photographs from every possible angle, revealing both the old and the new, the large and the small, capturing from rooftop and street level not only the city's outward appearance, but its very spirit. Each of her *Changing New York* images, such as that titled *Theoline, Pier II, East River*, is devoid of anything that can be regarded as either sentimental or manipulative. Yet her ability to capture shadow and light, to contrast horizontal with vertical, and to reveal both texture and space resulted in scores of photographs in which the distinction between art and document is often obscured.

Berenice Abbott *"Theoline" Pier II, East River, Manhattan* (1936)

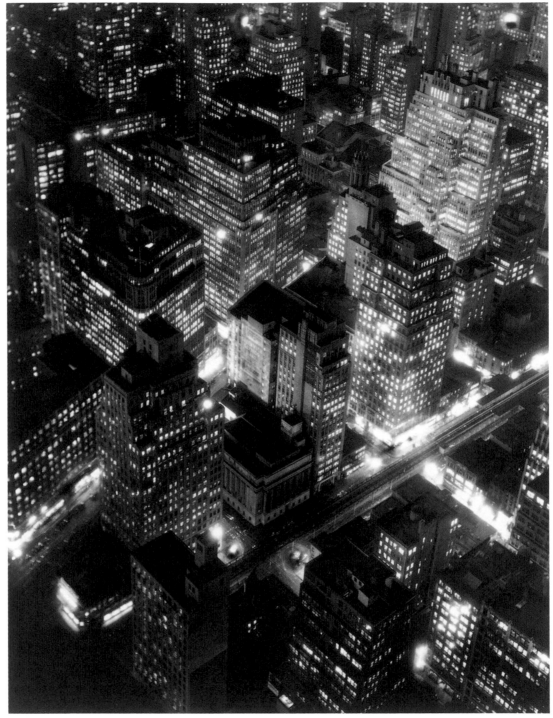

Against the Odds

Berenice Abbott *New York at Night* (1936)

Her photograph *New York at Night* is a prime example of the way in which she was able to use striking contrasts of patterns, light, and shapes to produce an image as strikingly beautiful as it is authentic. Similarly, in her photograph *El* she captures the patterns of light pouring through the massive iron structure in such a way as to create an image of great artistry while at the same time documenting an aspect of New York life that was soon to vanish.

Among the men and women who benefited from Federal Arts Project sponsorship was a group of West Coast photographers. Even more than those on the East Coast, these photographers were given license by the project's directors to choose their own subjects. Among their ranks was Sonya Noskowiak. Born in Germany, she spent her early years in Chile before moving with her family to California in 1915. Her interest in photography began in the late 1920s when she worked for a time as a receptionist in the studio of photographer John Hagemeyer. In 1929, she met Edward Weston and they began a long personal and professional relationship. In the 1930s, she opened her own studio, became a founding member of the influential photographic organization Group f/64 and produced a series of historical architecture photographs of San Francisco.

Her work for the Federal Art Project resulted in some of her finest images, including the masterful photograph she titled simply *Door and Windows*. Despite her obvious talent, she was never able to make a financial success of her picture-taking and was forced to support herself by printing other, often less talented photographers' work.

Both the FSA and FAP photographic projects came to an end with America's entry in World War II. The nation's involvement in the war produced another type of documentary photograph–

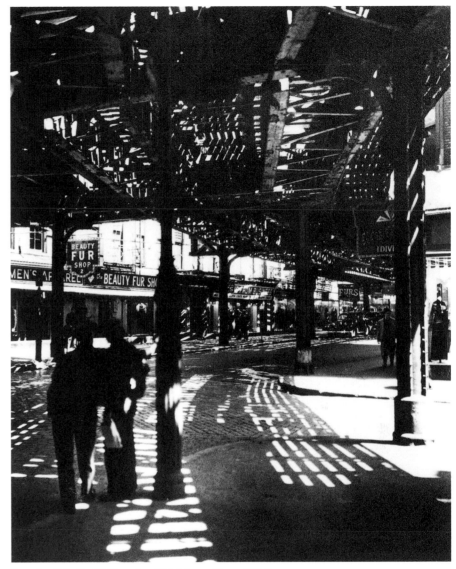

Berenice Abbott *"El," Second and Third Avenue Lines* (1936)

4 · The Documentary Eye 87

Sonya Noskowiak *Door and Windows* (1936)

er; men and women would literally risk their lives to record every aspect of the conflict. Included among these was Toni Frissell.

Frissell's participation in the war began when she secured a position as the official photographer for the Red Cross in both England and Scotland. She then was signed on by the United States Air Force as the photographer for its Fifteenth Air Force Squadron. Later she served as an official photographer for the Women's Army Corps and also took pictures for the Office of War Information, the successor to the FSA's photographic unit.

Her hopscotching across war-torn Europe continually placed her in physical danger, from which she never flinched. "We were on a very exposed part of the road–and easy targets," she wrote, "like ducks in a shooting gallery, apparently in full view of the enemy." The images she captured reveal both her command of the camera and her determination to document the human side of the conflict.

"The worst part of war," she later wrote, "is what happens to the survivors–the widows without home or family, the ragged kids left to wander as orphans." It was just such an orphan that became the subject of her most powerful wartime image. Photographing in the rubble of a London neighborhood immediately after a German V2 rocket attack, Frissell suddenly encountered "a small boy . . . sitting at the bottom of a high pile of haphazard planks and beams. I was told he had come home from playing and found his house in shambles–his mother, father, and brother dead under the rubble. . . . He was looking up at the sky, his face an expression of both confusion and defiance. . . . His was the face of war."

Toward the end of her career, Frissell said that "the story of my life is told in the photographs I have taken, places I have vis-

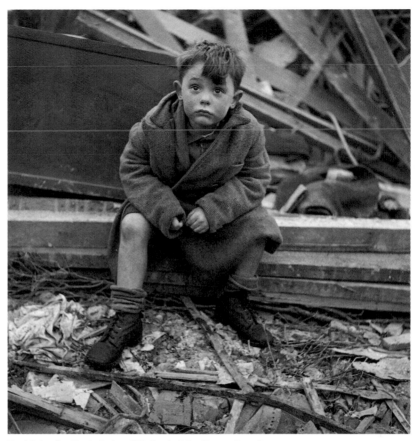

Toni Frissell *Boy in Ruins of His Bombed-Out Home* (1945)

ited, and people I have met. This is as it should be. A photographer keeps a biographical record with every new assignment and the photographer's subjects help shape her destiny."

Another photographer whose subjects profoundly shaped her destiny was Marion Palfi. Although she would produce powerful images of great documentary value, she did not regard herself as a documentarian: "I am a social research photographer who is trying to combine an art form with social research," she

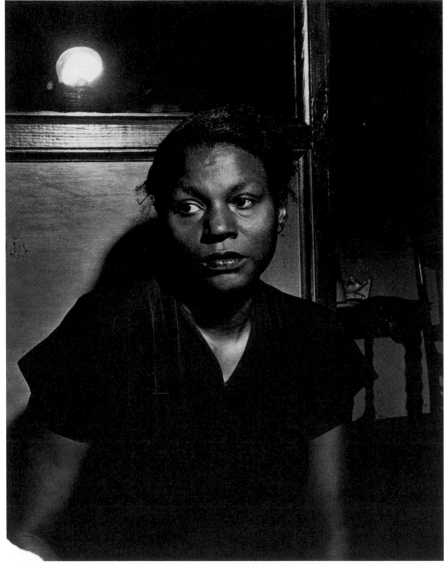

Marion Palfi *Wife of the Lynch Victim* (1949)

stated. "I don't want to just document. I want to know why something is upsetting and how it affects the person involved." This concern for people in distress would occupy Palfi's attention all her adult life.

Born in 1907 to wealthy Hungarian parents, Palfi had worked as a model and appeared in two motion pictures by the time she was seventeen. Dissatisfied with this way of life, she turned to photography. In 1934, she opened her own studio in Berlin and two years later moved to Amsterdam and opened another studio that proved to be an even greater success. But deeply disturbed by the first signs of Nazi tyranny, she emigrated to New York.

She supported herself by taking a job in a photo-finishing laboratory but spent every moment she could creating photographic essays, which she regarded as the most effective way of bringing about social change. Her work caught the attention of magazines, book publishers, and foundations, and through these avenues of support she was able to spend the better part of four decades documenting the lives of people she regarded as being "invisible in America."

In the 1940s, Palfi traveled throughout the United States capturing haunting images of racial discrimination. In the 1950s she focused on conditions of the elderly and on child neglect and juvenile delinquency. She spent much of the 1960s photographing voter registration of blacks in the South and living conditions of Native Americans. In the 1970s, she trained her camera on the American justice system and on life in American prisons.

It is almost impossible to encounter her pictures without being struck by the deep concern she felt for each of her subjects. She made a point of not calling herself a documentarian. Yet through photographs like that of the wife of a lynching

Marion Palfi *Residents of an Old Age Home* (1956)

1960s, a number of highly talented photographers, influenced, no doubt, by growing acclaim heaped upon Berenice Abbott's earlier documentation, focused their attention on the city and its street life.

The best of street photography is characterized by the way in which the photographer is able to capture distinct slices of urban life. Few have ever done this better in America than Lisette Model. Born Elise Amelia Felice Stern in Vienna in 1906, Lisette, who as a young girl studied music with Arnold Shoenberg, moved to Paris in 1922. In 1936 she married the Russian painter Evsa Model and at about the same time, seeking something challeng-

victim and residents in an old–age home, Palfi gave the world images that profoundly exemplify the power of the camera to reveal and to touch our emotions.

Although she brought her own distinct photographic style and motivation to her work, Palfi, in training her camera on the neglected and the disadvantaged, followed in the tradition of Dorothea Lange and Marion Post Wolcott. In the 1950s and

ing, took up photography. Almost immediately she displayed a natural ability with the camera and a particular talent for capturing urban types off guard. In 1938, on the eve of World War II, she and her husband visited New York and decided to remain there. Three years later she began a twelve–year stint as a freelance photographer for *Harper's Bazaar*. In 1951 she started what would become a thirty–year career as a teacher of photography

Lisette Model *Running Legs* (1940)

Against the Odds

Helen Levitt *Masked Kids, Brownstone* (c. 1945)

Ruth Orkin *Americans Waiting for the CIT Tour Bus, Rome* (1951)

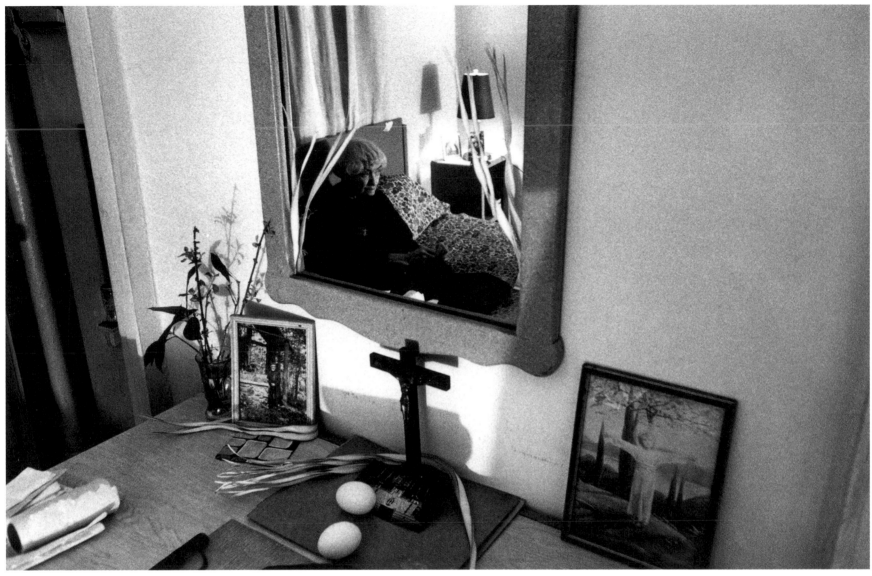

Marcia Keegan *Former Nun in Hotel Room* (c. 1960)

Linda Bartlett *Children In Their Neighborhood* (c. 1960)

produce images that intrigue as well as amuse.

As Lisette Model became a master at capturing images that depicted slices of city life, other camerawomen such as Helen Levitt, Ruth Orkin, Rebecca Lepkoff, and Eve Arnold left an indelible mark on street photography through their ability to spontaneously freeze a single moment in time in the urban experience. Helen Levitt was born in Brooklyn, New York, in 1913. At the age of twenty-seven, she went to work in a New York portrait studio. In 1935, she met Henri Cartier-Bresson who was then living in the city and was strongly influenced by his work. Levitt was an accomplished filmmaker as well as a photographer. For more than a decade she made documentary motion pictures with James Agee and others. Her urban photographic documentation was marked by her fascination with children and her love of the unexpected and the whimsical. This can be seen most clearly in the image she titled *Masked Kids, Brownstone.*

at the New School for Social Research.

Model was a shy and extremely private person. Yet in her street photography it was the flamboyant, the unusual, or those who seemed consciously to defy convention that caught her eye. Her photograph *Running Legs, NYC* typifies the way she was able to capture the pulse of 1940s urban life and at the same time

In the late 1950s and early 1960s, conditions in the United States once again led to a large-scale photographic project initiated and supported by the government. The impetus for the project grew out of the fact that within a nation that boasted one of the highest standards of living in the world, millions were so poor that they could not afford adequate food, housing, clothing, or medical care. In response, as part of President Lyndon Johnson's Great Society program, Congress passed the Economic Opportunity Act, the goal of which was to "eliminate the paradox of poverty in the midst of plenty."

At the heart of the act was the formation of the Office of Economic Opportunity (OEO), whose mandate was to administer scores of programs designed to help eradicate poverty. Like the FSA before it, the OEO hired a team of talented photographers to document the conditions it was attempting to alleviate. Marcia Keegan, Linda Bartlett, Arthur Tress, Paul Conklin, William Warren were among dozens of outstanding photographic talents hired. Like the FSA photographers, they photographed in every region of the country. And, like the FSA photographers, they produced countless images that went beyond the obligatory public relations shots, images that visually documented what sociologist Michael Harrington labeled "the other America." In one regard, however, there is an enormous difference between the two photographic projects. Unlike the world-famous FSA images, the OEO photographs have remained almost totally neglected.

As one studies the OEO images, it becomes clear that Marcia Keegan and Linda Bartlett are among the most important of the project's photographers. Keegan, who today is arguably the nation's leading photographer of the Native Americans of the Southwest, took her camera to several regions of the nation. Her most dramatic series was shot in a hotel in New York's Times Square. The hotel had been taken over by one of the OEO's relief organizations to house women who were down on their luck. One of these women was an ex-nun, who Keegan photographed in her small room. By capturing her through a reflection in the mirror that hung above a table filled with the evidence of her religious past, Keegan captured one of the most dramatic of all the OEO images. Linda Bartlett's OEO images reveal her special talent for capturing facial expressions to create the mood and message of her photographs. In her pictures of the urban poor, such as that of children in a run-down city neighborhood, she provided her own proof of how documentary photographers, from the beginning, were able to offer powerful insights into the human condition and at the same time provide images of outstanding photographic quality.

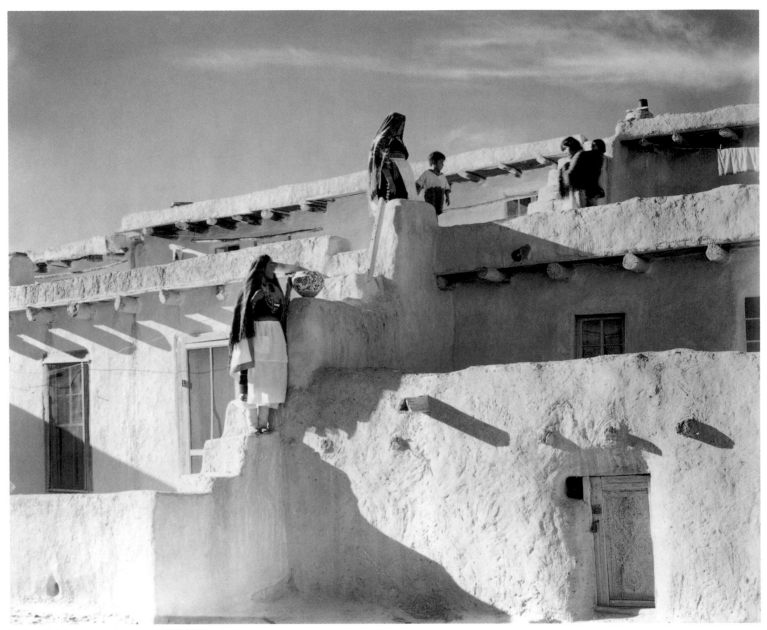

Laura Gilpin *Terraced Houses, Acoma, Pueblo* (1939)

5 · Photographing the Native Americans

AMERICANS HAVE ALWAYS been fascinated with those who were first on this land. With the possible exception of the cowboy, Native Americans have been the subject of more books, movies, television programs, and paintings than any other group, and the introduction of the camera made a whole new type of depiction possible. Through photography, more realistic pictures of this group than ever before–their likenesses, dress, customs, culture–could be captured. But there was a sense of urgency attached. By the time the dry plate was introduced, making it easier for photographers to leave the confines of their studios, the final bitter defeat of the Native Americans was close at hand. Photographers, amateur and professional, became determined to capture the Native American way of life before it vanished from the scene. Out of this determination emerged the work of such dedicated and talented cameramen as Edward Curtis, Adam Vroman, Will Soule, Roland Reed, and Summer W. Matteson. All of these men have long been regarded as premier photographers of Native Americans.

A great oversight in the literature about those who photographed the Native Americans has been the significant role women played in documenting the lives and customs of the indigenous group. The work produced by these women is among the best ever produced on this subject. These women pioneered the ethnological photographic documentation of the first Americans. Others took some of the most compelling of all Native American portraits. Still others spent years living among the Native Americans, photographing almost every aspect of their lives. Collectively it was an extraordinary achievement, too long left uncelebrated.

One of the earliest photographers to leave their mark on Native American photography was Matilda Coxe Stevenson. Mentioned only in passing in histories of the medium, hers was a vital contribution. In 1879 she played a key role in establishing the Bureau of American Ethnology, an agency that over the years would take the lead in fostering the written and photographic documentation of Native American culture. She also personally produced some of the rarest images of the Native Americans ever taken.

An accomplished anthropologist, Stevenson first came face to face with Native Americans when she accompanied her geologist husband on trips to the West, which he was conducting as an officer of the U.S. Geological Survey. On one of the earliest of these journeys she came into contact with Ute and Navajo Indians and was so fascinated by them and their way of life that she decided to devote the rest of her life to ethnological pursuits. At first her goal, like that of so many others, was to help bring Western "civilization" to them. After spending time among them, however, and after beginning to study Native American languages and religion, she developed a deep appreciation of the culture the Native Americans already possessed. She became one of the first government anthropologists to work actively toward the preservation of this culture.

After her husband's death in 1888, Stevenson became a staff member of the Bureau of American Ethnology and continually traveled to the Southwest where she focused, both in her research and her photography, on the Pueblo culture in New Mexico. One of the few whites accepted into Native American

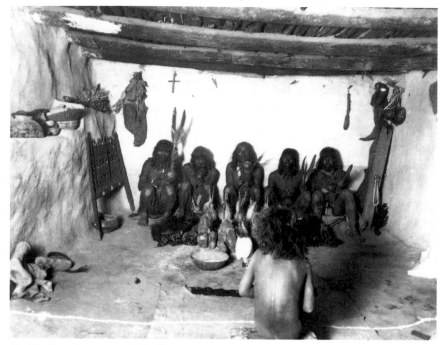

Matilda Coxe Stevenson *Sia Pueblo, New Mexico* (c. 1888)

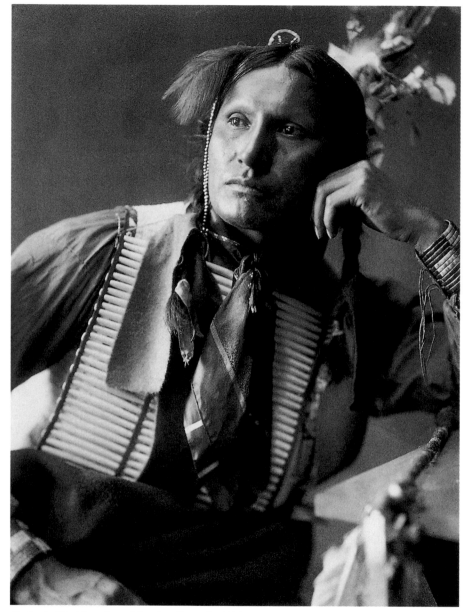

Gertrude Käsebier *Samuel American Horse* (c. 1900)

society, she was able to photograph inside ceremonial huts and to capture scenes of sacred ceremonies.

Typical of the images she captured was that of shamans invoking the power of the bear to cure a sick boy. Taken inside the shamans' ceremonial chamber, the photograph records a scene almost never witnessed by outsiders. Seated behind a collection of fetishes, the five shamans grasp plumes, straws, and rattles while uttering chants to rid the boy of his illness. Many of her other pictures recorded the various dances that were an integral part of the Pueblos' way of life. Accompanied by Matilda's extensive notes, these images provided authentic information to ethnologists interested in the unique rituals of the first Americans.

As Stevenson was working to record and preserve the culture of Native American nations in the Southwest, another woman anthropologist was pursuing similar interests on the Great Plains. Alice C. Fletcher was a reformer and a humanitarian as well as an anthropologist. A pioneer of long-term ethnological field projects and a collector of artifacts for Harvard's Peabody Museum, she spent much of her life working for Native American rights, particularly in regard to education and ownership of land.

Most of Fletcher's ethnological work was with the Omaha, Winnebago, Dakota, and Nez Percé nations. Beginning in 1881, she was joined in her endeavors by the Native American Francis LaFlesche, whose father was the last chief of the Omahas. Under Fletcher's tutelage, the highly educated LaFlesche, who was both a lawyer and an ethnologist, would carve out a distinguished career in anthropology and would become Fletcher's collaborator and longtime companion. Fletcher was also assisted by a talented amateur photographer named E. Jane Gay. Between them they produced revealing photographic documentation of the Plains Indians.

Katherine T. Dodge *Issue Day at San Carlos, Arizona* (c. 1899)

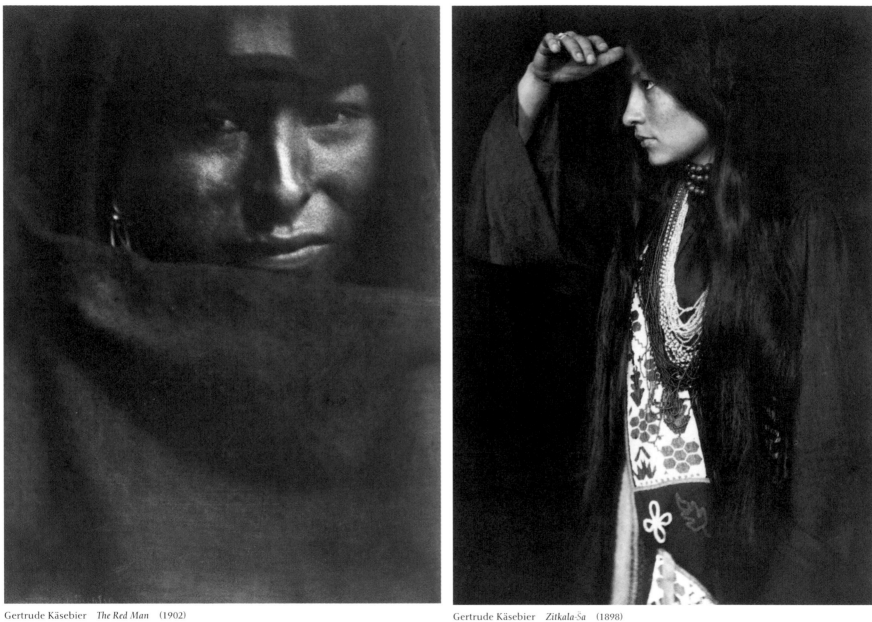

Gertrude Käsebier *The Red Man* (1902)

Gertrude Käsebier *Zitkala-Ša* (1898)

During the same period, Katherine T. Dodge was photograph-
ing reservation life among the Apaches in Arizona. We know little
about her, but of the photographs she left behind the most com-
pelling is the one she took of men, women, and children receiving
food and clothing on what was known as "Issue Day" at San
Carlos, Arizona. It is an intriguing image, distinguished by the way
in which Dodge was able to capture the expressions on the faces
of many of those in line. We are left wondering whether their per-
plexity was caused by the dependent situation into which these
once fiercely independent people had been forced or by the rare
presence of a photographer, and a female photographer at that.

Matilda Coxe Stevenson, Alice C. Fletcher, and Jane Gay were
primarily interested in ethnological pursuits; their goal was not
to become master photographers. Katherine T. Dodge did not
leave behind a body of work large enough to be judged. The im-
portance of all these women to Native American photography
lies in their pioneering efforts in the field and in the authentici-
ty of their images. Gertrude Käsebier, on the other hand, was
well on her way to becoming a photographic giant when she
took her most important pictures of Native Americans.

In 1898, Buffalo Bill's Wild West Show came to New York.
Käsebier invited more than forty Sioux members of the troupe to
come to her studio to have their portraits taken. There she cap-
tured some of the most sensitive and revealing Native American
images ever produced. Her stated goal was to present a portrayal
of individual Native Americans as far removed as possible from
the stereotypical images that had become so common. "I want a
real raw Indian for a change," she wrote. "The kind I used to see
when I was a child."

To achieve this goal and to capture the individuality of each
of her subjects, Käsebier took hundreds of photographs of these

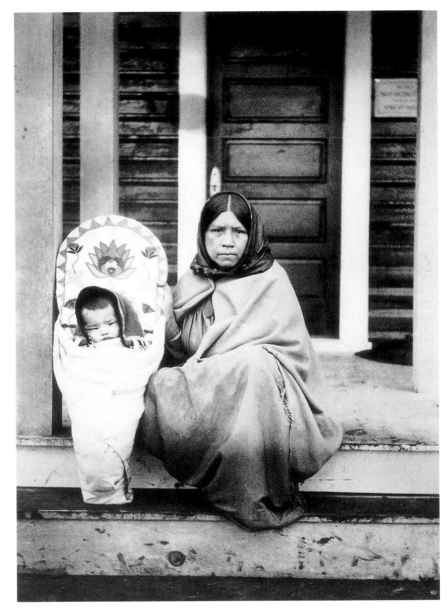

E. Jane Gay *Mother and Child* (c. 1890)

Native Americans over many sittings. Perhaps the greatest of these pictures is that of an unidentified man, which she titled *The Red Man*. This haunting, almost mystical image was the result of numerous attempts with several different sitters to achieve the depiction she sought. "I could never get what I wanted," she said. "Finally, one of them, petulant, raised his blanket about his shoulders and stood before the camera. I snapped and had it."

One of Käsebier's most dramatic Native American photographs would come as the result of a friendship she struck up with a remarkable woman named Zitkala-Ša Raised on a reservation, Zitkala-Ša became a teacher at the Carlisle Indian School. An accomplished violinist and pianist, she gave many successful concerts. She also became known for her efforts on behalf of Native American rights, the Indian origin tales she wrote, and her memoirs, which were published in *Atlantic Monthly*.

Throughout her adult life, Zitkala-Ša obviously struggled with the inner tensions created by the relative ease with which she traveled both inside and outside the Native American world. It can be seen in the content of some of her articles and in the fact that on official documents she called herself Gertrude Simmons. In her striking photograph of this unique woman, Käsebier posed her shielding her eyes as she gazed far into the distance. In the image, Käsebier captures Zitkala-Ša's longing for the distant, open West she had once known, and, perhaps unwittingly, created a symbol of the yearnings of all Native Americans for the life that once was theirs.

The New York City appearance of Buffalo Bill's Wild West Show had given Käsebier the opportunity to photograph Native Americans in her own studio. During the last half of the nineteenth century, another type of event brought large numbers of Native Americans from their reservations to the public arena.

Staged as showcases for what was hailed as a "century of progress," expositions and world fairs gave Americans the chance to marvel at the glories of all that had been accomplished and to consider still greater triumphs to come. Along with spectacular displays of mechanical wonders and the nation's agricultural developments, almost every exposition gave its throngs the opportunity to come face to face with Native American men, women, and children, about whom the visitors had heard and read so much.

By the time major fairs like the World Columbian International Exposition and the Louisiana Purchase Exposition took place, the Native Americans had lost their long struggle to retain their land and had been forced to move to reservations. Through government and private funding, fabled Native American chiefs and warriors, along with artisans, medicine men, and whole families, were brought to the expositions where they staged reenactments of their traditional ways of life.

By bringing together Native Americans willing to be photographed, the expositions gave photographers the unique opportunity to capture images of them without having to travel to the reservations or spend months or even years gaining their confidence. Many of these photographs were those taken at the Louisiana Purchase Exposition, which was held in St. Louis from April to December, 1904. In order to keep at bay the hordes of amateurs eager to take pictures of the Native Americans and other native groups in attendance, only professional photographers who used large-format view cameras were granted licenses to take formal pictures at the fair. Among these professionals were two sisters from St. Louis, Mamie and Emma Gerhard.

Unfortunately, we know almost nothing about the Gerhards' personal life except that they maintained their own studio in St. Louis and that more than three hundred of their negatives were

destroyed when their studio caught fire. What remains of their work, however, provides ample evidence of their photographic skill. During their career they captured images of Hopi, Snake, and Eagle dancers and took interior shots of Cheyenne houses.

Their portraits of Native Americans taken at the Louisiana Purchase Exposition, represent their greatest work. In keeping with the goals of the fair itself, the Gerhards sought to depict the Native Americans as the possessors of a proud heritage. Their photograph of the Indian chief Wolf Robe, for example, presents him complete with the trappings of his glory days—head feathers, pipe, and robe. Ironically, he is also adorned with one of the large peace medals given to Native American leaders by a government that had failed to live up to the terms of almost every treaty it had signed with them.

Similarly, the portrait in profile of a man known as San Diego depicts him attired in the tradition of his tribe. It is a haunting portrayal. The ring of dots painted beneath his eye has meaning pertinent to his nation, but it is not difficult to imagine it as a string of tears as well. Like Gertrude Käsebier, the Gerhards captured both the pride and the longing of their subjects, elevating their Native American portraits above those commonly produced.

Between 1905 and 1912, some of the most natural photographs of Native American life were taken by a woman named Kate Cory. Born in Waukegan, Illinois, in 1801, Cory spent her early years studying to be an artist. In 1905, she traveled to northern Arizona to become part of a proposed artist's colony that was to be established there. When the colony failed to be established, Cory, who had become intrigued with the Hopi Indians who had long dwelled in the region, decided to settle there. Along with her paints and brushes, she had taken a cam-

era with her. For the next seven years she lived in Hopi villages, perfected her photographic techniques, and took scores of pictures of the Hopis, their daily life, and their rituals. Somehow she also found time to publish articles about them and to compile a dictionary of the Hopi language.

A study of Cory's images reveals the benefit of the artistic training and experience she brought to her photography. Her picture of the women preparing corn, a staple of the Hopi diet, exemplifies her sophisticated sense of composition, her ability to capture tones and textures. The image also evokes the rare sense of ease that these Native Americans had with a woman who had dedicated herself to living among them and sharing their life.

One of the most dramatic of all Native American images is that taken by a photographer not known for her Indian portray-

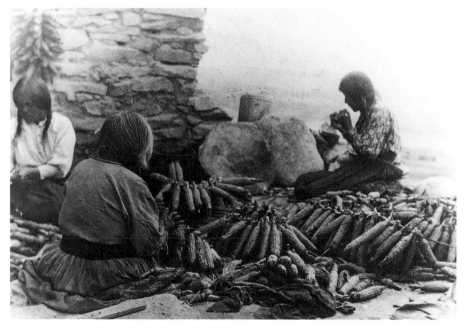

Kate Cory *Indian Women Shucking Corn* (c. 1905)

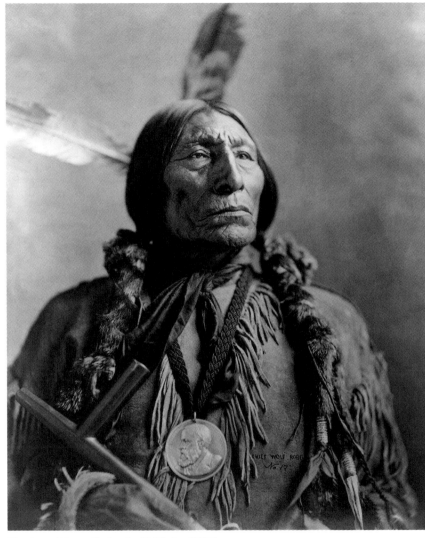

Mamie and Emma Gerhard *Wolf Robe* (1904)

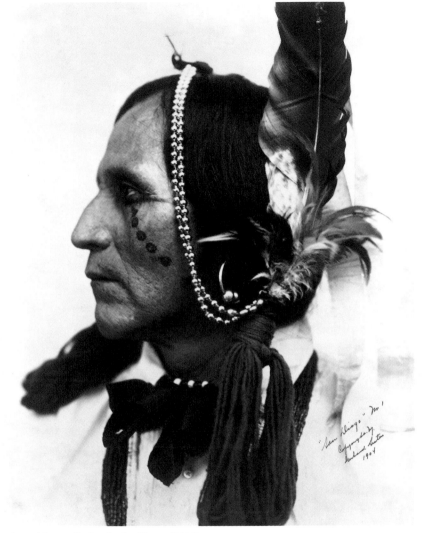

Mamie and Emma Gerhard *San Diego* (1904)

als. In 1922, a young Dorothea Lange embarked on one of her first photographic journeys outside her studio, accompanying her husband through the high mesa region of Arizona, which included Native American reservations. There, more than fifteen years before she would begin her march to fame through the FSA, Dorothea took numerous exceptional pictures including an extraordinary close-up portrait of a Hopi Indian, a photograph that in the words of one of her biographers was "the first powerful image in the Lange opus."

Among the most ethereal of all Native American images is that of two Native American men, taken by Lange's fellow California photographer, Laura Adams Armer, in the 1920s or 1930s. One of the first women to break into the world of book illustration, Armer brought her own sense of mystery to the picture. Like many great photographs it takes us beyond the subjects themselves, evoking thoughts of past and present, challenging us to find our own meaning in the image. The one clue that we do have to Armer's intent is the fact that she poignantly titled the photograph *Americans*.

Throughout the 1920s and 1930s, photographic projects similar to those pioneered by Matilda Coxe Stevenson and Alice Fletcher continued to take place. One of the most important of these was undertaken by a woman named Florence Randall. Working under the same type of WPA sponsorship that had made possible Berenice Abbott's examination of New York City, Randall traveled throughout Florida photographing the Seminole Indians. There she produced images that were as artistic as they were ethnologically valuable.

As Randall was training her camera on the Seminoles, more than two thousand miles across the continent, another woman was launching a project that she would pursue for an extraordi-

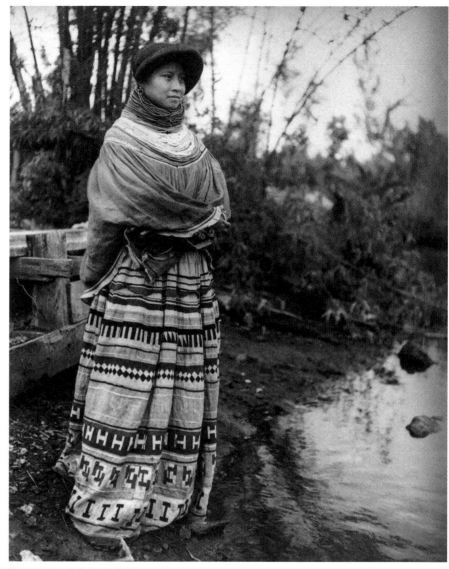

Florence Randall *Seminole Woman* (c. 1937)

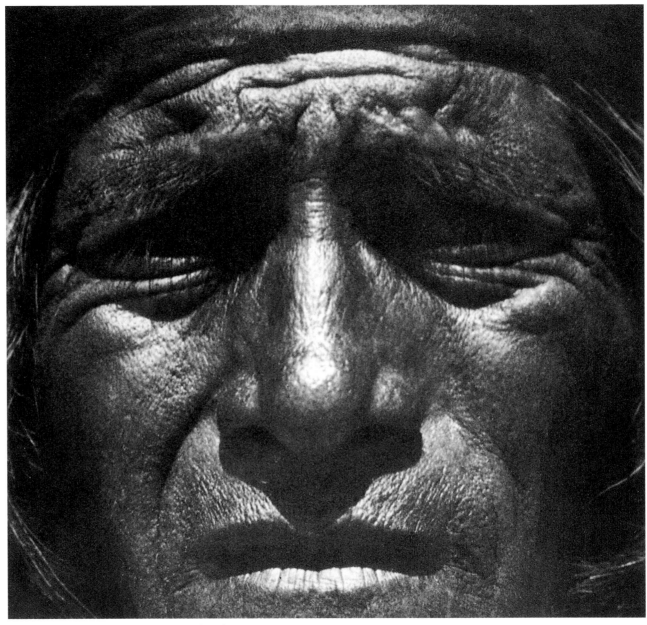

Dorothea Lange *Hopi Indian, New Mexico* (1923)

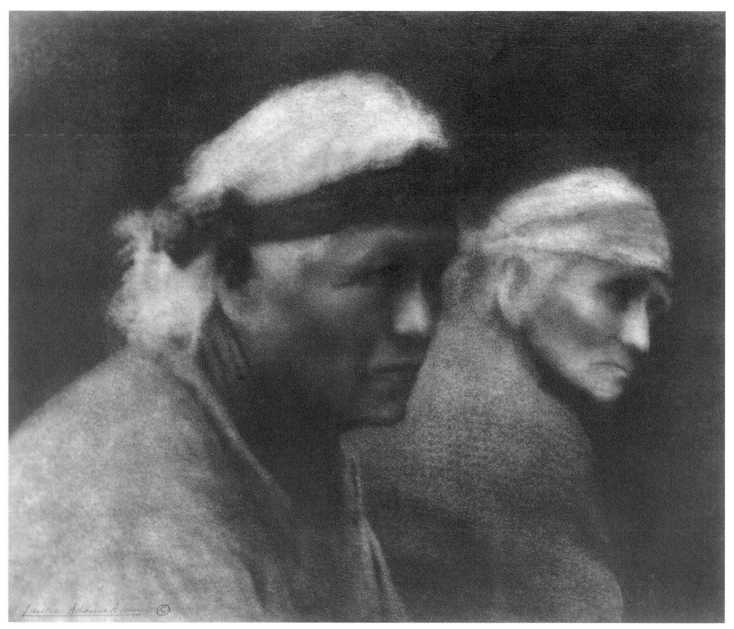

Laura Adams Armer *Americans* (1930s)

nary forty-eight years. In a career that spanned seven decades, Laura Gilpin was still launching arduous new projects when she was eighty-one and was capturing images by leaning out the window of a small airplane only two months before she died at eighty-eight.

Gilpin was born in Austin Bluffs, Colorado, in 1891. Her interest in photography began in 1903 when she received a Brownie box camera for her twelfth birthday. A year later she was sent to St. Louis to accompany one of her mother's friends, a blind woman, to the same Louisiana Purchase Exposition where Mamie and Emma Gerhard were taking their most important pictures. It turned out to be a journey that would both hone Gilpin's photographic skills and introduce her to a subject that would later consume her attention. "We went to the World's Fair every other day," she would write, "and it was my job to describe [the] exhibits. The experience taught me a kind of observation that I would never have learned otherwise. I can also remember being fascinated by some Igorot natives from the Philippines who were there."

When she was still only fourteen, Gilpin's mother took her and her young brother to New York to be photographed by Gertrude Käsebier. It was the beginning of a friendship between Gilpin and Käsebier that would have a profound influence on Gilpin's photographic career. In 1917, at Käsebier's urging, Gilpin enrolled at the Clarence White School, where she found that there were more female students than male. When her studies were completed, she returned to her native Colorado and set up a studio for portraiture and architectural photography.

Her interest in the land increasingly took her outdoors, and went beyond the terrain itself to the most ambitious and greatest of all her endeavors. In the 1930s she began a project she ti-

tled "The Enduring Navaho." It was an undertaking that would continue throughout her career. Fascinated by the courage and the durability of the Navajo people, who had inhabited the Southwest long before the first white settlers arrived, Gilpin was determined to document not only their ways of life but to reveal the age-old spiritual relationship between these people and the land upon which they lived.

"The Enduring Navaho project," she wrote, "was fifteen years in the making. I had no backing, no grant or anything like that. It was just something I had to do. It was not an easy job–it took patience and more patience–but it was worth it. As things built up, I had a loose-leaf dummy with prints in it to show people. All the Navahos wanted to look at the pictures; somebody would find someone they knew in a print, and that always opened a door. They don't forget, they just never forget you–it's incredible. My involvement with the Navaho people has affected my own way of life, of course, as I came to understand their philosophy."

Over the years Gilpin would spend countless hours with the Navajo in both Arizona and New Mexico, earning their trust and respect. The result was some of the most sensitive of all depictions of the first Americans. In an image of a Navajo girl standing in an enormous stone entranceway, Gilpin's masterful use of light and shadow, and the scale and textures of the surroundings she selected, make it appear as if the young woman is suspended in time and space. There is a real sense of mystery to the photograph: What is the girl thinking as she peers into the bowl? What kind of place is this? The natural light playing on the stone column to the left seems to invite us to enter and turn the corner. What would we find?

Light and shadow are also key features of the photograph

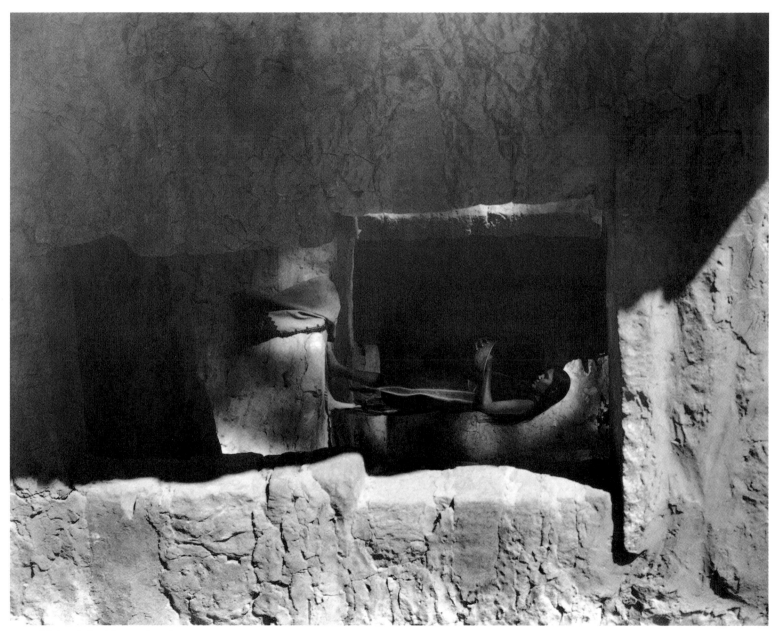

Laura Gilpin *Indian Woman* (1939)

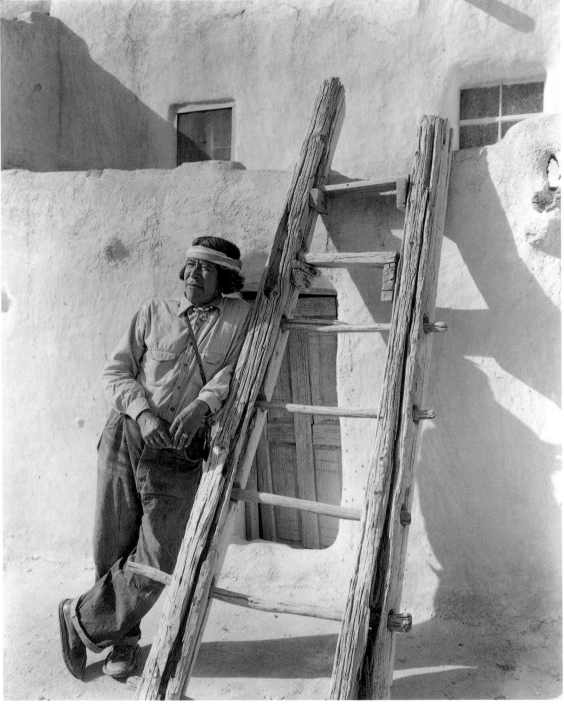

Against the Odds

Laura Gilpin *The Ladder* (1939)

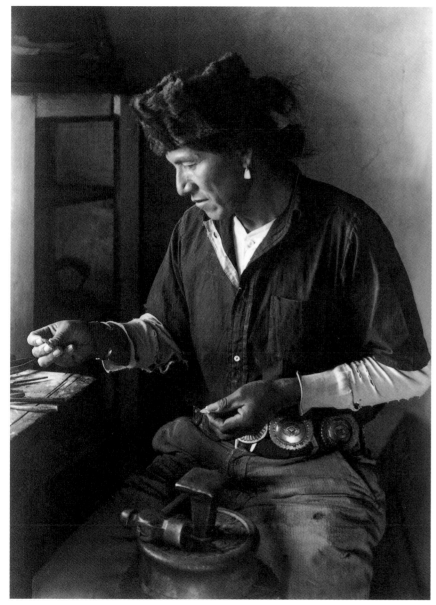

Laura Gilpin *Navaho Silversmith* (1939)

Gilpin took at the Acoma Pueblo that she titled *The Ladder*. Various shadows throughout the image cast their own dramatic shapes and forms. Like her photograph of the Navajo silversmith and many of her images, *The Ladder* is marked by a marvelous simplicity. It was a simplicity that would characterize her life as well. "I come from a line of Quaker ancestry," she wrote, "and my whole belief is very simple. It is in how you behave and how you take what happens to you: those are the two main things in life. . . . If you're busy and interested, life seems not to be complicated." Laura Gilpin behaved and took what happened to her with grace and determination and gave us portrayals that, like the people she immortalized, will long endure.

Laura Gilpin *White Sands* (1941)

6 · Landscape and Nature

ONE OF THE greatest misconceptions perpetuated by the various histories of photography has been the notion that early women photographers did not play a major role in landscape photography. These studies routinely declare that the heavy, cumbersome equipment necessary to adequately capture the landscape discouraged women from entering this field. They also portray women photographers as being too bound by family and home to undertake the arduous travel that photographing the landscape, particularly on a grand scale, requires. Even those histories that acknowledge women; participation in this genre qualify their contributions by stating that their landscape photographs were merely minor departures from the types of images they usually produced, which were usually scenes within their immediate surroundings.

These declarations are simply not true. There *were* a significant number of women who, even in the era of the difficult-to-manage wet plate process, captured dramatic images of the American land, some on a truly grand scale. There *were* early camerawomen, many of them wives and mothers, who traveled significant distances to photograph in areas that intrigued them. And there *were* early women photographers who made landscape photography their main area of concentration.

In presenting a major exhibition of landscape photography, the curators of the Minneapolis Institute of Arts labeled their exhibition "Poetry of Place." It is a most appropriate title, for in the hands of masterful photographers, pictures of the land often go well beyond the simple visual recording of a particular locale. Early women photographers not only gave us views of almost every area of the American land but brought their own brand of poetry to their photographs. And for some, the majesty of the scenes before them or the unique shapes and forms they encountered, provided a subject to which they could bring their deepest spiritual, or even mystical, interpretations.

Allied to the field of landscape photography is the photographic world of nature studies. The contributions of women photographers in this field have been, for the most part, recognized. Women such as Imogen Cunningham and Ruth Bernard have long been heralded as giants in this genre. Yet there have been some oversights resulting in many masterful women photographers who have not received the recognition they deserve, some of whom will be introduced here.

The earliest women photographers who captured images of the land did so for a variety of reasons. Marie Hartig Kendall, anxious to augment her family's income, took pictures of the Connecticut landscape that she sold both as postcards and to the New Haven Railroad Company, which used them in publicity campaigns. Eva Watson-Schütze, along with a group of early women photographers known as the Philadelphia Naturalists, applied her budding pictorialist approach to a series of landscapes.

For the insatiably curious Francis Benjamin Johnston, capturing images of the land presented yet another avenue of photographic exploration. She was particularly fascinated with the challenges presented by underground photography. In 1892 she traveled to Kentucky and descended into Mammoth Cave where she mounted a campaign "to vanish the arch-enemy darkness with flash powder." The resulting images, though not having the social impact of her earlier coal mine photographs, were, to Johnston, far more adventurously satisfying.

Evelyn Cameron *Buttes in the Badlands of Eastern Montana* (c. 1900)

Evelyn Cameron *Hawk's Nest* (c. 1900)

Frances Benjamin Johnston *Lower Falls of the Yellowstone* (1903)

Elizabeth Ellen Roberts *Harvesting* (c. 1905)

Her interest in natural wonders on a grander scale led to her most spectacular landscape images. Today Yellowstone National Park is one of America's most visited sites, but in 1903 when Johnston photographed there, the only access to the area was on horseback or by stagecoach, and bears outnumbered tourists. The landscape images she captured were of a region still unspoiled by human intrusion. Of these the most spectacular is the photograph titled *Lower Falls of the Yellowstone*. It is an image that helps us understand why the original Native American tribes in the Yellowstone area regarded this land as sacred ground.

While Johnston was portraying the grandeur of the Yellowstone region, Elizabeth Ellen Roberts was taking her photographs on the plains of North Dakota. One of her goals was obviously to convey the enormity of the flat, seemingly endless prairie that dominated her life and those of her fellow frontier men and women. Even at this early stage of photography, she accomplished her goal on the grandest of scales.

Her achievement was made possible in part by owning an early panoramic swing camera which allowed her to capture wide angle views. It was due in even greater measure, however, to her ability to convey space and scale. In her photograph of hundreds of grazing sheep, for example, she included the figure of a rider astride his horse. He appears as a distant speck, dramatically emphasizing the vastness of the land around him. Similarly, Roberts's photographs of two women standing in a cornfield reveals how human figures were dwarfed by the prairie landscape. Our eyes are drawn to the rows of corn that seem to stretch on forever. The distance between the women harvesters and the homestead is enormous, leaving one to wonder if there is anything but more miles of flat land beyond the slight rise in the distance.

Evidence that early women photographers were willing and able to take on even the most dangerous and physically demanding challenges of landscape photography is dramatically provided by the landscape images of Evelyn Cameron. Her approach to landscapes differed from that of the early government survey photographers of the American West. Overwhelmed by the grandiosity of western topography, they had most often focused on expansive vistas, towering mountain ranges, and deep canyons and valleys. Cameron, however, was interested in photographing close-up the extraordinary shapes and textures of the buttes and other rock formations spread throughout the Montana Badlands. She found a special aesthetic quality in these formations and would travel for hours, even days, to photograph them.

Even more arduous was her photographic pursuit of the wildlife that lived within the Badlands, particularly those that nested thousands of feet high in the mountains. As author Donna Lucey has noted, "By a combination of daring, patience, and a knack for dealing with animals, Evelyn was able to take extraordinary close-ups of eagles, hawks, and other wild birds—images that are among the earliest photographs ever made of western American birds in their native habitat."

To capture these images Cameron would climb as high as 5,000 feet into the hills and mountains hauling both her nine-pound camera and her tripod. One image in particular, that of a nest of a red-tailed hawk, four feet high and three and a half feet wide, perched upon what Cameron termed "a high pillar of rock," is spectacular. One can only imagine the risks involved in capturing such a photograph. But for Evelyn Cameron risk was a way of life. Her reward and ours was the photographs she worked so hard to get, images of special places.

Just as the photographs of Elizabeth Ellen Roberts give the lie to the myth that women did not take pictures on a large scale, and

Lily White *Moonlight on the Columbia* (c. 1902)

Laura Gilpin *Casa Blanca, Canyon de Chelly* (1930)

the images of Evelyn Cameron refute the notion that women avoided the greatest ardors of landscape photography, the work of Lily White contradicts the contention that women did not concentrate on the landscape for their subject.

Educated in the Portland, Oregon, public schools, White showed an early interest in art and went first to San Francisco and then to Chicago to complete her education. While pursuing her art education she had also received instruction in the use of the camera and in developing and printing, and in 1892 she began a dual career as both a photographer and an artist.

She also became an influential teacher of photography and her work did not go unnoticed at the time. "The Oregon Camera Club of Portland," stated the *Oregon Native Son*, "has had many instructors during its existence but was never satisfied with those employed to teach its members more about their chosen hobby, until they secured the services of Miss White. All of its members have made great progress under her instructions, and its membership is now rapidly increasing in members."

It was through her own photographic accomplishments, however, that White would make her greatest contribution to the medium. She was fascinated with the topography of the Oregon coast, capturing often spectacular images of that still unspoiled area of the country. She was particularly intrigued by the continual play of mist upon Oregon's mountains and waters, and in photographs such as *Moonlight on the Columbia* used shapes and forms created by the mist as the backdrop for her images. Hers was a special talent, one which has gone unheralded for far too long.

Although Laura Gilpin spent dozens of years photographing Native Americans, she regarded herself first and foremost as a landscape photographer. As a youngster growing up in sparsely

settled Colorado, she was profoundly influenced by the openness of the West. Her childhood of camping, hiking, and riding in the most remote areas led to her love of the land and a unique spiritual vision of her natural surroundings. She was influenced also by the friendship that her father maintained with her distant cousin, William Henry Jackson, the premier landscape photographer of the day. Jackson frequently visited the Gilpins' cattle ranch and she fondly recalled the long talk they had on the challenges of photographing the land.

Gilpin and Jackson did, however, have differing views on photographing the landscape. Jackson was interested in the West solely for its magnificent topography. For Gilpin, the land had a much deeper meaning. She viewed it as nothing less than an historical setting upon which, over hundreds of years, people had acted out their lives. It was a belief that explains her particular affinity to the Native Americans. It also explains the extraordinary sensitivity with which she approached each of her landscape images.

This awareness of past peoples and past cultures in relationship to the landscape led Gilpin time and again to ancient Native American dwellings at the Canyon de Chelly. "I first stopped at the Grand Canyon in 1915," she said, "and I've photographed the Canyon de Chelly more than any other place. On one of my trips there I tried to find the exact spot where the great photograph with seven horsemen by Edward Curtis was taken. I grew up under that print. It hung on our wall at the ranch for years. I'm sure that is why I have photographed so often in the Canyon."

Above all else, Gilpin had a clear sense of what it took to produce an outstanding landscape image: "One can spend hours hunting for fine pieces of design in nature. They do exist; it remains only for us to find them. Learning to see things is what every one of us should practice daily. Often one finds fine compositions in line or mass, but would they be better in another light? Wait and see. Go back at all hours of the day and find the time when the light helps the composition, for it is an amazing thing how different a subject can be at different times of the day. . . . Acquiring the habit of noting the changes of light and watching for designs, fits and makes us ready for those rare moments when unusual and remarkable things happen, which may only last for a fleeting moment. These are the things that photography, and only photography, can catch if we are so well trained that we do our part."

Given her passionate love of the land, it is not surprising that Gilpin was an avowed environmentalist long before conservation became part of our national consciousness. In her book, *The Rio Grande: River of Destiny*, she presented magnificent images of the mighty river, accompanied by text that pleaded with future generations to stop the environmental abuses that threatened what she regarded as a national treasure. Ansel Adams would praise Gilpin for her "highly individualistic eye," but her contribution to her medium went far beyond that. By bringing her soul as well as her eye to her passion for the land, she gave a new meaning to landscape photography.

Consuelo Kanaga's landscape images, like most of her other work and indeed her life itself, also differed sharply from the established mode. Hers were not scenes of the land inspired by the early photographers of the West or by those who had sought to emulate the paintings of the Hudson River school. As photo-historian Sarah McLowe has pointed out, "Instead of memorializing scenic wonders or formulating impressionistic tableaux, Kanaga celebrated humble locales, places where traces of a human presence are visible and exist in the realm of nature."

Kanaga and Gilpin shared an interest in the celebration of natural settings where people acted out their lives. But unlike Gilpin,

Laura Gilpin *Los Ranchos de Taos Church* (1939)

Against the Odds

Laura Gilpin *Rio Grande* (c. 1946)

who focused almost entirely on the land itself, Kanaga's most powerful landscape photographs are dominated by artifacts, symbols of the day-to-day life of hard-working common people, many of whom came from pioneering stock similar to her own.

Perhaps more than those of any other photographer, Kanaga's landscape images convey a sense of place that is distinctly American. They may be photographs devoid of people, but they are images that unmistakably reveal that the people who either live or had lived in this place are people for whom the photographer has the deepest respect. *Seddie Anderson's Farm*, for example, is not only formally compelling but informs us that the life being lived here is without frills or advantages. *Ghost Town* is quintessentially American, an evocation both of the challenges of the American experience and of Kanaga's sense of the spiritual, which she found in the most common of objects.

Although the Farm Security Administration (FSA) collection remains the most heralded compilation of photographs ever taken for a single project, its acclaim has come almost solely from the response to its people-oriented images. What has gone relatively unnoticed is the quality of the scores of landscape photographs that were taken. Of all these photographs, none are more beautifully rendered than those taken by Marion Post Wolcott.

One of Wolcott's earliest FSA assignments took her to Vermont and New Hampshire in the dead of winter. "By all means, take all the time you are going to need to do a good job," Roy Stryker instructed her. "It is,

Consuelo Kanaga *Seddie Anderson's Farm* (c. 1920s)

after all, terribly important. It is our first chance to do real good winter scenes. And New England has pretty much been neglected, as far as our files are concerned."

The task was not an easy one. Several of the FSA photographers had traveled the region, but not during the harsh winter months. "Shall I even try to tell you the difficulties I ran into with equipment when the temperature was so low?" wrote Wolcott. "Everything stuck and just refused to operate at *least* half the time. Shutters, diaphragms, tracks, films, and magazine slides became so brittle they would just snap in two. . . . Tripods were out of the question because of the time element and also the snowdrifts. I finally rigged up something which should help—have put a ski pole basket on each tripod leg so that they act like snow shoes and it doesn't sink in so easily."

Determined as always, she persevered and produced the type of photographs that Stryker so desperately sought. Typical of these images is the one she took in the center of Woodstock, Vermont, immediately after a blizzard. It is a photograph that captures the essence of a small New England town in winter.

A year after work in New England was completed, Wolcott again demonstrated her versatility by producing a series of landscape photos in a radically different terrain. In Montana's Glacier National Park she captured images very different from those she took in Vermont and New Hampshire. One photograph in particular reveals her mastery of the landscape image, a picture of a glacier, which she took from Logan Pass. By framing the natural beauty of the glacier within the surrounding mountains and trees, she allowed the scene to speak for itself. It is this simple yet exquisite approach that, regardless of subject, marked all of her work.

Versatility was also the hallmark of Clara Estelle Sipprell. In a

Consuelo Kanaga *Ghost Town, New Mexico* (c. 1950s)

Marion Post Wolcott *After a Blizzard in Woodstock Vermont* (1940)

Marion Post Wolcott *Glacier National Park, Montana* (1941)

Clara Sipprell *El Capitán, Yosemite, California* (1920s)

photographic career that began when she was nineteen years old and continued until she died at eighty-nine, she produced portraits, still lifes, cityscapes, and landscapes, all marked a soft focus, meticulous composition, and her special talent with natural lighting.

Sipprell's father died before she was born–in Tillonsburg, Ontario, in 1885–leaving her mother to raise her and her five brothers. After several of her brothers moved to Buffalo, Sipprell and her mother joined them. In 1902, her brother Frank opened his own photographic studio and two years later Sipprell went to work as his assistant. It was Frank who gave her her first camera and her first photographic instruction. "He taught me all I seem to know," Sipprell later wrote. "He taught me by letting me alone with my many mistakes and for that reason I have never become conscious of the limitations of photography."

By 1905 Sipprell had become Frank's full partner. Along with the portraiture conducted in their studio, they traveled together, particularly in the Lake Placid area, taking photographs of friends and relatives and of the surrounding landscape. In 1915, Sipprell opened her own studio in New York's Greenwich Village. Later she established a second studio in Thetford, Vermont. In 1917, she studied with Clarence White, an association that intensified her belief that photographs could be artistic no matter what the subject.

Although she operated at a time when the pictorialist movement was on the wane, Sipprell was dedicated to the artistic approach. Above all else, she was driven by the desire to convey the beauty she found in nature. Her greatest weapon was her understanding of all the nuances of natural light, an awareness she first acquired while working with her brother. "I had made many photographs but took light for granted," she later stated.

"One day I was passing through our studio room as I had many, many times to get to the reception room. I looked over to where a big chair was by the window and something happened. I saw it. I mean I had an ache of realization and then began my consciousness of light, like music. More and more my world was interpreted in terms of light, natural light." Thanks to the way she was able to utilize natural lighting, most of Sipprell's photographs are marked by their soft focus. Her personal life, however, was distinguished by a certain audaciousness absent in her photographic work. She loved to make an entrance enveloped in a large, flowing cape. She wore enormous jewelry and topped off her outfits with a fedora or a safari helmet. She constantly smoked cigars, pipes, and cigarettes, enveloping her friends in a cloud of smoke. She loved fast-moving automobiles and drove at speeds that terrified those who drove with her.

Perhaps this exotic behavior was a release from the seriousness and introspection with which she approached her photography. "My aim," she declared, "is to be some kind of interpreter of humanity's external struggle to know itself and its surroundings through an unswerving faithfulness to the external truths."

Just as the vast and varied American landscape has provided photographers with the subject matter for images as varied as the nation's topography, so too has the extraordinary array of flora and fauna. Fascinated with the beauty of plants and flowers, photographers have also found and conveyed meaning in the intriguing shapes and contrasts provided by the natural world.

Of the photographers who concentrated on the objects of nature, one of the earliest, Mary T. S. Schaeffer, produced images of such beauty that they have rarely been equaled. Mary Townsend Sharples was born in 1861. We know little about her early life except that she developed a passion for natural science. Her interest

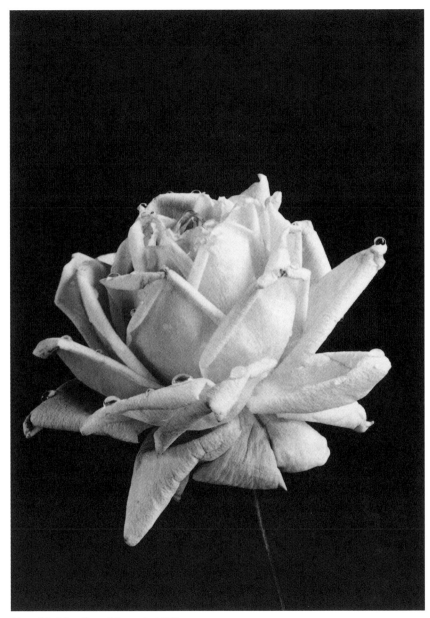

Mary T.S. Schaeffer *A Rose* (c. 1900)

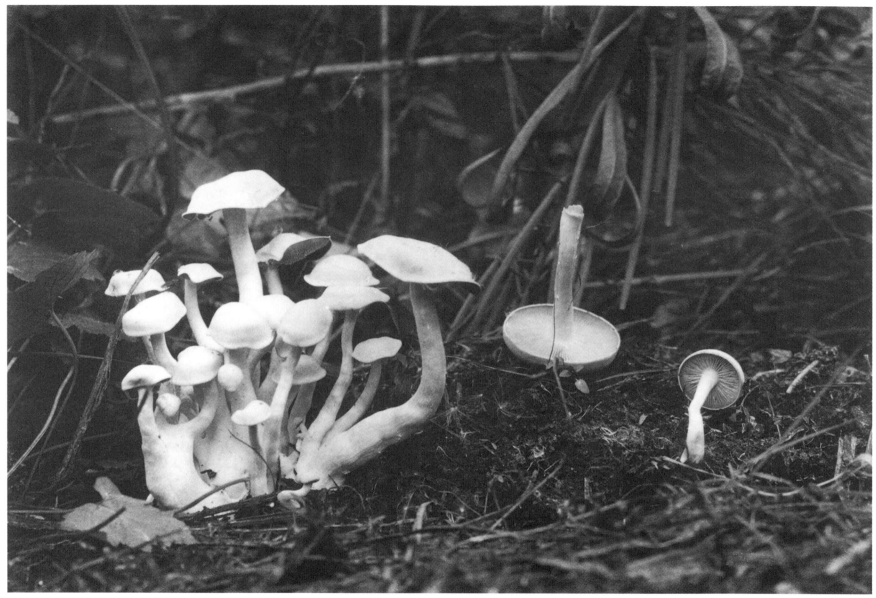

Mary T.S. Schaeffer *Toadstools* (c. 1900)

in botany, in particular, was intensified when she married Dr. Charles Schaeffer, who was preparing a catalog on the flora and fauna of the Canadian Rockies. The new Mrs. Schaeffer illustrated the catalog with both photographs and watercolors. After her husband died in 1904, she continued photographing in the Rockies and published several articles that helped establish her as an expert in the field. The photographs she took are distinguished by the details she was able to capture, such as drops of water on a rose, and by her talent for using light and shadow to bring added drama to such natural forms as a cluster of toadstools.

Similarly, Jeanette Klute, from the time she was a child, was deeply interested in the aesthetic qualities of plant life, particularly those varieties found in the wood. She would devote almost her entire photographic career to capturing images of the unique vegetation that grew within the woods. These images would eventually be exhibited in over 250 solo exhibitions throughout the world.

"Many times," she wrote, "when I first walk into the woods it seems like an impenetrable mass of greenness, but gradually as I become attuned to the spirit of the woods, the greenness gives way to a miracle of individual colors and sensations. My purpose has been to somehow express the feeling one experiences being out-of-doors. I am concerned with the delight to the senses as much as with the intellectual. The woods are mystical and enchanting as well as spiritual. In each of my pictures I have tried to show a single aspect of the way I see and experience the woods."

Klute trained her camera not only on the plants and flowers she encountered but also on the life-forms that dwelled within her beloved woods. Her image of an American copper butterfly

Jeanette Klute *American Copper Butterfly* (c. 1954)

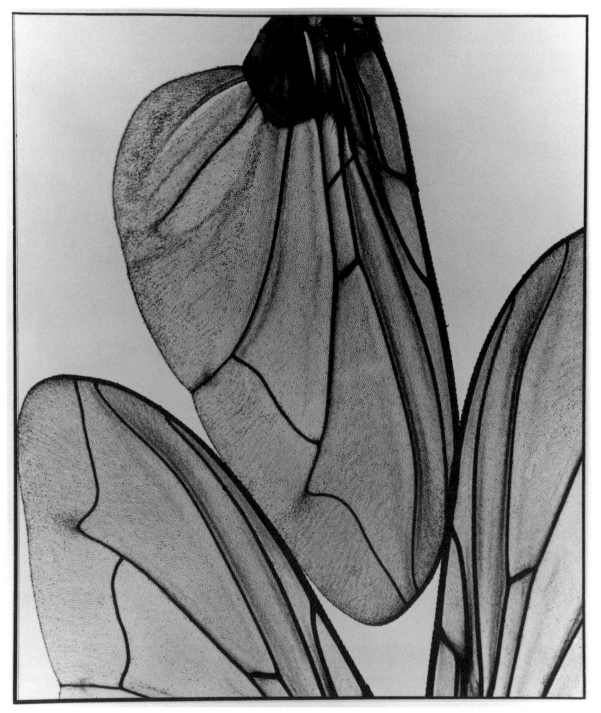

134 *Against the Odds* Virna Haffer *Butterfly Wings* (1960s)

Ruth Bernhard *Cactus* (1937)

Ruth Bernard *Violet Snailshow* (1943)

Against the Odds

Imogen Cunningham *Exploding Bud* (1920)

exemplifies both her artistry and her determination to convey every facet of the woodland environment. Klute served as a technician in the Color Technology Division of the Eastman Kodak Company and as head of Kodak's Photographic Technology studio. But she will be best remembered as the photographer who found both mystery and a sense of the spiritual in what nature provides.

Virna Haffer was also a woman with a passion for the outdoors. Like several of the photographers whose love of nature motivated their careers, she was one of the nation's first ardent environmentalists. "If homo sapiens keep . . . ravishing our earth with no more foresight than in the past or present," she wrote, "we will not survive. But the grasses and the weeds! Ah, the grasses and the weeds. And the bugs. And the bees. With their tenacity for life. [They] will survive when long we have fallen by the wayside." In the photograph she titled *Butterfly Wings* Haffer gave expression to her fascination with insect life.

Some of the most beautifully rendered photographic portrayals of natural objects were those produced by Ruth Bernard, a woman whose career was distinguished by its versatility. Bernard was born in Berlin in 1905. Her parents divorced when she was only two. When her mother moved to the United States to remarry, she remained in Germany with her father, who was a well-known graphic and typeface designer. By 1927, both she and her father had moved to New York. In 1929, she began her photographic career, taking portraits, photographing nudes, and producing both advertising and fashion images. Her love of nature, however, led to some of her most compelling work.

"For me," wrote Bernard, "photographing is a heightened experience perhaps most akin to poetry and music. The image is an attempt to express my sense of wonder at the miraculous visible world and the mysteries that lie beyond our limited human perceptions. Intensified observations lead to exciting discoveries. Looking at everything for the first time reveals the commonplace to be utterly incredible, if only we can be alive to the newness of it. I see a tiny seed and a mountain range as equally significant in the order of the universe, as are life and death. These are some of the concepts that have challenged me to work."

Bernard was particularly fascinated with seashells. It was an interest that had begun in childhood, one which in 1941 led her to Florida's Sanibel Island, which she found to be a collector's paradise. At Sanibel she formed a friendship with conchologist Jean Schwengel who was affiliated with the Academy of Natural Sciences of Philadelphia. Bernard devoted almost a year photographing Schwengel's unique collections of shells, producing images that gave life to her passion for making the commonplace incredible.

The photographer Roger Sturlevant once observed that the key to capturing a masterful photograph from nature is to gain the viewer's attention by directing it to "the strange beauty of organic growth." No photographer ever achieved this goal better than Imogen Cunningham. In 1901, while a high school student in Seattle, she came across Gertrude Käsebier's *Blessed Art Thou Among Women* and was so taken with it that she decided to become a photographer. She mailed fifteen dollars to the International Correspondence School in Scranton, Pennsylvania and in return received a 4 x 5 inch camera, a book of instructions on how to use it, and a box in which she could send back the glass plates of her images so that the school could provide commentary on her technique.

After high school, Cunningham went to the University of Washington where she majored in chemistry while photograph-

ing whatever she could at every opportunity. Upon graduation she obtained a job at Edward Curtis' photographic studio in Seattle. In 1900 Curtis had begun his monumental project of photographing various Native American tribes throughout the nation and Cunningham, along with several other young women, was given the task of printing the negatives he brought back from each of his sojourns. In 1909, after she had been at the Curtis studio for two years, she received a scholarship to study photographic chemistry at the *Technische Hochschule* in Dresden, Germany, where she created a new method for coating photographic papers. In 1910, she returned to Seattle and opened her own portrait studio.

In 1915, Cunningham married the artist Roi Partridge, and in less than three years, she gave birth to three children. Her portrait studio had been a success but, as a busy and devoted mother, she felt she could no longer commit to the amount of time her portrait-taking required. Instead, in whatever free time she could manage, she began capturing images of the various plants that grew near her home. Before her career was over she went on to photograph countless plants, flowers, and other natural objects in various locales. She always claimed that her greatest talent was her ability to convey what she termed "distinct personality" of each of the objects of nature she photographed.

Cunningham exerted a profound influence on the medium. She was one of the founders of Group f64. Her images, frequently published and widely exhibited, inspired the work of scores of young photographers.

Cunningham was still photographing when she was in her nineties. Her greatest motivation remained then as it had been since she had been a high school student. "As document or record of personality," she wrote, "I feel that photography isn't surpassed by any other graphic medium. . . . Lewis Mumford says there are fewer good photographers than painters. There is a reason. The machine does not do the whole thing."

Marion Post Wolcott *Baptism in Kentucky* (1940)

7 · For the Printed Page

AT THE TURN of the century Eva Watson–Schütze stated, "There is one open field yet very little touched by the camera, and that is illustrations, and I look for great things in that direction in the future." Little more than a decade later, *Collier's* magazine would proclaim, "It is the photographer who writes history these days. The journalist only labels the characters."

Actually, photographs had been used as the basis for illustration as early as the 1850s, when wood engravings copied from photographs adorned the pages of many newspapers and magazines. It was the introduction of the halftone plate in the 1880s that made the reproduction of actual photographs in publications possible. The key to the halftone printing process was the use of a screen of fine lines on glass that broke a photographic image into thousands of dots. The pattern of dots was transferred photographically onto a chemically treated printing plate. All of the tones—blacks, whites, grays—could be reproduced.

Of all the countless advancements in the history of the medium none had a more profound impact on emblazoning photography in the public's consciousness than did the halftone plate. By the late 1920s, photographs printed in newspapers became one of the chief means by which people received their news. Out of this development grew the news photographer, a new type of cameraperson with the ability to anticipate when a newsworthy event was about to take place, the talent to snap the shutter at the most telling moment during the event, and the stamina to travel from assignment to assignment.

By the 1930s, the success of photographs in newspapers led to the establishment of photographic magazines. Destined to become extraordinarily popular, the picture magazine spawned the photo essay and created yet another new type of photographer, the photojournalist.

New types of photographic styles would emerge as well. The ability to put pictures into print would lead to the development of advertising, fashion, and industrial photography as vital and distinct avenues of photographic expression. As in news photography and photojournalism, women would play a pioneering role in all these approaches.

A woman, in fact, was among the earliest photographers to have their pictures appear on the printed page as news photographers. Jesse Tarbox Beals, born Jesse Tarbox in 1879, received her first camera at the age of eighteen when, while teaching in a one-room schoolhouse in Williamsburg, Massachusetts, she responded to an advertisement in *Youth's Companion* offering a free camera, plates, and instructions to new subscribers. After taking some pictures, she found that she could make more money taking portraits than she could teaching school.

In 1897, she married machinist Alfred Beals and taught him photography. Three years later the couple went into business together as itinerant photographers. In 1902, Beals was hired by the *Buffalo Courier* to head its fledgling photographic department. She approached her new position with extraordinary energy and ingenuity. In 1903, she achieved what may well have been the nation's first newspaper "scoop" when, at a murder trial where no cameras were allowed, she captured images of the proceedings by photographing through a transom above a door. The amazing number of pictures that she produced for the newspaper on a variety of subjects soon captured national attention. "She levels her camera lens," stated a magazine, "on nearly everything that creeps, walks, swims, or crawls within the

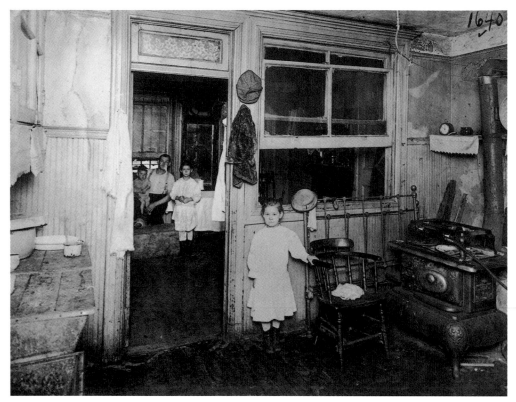

Jesse Tarbox Beals *Family in Tenement* (n.d.)

boundaries of the United States and Canada."

Her determination to photograph every newsworthy event within her reach often placed her in real danger. When her editor at the newspaper informed her of a major fire in Rochester, New York, and told her she had fifteen minutes to catch a train to the site, Beals hastily gathered up her bulky equipment, finished dressing on the trolley to the station, and made the train. Of her experience in recording the fire she later wrote, "I had never seen anything that so reminded me of Dante's Inferno as the smoking areas of burned-over blocks at the fire. But I

plunged in and did all that I could, and when I came out of that fire place I would not have known myself. Icicles were frozen over all my wraps and it took literally hours to get thawed out so I could finish up my negatives."

Some of Beals' most moving photographs were those she took of the appalling conditions under which immigrant families were forced to live in New York City's tenement districts. Her photographs of life in these tenements and alleys, like the work of fellow photographer Jacob Riis, helped make the nation aware of this social ill and influenced the reform that was eventually achieved.

While Beals focused exclusively on news photography, Frances Benjamin Johnston, like many of her colleagues, captured both newsworthy images for newspapers and compiled photographic stories for some of the earliest picture magazines. As early as 1886, Johnston distributed posters describing herself as "making a business of photographic illustration and the writing of descriptions for magazines, illustrated weeklies, and newspapers." An astute businesswoman, she revealed her personal and professional approach to her work by stating, "I have not been able to lose sight of the pecuniary side, though for the sake of money or anything else I would not publish a photograph that fell below the standard I set for myself."

As in the documentary photographs she captured at Tuskegee and Hampton Institutes, the pictures Johnston took for various publications revealed her concern for humanity, particularly the status of women. The series of pictures she took of

women working in a Lynn, Massachusetts, shoe factory, for example, are marked by a sensitivity to the dignity of these workers who labored long hours for three to five dollars a week.

One of Johnston's most dramatic accomplishments as a press photographer came about in 1899 through her friendship with then Assistant Secretary of the Navy Theodore Roosevelt. Vacationing in Europe, she was made aware that Commodore George Dewey, the hero of Manila Bay, was making several European stops before returning to a triumphant homecoming in America. At Johnston's request, Roosevelt contacted Dewey and got the commodore's permission for Johnston to board his flagship *Olympia* in Naples and take the first photographs of America's newest hero and of life aboard the celebrated vessel.

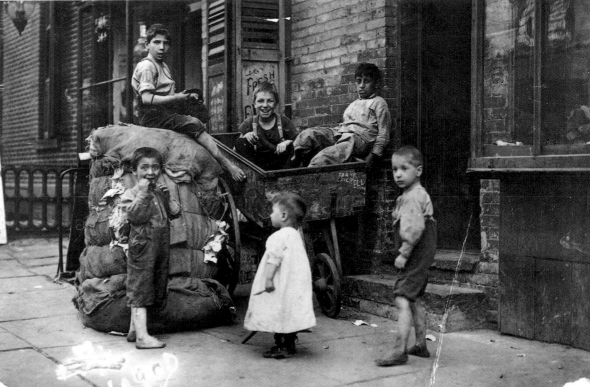

Jesse Tarbox Beals *Children with Burlap Sacks* (n.d.)

The scores of photographs that Johnston took of Dewey and of the members of the *Olympia's* crew at work and at leisure represented a real coup. Dozens of photographers had been attempting to get such pictures. That this early photographic scoop had been accomplished by a woman was, no doubt, particularly galling to many of her male competitors.

Consuelo Kanaga also earned her living by pursuing a variety of photographic genres. She entered the world of news photography in 1919 as a photographer-reporter for the *San Francisco Daily News*. In the early 1920s, she photographed for the *San Francisco Chronicle*. For the better part of the next forty years she would intermittently carry out news assignments for a variety of publications.

Kanaga brought to her press photography all those special talents that distinguished her work in other areas of the medium. As author Barbara Millstein has written, where Kanaga differed from her fellow press photographers "was in her choice of subject matter, in her deliberate composition, in her meticulous printing, and finally, in her heart."

Consuelo Kanaga *Fire* (1922)

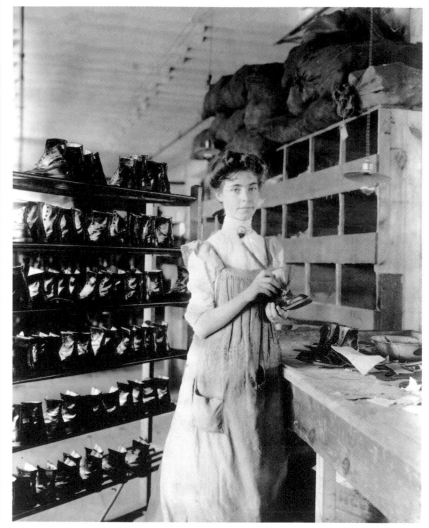

Frances Benjamin Johnston *Lynn Shoeworker* (1895)

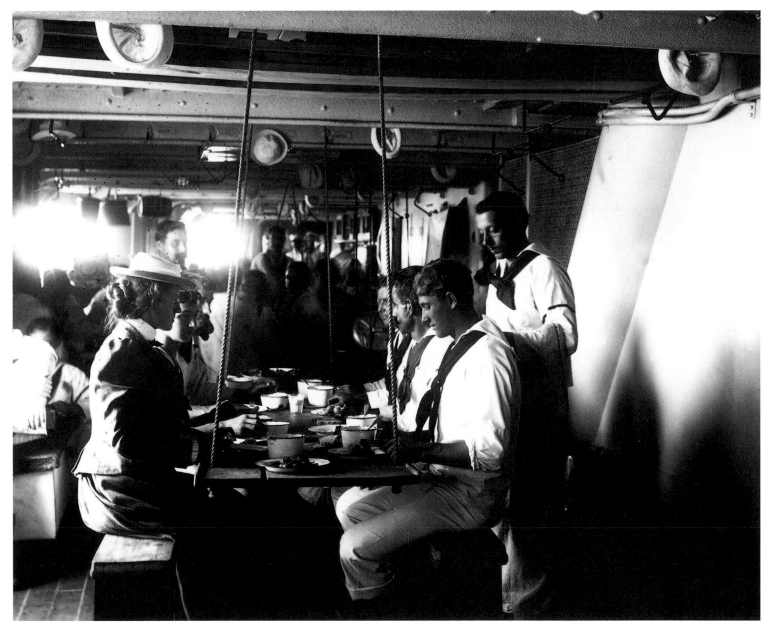

Frances Benjamin Johnston *Aboard Commodore Dewey's Flagship* (1899)

Margaret Bourke-White *Taxi Dancers, Fort Peck, Montana* (1936)

Toni Frissell *Elizabeth Taylor, Mike Todd, and Daughter Liza* (from *Life* magazine) (1957)

Toni Frissell *Coco the Poodle on New York Street* (from *Life* magazine) (1949)

Kanaga's talent at composition is clearly apparent in the photograph she titled *Fire*. Photographing at close range, Kanaga waited until the main figure in the center revealed her deepest anguish. She framed this woman with two other figures, capturing the solemn expression of the woman to her right and the hint of curiosity on the face of the woman to her left. Given that this was all accomplished under the constraints of a spontaneous news photograph, it was a masterful achievement.

By the beginning of the 1930s, pictures in newspapers and early picture magazines had established the photograph as a primary means of communication. Early picture-dominated magazines such as *Fortune*, *Collier's*, and *National Geographic* in particular had captured the nation's attention through their photographic coverage of people and conditions throughout the world. It would be one picture magazine above all, however, that would have the greatest impact.

In 1936, Henry Luce, the founder of *Fortune*, launched a new picture magazine called *Life*. The prospectus described the publication as different from even the most ambitious of its predecessors: "Pictures are taken haphazardly. Pictures are published haphazardly," the prospectus proclaimed. "Naturally therefore they are looked at haphazardly . . . almost nowhere is there any attempt to edit pictures into a coherent story. . . . The mind-guided camera . . . can reveal to us far more explicitly the nature of the dynamic social world in which we live."

On November 19, 1936, the first issue of *Life* hit the newsstands with an impact equaled only by the advent of television some two decades later. Optimistic estimates predicted an initial circulation of about 250,000. Within four hours, all 466,000 copies of the first issue had been sold. The "mind-guided camera" had touched a vital nerve.

Over the years countless photographers, many of them famous or destined to become so, would join *Life* or contribute images to the magazine. They were aided in great measure by technical advancements, particularly advantageous to photojournalists and news photographers. These advancements included the introduction of the Leica and other small 35mm cameras that permitted a photographer to shoot quickly and repeatedly at eye level, rolled "fast" film that allowed for the taking of sequences of pictures in thousandths of a second, and the flashbulb, which replaced cumbersome, often ineffective, flash powder. Armed with these new tools, *Life*'s photographers captured images that would remain in the public memory. Of all these photographers, none was more important or more vital to the magazine's early success than Margaret Bourke-White. Destined to become the world's best-known photojournalist, she would shoot more press photographs than any other photographer in history. She traveled the globe, captured images of people and places rarely seen, and set the standard for generations of photojournalists to follow.

She was born in New York City in 1904 and raised in Bound Brook, New Jersey. Both of her parents were connected to the publishing industry—her father a printing engineer, her mother working on publications for the blind. In 1921, Bourke-White studied photography with Clarence White. She went on to college, but was far from a committed student and attended seven colleges before finally earning a bachelor's degree at Cornell. It was while taking photographs for the yearbook at the University of Michigan that she determined what her life's work must be. "We all find something," she later wrote, "that is just right for us, and after I found the camera I never really felt a whole person again unless I was planning pictures or taking them. . . ."

Margaret Bourke-White *Logs* (c. 1940)

Margaret Bourke–White *Winding Condensor Coils* (c. 1933)

Bourke–White's photograph of the newly built Fort Peck Dam in Montana adorned the cover of *Life*'s premier issue. The main story in the magazine was her long photo–essay on the workers who were building the dam and the local townspeople, and for this she received *Life*'s first photo credit.

For the next twenty–one years, Bourke–White was *Life*'s most pro-lific and important photographer. She took tens of thousands of pic-tures recording people and places at home and in almost every corner of the globe. She photographed miners in South Africa, field–workers in Slovakia, aristocrats in Hungary, and emigrants in Pakistan. She took memorable pho-tographs of Mahatma Gandhi just six hours before he was assassinat-ed and recorded the first German air raids on Moscow. She was the first photojournalist to enter Russia after its revolution and sent back the first views of this almost unknown society that Americans had ever seen. In 1943 she became the first woman to fly on a United States combat mission. Two years later, she was among the press corps that encountered the barbarism at Buchenwald and other concentration camps.

Bourke–White began her professional career as an archi-tectural photographer in Cleveland, Ohio. She then undertook advertising work before accepting a commission to photo-graph a Cleveland steel company. These industrial images so impressed Henry Luce that, in 1929, he offered her a job as a staff photographer on his new magazine, *Fortune*. Her photog-raphy was so instrumental in *Fortune*'s success that when Luce launched *Life*, he immediately hired her as one of the publica-tion's first photographers.

Bourke–White was the consummate photojournalist. She would let nothing deter her from getting the pictures or the

story she pursued. "Sometimes," she said, "I could murder someone who gets in my way when I am taking a picture. I become irrational. There is only one moment when a picture is there, and an instant later it is gone–gone forever. My memory is full of those pictures that were lost."

Aside from her photographs themselves, one of the most important contributions Bourke-White made to photography was pioneering the photo essay. Two other women photographers, although they were not photojournalists, also provided early evidence of the effectiveness and appeal of stories told through a series of pictures. They accomplished this through two special assignments they carried out while members of the FSA photographic corps.

One of these picture stories, titled "Cross Country Bus Tour," was taken by Esther Bubley. Born in 1921, she was raised in Superior, Wisconsin, and attended Superior State Teacher's College for two years before studying art at the Minneapolis School of Art and Design. In 1940, she moved to Washington, D.C., and a year later became a microfilmer at the National Archives. Some months later she was hired by the FSA as a darkroom technician. In 1942, she was promoted to join the ranks of the agency's photographers.

Bubley's assignment in compiling "Cross Country Bus Tour" was to capture images of a specific aspect of the American home front in World War II. Her task was to photograph soldiers, and other wartime travelers, on a Greyhound bus route that went from Washington to Pittsburgh and then on to Chicago, Louisville, Memphis, Chattanooga,

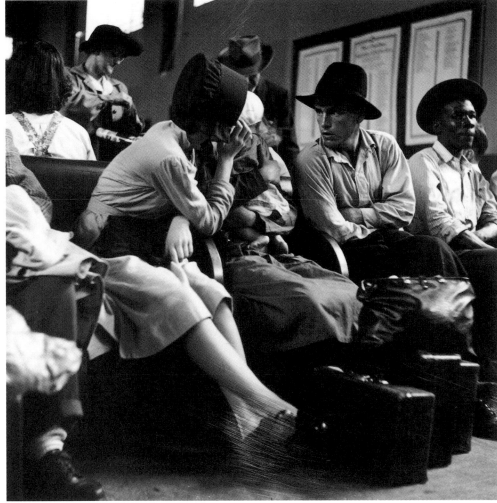

Esther Bubley *Bus Terminal in Pittsburgh, Pennsylvania* (1943)

Knoxville, and then back to Washington. Bubley boarded a bus and traveled the entire route capturing images of passengers waiting in the bus terminals, boarding the bus, traveling aboard the vehicle, and pausing between stops. She displayed a particular tal-

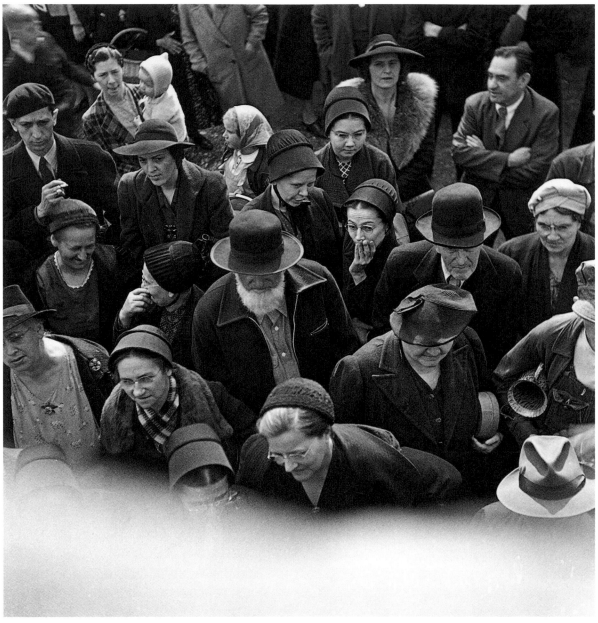

Marjory Collins *Bidders at an Auction* (1942)

ent for depicting passengers in relaxed and poignant moments, elevating the series beyond that of a mere visual chronicle. She also accompanied each of her pictures with detailed notes. The photographs that the FSA photographers took were made available free of charge to commercial publications. Editors of several magazines and newspapers selected images from Bubley's series and created their own "Cross Country Bus Tour" picture stories.

Marjory Collins's major contribution to the FSA files was also a photographic series designed to portray the American home front during World War II. Collins was born in 1912 and spent her childhood in Scarsdale, New York. After studying photography with Ralph Steiner in the 1930s, she worked as a photographer in New York City before being hired by the FSA.

One of her early assignments was to portray small–town life in wartime. Specifically, it was to capture images of people engaged in civil defense activities, planting victory gardens, and immersing themselves in other patriotic wartime efforts. "Make people appear as if they really believed in the U.S.," read her shooting script.

Collins selected Lititz, Pennsylvania, as the appropriate setting for the series she titled "Small Town in Wartime." There she took many pictures of such home front activities as scrap drives and draft board meetings–but she went much deeper. As one studies the photographs in the series, it becomes apparent that her main goal was to portray the special nature of everyday life in a small town even during a time of national stress. Like Bubley's "Cross Country Bus Tour" images, select photographs from "Small Town in Wartime" were acquired by national publications that presented their own picture stories based on the Collins series.

Margaret Bourke-White *Ammonia Storage Tanks* (1930)

Margaret Bourke-White *George Washington Bridge* (1930s)

154 *Against the Odds*

Aside from providing photographers the opportunity to produce images for magazines and newspapers, the ability to reproduce photographs on the printed page created another vital outlet for photographic expression. Once the halftone process was fully developed, photographs began to appear in all types of books. One of the most significant of these books was *An American Exodus*, compiled by Dorothea Lange and her husband, Paul Taylor, published in 1939. A pioneering effort to combine words and photographs in book form, Lange and Taylor used conversations by Lange's subjects as the basis for the book's narrative. A different narrative technique was used in their book, *Land of the Free*. In this book, the photographs were accompanied by a "sound track," a lyrical poem written by Archibald MacLeish. So impressed was MacLeish by the images that he later explained, "The original purpose had been to write some sort of text to which the photographs might serve as commentary. But so great was the power . . . of these vivid American documents that the result was a reversal of that plan."

One of the images with which MacLeish was so taken was a Great Depression–era picture destined to become the most widely reproduced photograph in history. It took Dorothea Lange all of ten minutes to produce the immortal image that she titled *Migrant Mother*. Passing by a sign that read PEA PICKERS CAMP, she turned her car around and entered the wet, soggy place where she almost immediately encountered a woman and her two children. As Lange later described it, "I saw and approached the hungry and desperate mother, as if drawn by a magnet. I do not remember how I explained my presence or my camera to her, but I do remember she asked me no questions. . . . She told me her age, that she was thirty-two. She said that they had been living on frozen vegetables from the sur-

Esther Bubley *Tombal, Texas, Gasoline Plant* (1945)

rounding fields, and birds that the children killed. She had just sold the tires from her car to buy food. There she sat in the lean-to tent with her children huddled around her, and seemed to know that my pictures might help her, and so she helped me. There was a sort of equality about it." Beginning with its publication in *Land of the Free, Migrant Mother* became such an icon of an era that throughout the rest of her career Lange would complain that it threatened to make her known for nothing but having taken that image.

An *American Exodus* and *Land of the Free* were but two of the many books that appeared in the 1930s and 1940s featuring FSA photographs. Of all these volumes, one that found the largest readership was *In This Proud Land*, with text by Roy Stryker and Nancy Woods. Works by Marion Post Wolcott and Marjory Collins were all featured in the book, including Lange's memorable photograph of a woman at a revival meeting and Wolcott's compelling image of a judge at a Virginia horse show.

It was through books such as *American Exodus, Land of the Free*, and *In This Proud Land* that Dorothea Lange's photographs in particular received their widest distribution. In the decades following their publication, other women photographers such as Laura Gilpin, Barbara Morgan, Imogen Cunningham, Nell Dorr, and Margaret Bourke-White would all present many of their images to the world in book form.

The halftone printing process was introduced at a time when the United States was rapidly becoming the world's industrial leader. In a nation of people who had long been captivated by pictures of the "largest" or the "most recent," images of machines and industrial structures held a particular fascination. The ability to reproduce photographs in newspapers and magazines came also at a time when, more than ever before, the camera was be-

coming regarded as a faithful recorder of those symbols that defined an era. As the nation entered a new century, there was no greater symbol of all that America had achieved and of the widely held belief in the inevitability of continued progress than the machine. By the late 1920s, the pages of the nation's magazines and major newspapers were filled with photographs of the latest machines and industrial structures and with images of those who worked above, beneath, and around them. Within a decade, museums throughout the nation were proudly displaying photographs as well as paintings depicting all the various aspects of industrialism.

Out of this burgeoning industrial photography emerged photographers who would not only record the evidence of industrial progress but would bring their own interpretations to their images. Of these photographers Margaret Bourke-White most significantly expanded the horizons of photographing the industrial world.

Many of the earliest Bourke-White industrial images were taken on assignment for *Fortune*. Dedicated to presenting industrial life in words and pictures, *Fortune* became American industry's greatest champion. And Bourke-White was the magazine's most important photographer—not only in terms of the photographs she contributed but in the manner in which she helped make the pictures as important as the words in the publication's approach.

To Bourke-White, it was the aesthetic qualities found in otherwise utilitarian industrial objects that defined their importance to photography. "Any important art coming out of the industrial age," she wrote, "will draw inspiration from industry, because industry is alive and vital. The beauty of industry lies in its truth and simplicity: every line is essential and therefore beauti-

ful." It was this focus on simplicity and detail, even in the largest objects, as well as the emotion she conveyed through these images that characterized her industrial photographs.

One of the greatest icons of the industrial age was New York's George Washington Bridge. The building of the bridge was a monumental achievement to which Bourke-White paid homage. Of the many pictures she took of the structure, the most compelling is the one in which the viewer is drawn into the photograph by the two enormous pipes in the foreground of the image. The long spans of cable, the gigantic superstructure, even the huge bolts anchoring the pipes are revealed, testimony to Bourke-White's special ability to portray size and detail while simultaneously conveying the special type of beauty that she continually found in the industrial world.

Just as *Fortune* and other publications played a pivotal early role in advancing the development of industrial photography, so too did one of America's largest corporations, Standard Oil of New Jersey. In 1941, a Roper poll revealed that Standard Oil was the least respected company in the nation. In response, the corporation hired a public relations firm to better its public image. After a period of study, the public relations people sent back a report stating that the image problems Standard Oil was having were due in large measure to the fact that the company, despite many good things it was doing, was not controlling the publicity that surrounded the corporation and its work. Among the recommendations was that Standard Oil hire a team of photographers to take pictures showing as many aspects as possible of the work that company employees were doing and the many benefits that the nation's citizens were deriving from these activities. The report went on to point out that these photographs should not only be published regularly in the company's trade journal, *The Lamp*,

but even more importantly, funneled to the large-circulation magazines.

Standard Oil's management seized upon the report, particularly the idea of disseminating photographs that would enhance the company's image. Using the FSA's photographic accomplishments as a model, they created the Standard Oil of New Jersey Photographic Project. Convinced that they could replicate the FSA's success, they hired Roy Stryker away from his government work and instructed him to hire the best photographers with a bent toward industrial photography he could find. Among those Stryker brought aboard were Todd Webb, Edwin Rosskam, and Esther Bubley. Such FSA luminaries as Russell Lee, John Vachon, and Gordon Parks also agreed to take on special assignments.

The photographers who worked for what came to be known as the SONJ project were given great latitude. They were allowed to apply the broadest of interpretations to their mandate of extolling the virtues of Standard Oil. Esther Bubley, for example, produced a photo story on cross-country bus travelers similar to the one she had compiled for the FSA.

Many other images that Bubley captured for the SONJ project were industrial photographs in the truest sense of the term, and although she never attained the status of a Bourke-White, they are images that rival the best of the genre. One theme that developed within the world of industrial photography, for example, was in direct contrast to the notion of the all-powerful machine, espousing instead that regardless of the awe-inspiring feats of modern machinery brought to everyday life were, human beings still controlled them. Bubley's photograph of a worker standing atop an enormous structure at the Tomball, Texas, gasoline plant is a powerful presentation of this theme.

The SONJ project photographers produced more than eight

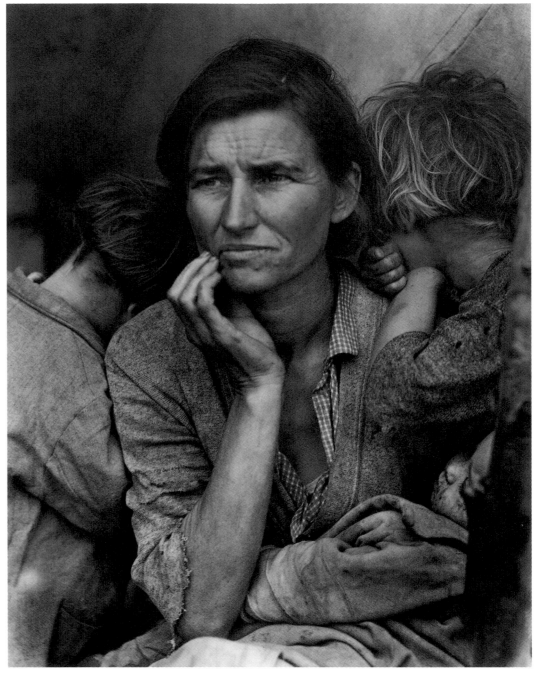

Dorothea Lange *Migrant Mother* (1936)

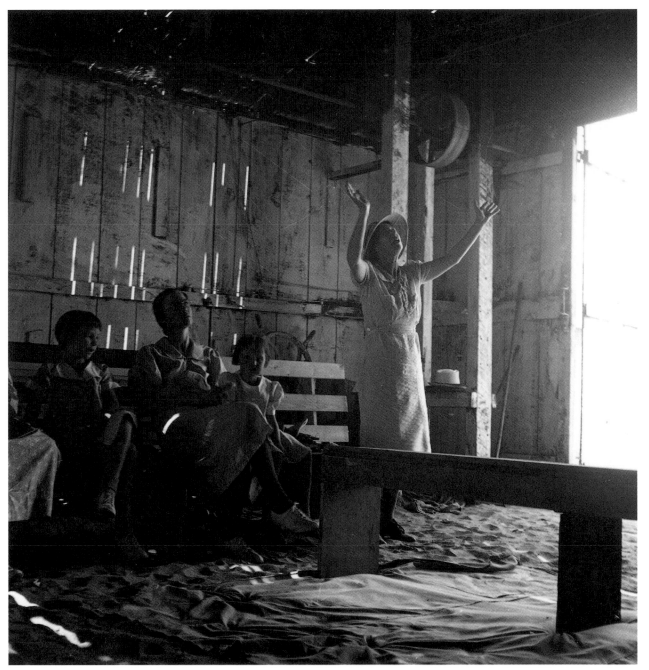

Dorothea Lange *Revival Meeting in a Garage* (1938)

Esther Bubley *Crude Oil Pipe Still No. 7*

Margaret Bourke–White *A Judge at the Horse Races* (1941)

Esther Bubley *Railroad Yard, Superior, Wisconsin* (c. 1945)

162 *Against the Odds*

thousand images. Ironically, despite their quality, the photographs never achieved the results that Standard Oil desired. While due to the images *The Lamp* became the most effectively illustrated of all trade journals, their use by national magazines was extremely limited, probably because they were regarded by many editors as an extreme example of Standard Oil "blowing its own horn." Today we can appreciate the role the project played in giving industrial photographers the chance to experiment within certain parameters and how it revealed that corporate sponsorship, like government support, could provide photographic opportunities.

The development of the halftone had also given rise to the proliferation of the photograph in mass media and perhaps nowhere more effectively than in advertising. Those with products to sell could now enhance their ads with photographs of their goods rather than with drawings. As early as 1902, Kodak featured photographs by Nancy Ford Cones in its newspaper and magazine advertisements. In the 1920s, Ruth Bernard, Clara Sipprell, and other female photographers enhanced their careers with advertising work, and two women, Margaret Watkins and Wynn Richards, became leaders in the field.

No area of commerce benefited more from the ability to include photographs on the printed page than did the fashion industry. For designers and merchants, the photograph became an indispensable means of conveying trends and selling merchandise. For photographers, the world of fashion presented broad new vistas accompanied by significant new challenges.

By the late 1930s, increasingly successful magazines such as *Vogue, Harper's Bazaar,* and *Woman's Home Companion* were bringing the latest styles into homes throughout America and abroad. With millions of dollars at stake in potential sales and with

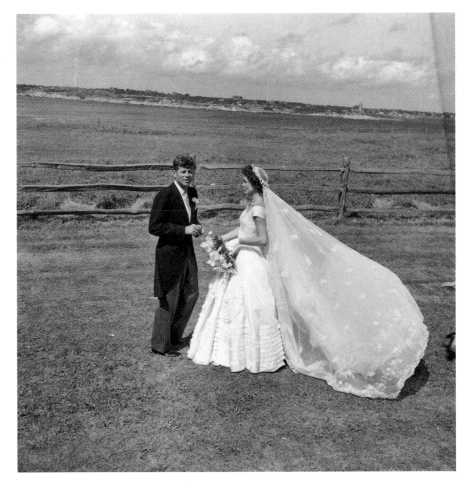

Toni Frissell *Kennedy Wedding* (1953)

designers' reputations continually on the line, fashion photography became the most competitive undertaking women photographers had ever faced. Even more than the world of advertising, it was a field dominated by men, one in which significant barriers against women photographers, consciously and subconsciously, had been established from the beginning.

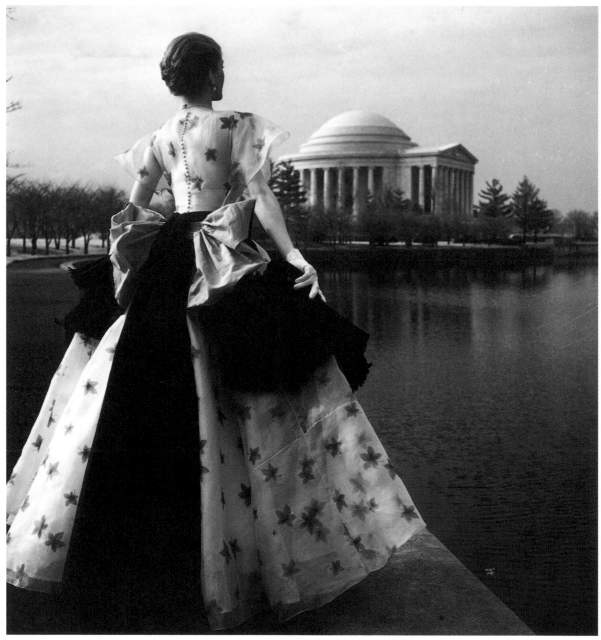

Toni Frissell *Model Facing Jefferson Memorial* (1948)

Some women, however, did break through. Two sisters, Kathryn Abbe and Frances McLaughlin-Gill, along with Genevieve Naylor and Kay Bell Ragnall were among those women who were able to secure significant freelance work. And two women, Toni Frissell and Louise Dahl-Wolfe, not only succeeded but became true pioneers of the high-fashion image.

Toni Frissell first gained widespread recognition for her fashion work when she became a staff photographer for *Vogue* in 1931, a position she held for eleven years. Just prior to that, *Town and Country* had published her first series of fashion photographs, titled *Beauties at Newport*.

Frissell brought both energy and daring to her work. She let nothing deter her from getting exactly the picture she sought: "[T]he other photographers were all men," she would recall, "but I didn't think much about it. I used to be absolutely un-self-conscious. For example, when I was very, very pregnant and photographing from an odd angle from the floor I saw next to me a beautifully creased pair of pants and perfectly polished shoes. I looked up and there was Condé Nast himself looking down at me. He said, 'What are you doing down there?' and I answered, 'Well, I'm interested in the way it looks from down here. I see things in my own way.' "

Frissell's pictures are marked by her understanding that a great fashion photograph is as much an image of a woman as it is of an article of clothing. "Instead of using studio lights," she later wrote, "I took my models outside to natural settings, even though they were dressed in furs and evening gowns. I wanted them to look like human beings, with the wind blowing their hair and clothes. As a photographer I was most successful when I did things naturally."

Frissell was the first fashion photographer to take models away from the confines of the studio. In conducting her "shoots" in exotic places around the world, she set a pattern followed by fashion photographers to this day. As her greatest contribution to the field, it was an innovation that in great measure paved the way for a fashion photograph to be judged not simply for its content but for its photographic attributes. Along with the images she captured for *Vogue* and *Harper's Bazaar*, Frissell also photographed extensively for Garfinkel's department stores in Washington, D.C., images which were distinguished by the inclusion of treasured national landmarks.

In the 1930s, another woman photographer, Louise Dahl-Wolfe, began a career in fashion photography that would eventually bring her to the top of the field. Born Louise Dahl in San Francisco in 1895, she attended the California School of Design and studied painting with artist Frank Van Sloan. In 1921, a friend invited her to the studio of Anne W. Brigman, a visit that changed her life: "I was floored by the beauty of the Brigman photographs," she later wrote, "and entranced by the prospects of what the camera could do."

In order to make ends meet while developing her photographic skills she took a job designing electric signs in New York, and then returned to San Francisco to work for a decorator. Her career took another positive turn when she was introduced to Consuelo Kanaga, who became a lifelong friend. In 1927, the two traveled together to Italy and Morocco where Dahl-Wolfe carefully observed Kanaga's photographic techniques.

In 1928, Dahl met and married sculptor Mike Wolfe. Four years later the couple moved to a mountain cabin in the Great Smoky Mountains of Tennessee. It was there that Dahl-Wolfe began to photograph seriously. She captured scores of images of

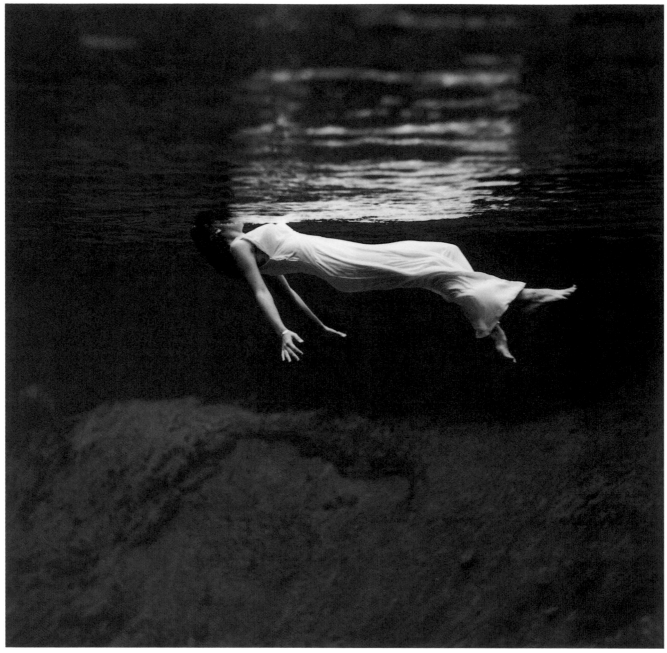

Toni Frissell *Weeki Wachi Spring, Florida* (1947)

mountain people, which were eventually published in *Vanity Fair*. In 1933, she and her husband returned to New York and a year later she acquired her first advertising account. Encouraged by her success, she set herself up as a freelancer and obtained photographic commissions from *Woman's Home Companion* and from department stores, including Bonwit Teller and Saks Fifth Avenue. In 1936, she became a staff photographer for *Harper's Bazaar*, a position she held for twenty-two years, and one through which she produced her finest work.

A leader in the photographic presentation of high fashion, *Harper's Bazaar*, following the lead set by Toni Frissell, sent Dahl-Wolfe throughout the world to capture images of the world's top models, elegantly clothed in exotic surroundings. Her fashion assignments took her to South America, Africa, Hawaii, the Caribbean, and many other locales. At a time when most fashion photographers worked in black and white, Dahl-Wolfe became known for her mastery of color. "One has to have a sense of putting color together in harmonious arrangements," she said, "planning backgrounds carefully, with an eye responsive to color." Her photographs were marked also by the dramatic manner in which she positioned each of her models within the framework of the page upon which the image would be published. She had a special ability to include arresting scenes within her photographs without diminishing the viewer's focus on the clothing the model was wearing. These groundbreaking techniques combined to establish Louise-Dahl Wolfe as one of the most influential photographers to bring the world of fashion to the printed page.

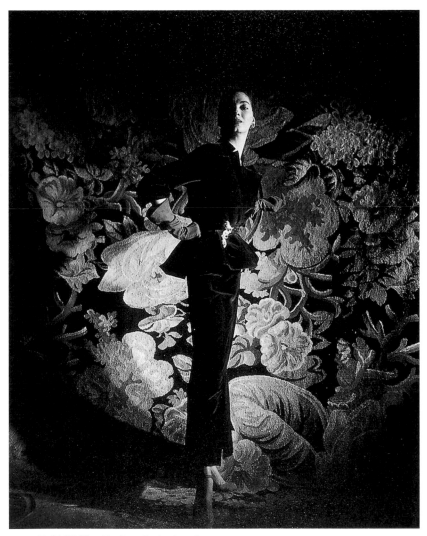

Louise Dahl-Wolfe *The Covert Look* (1949)

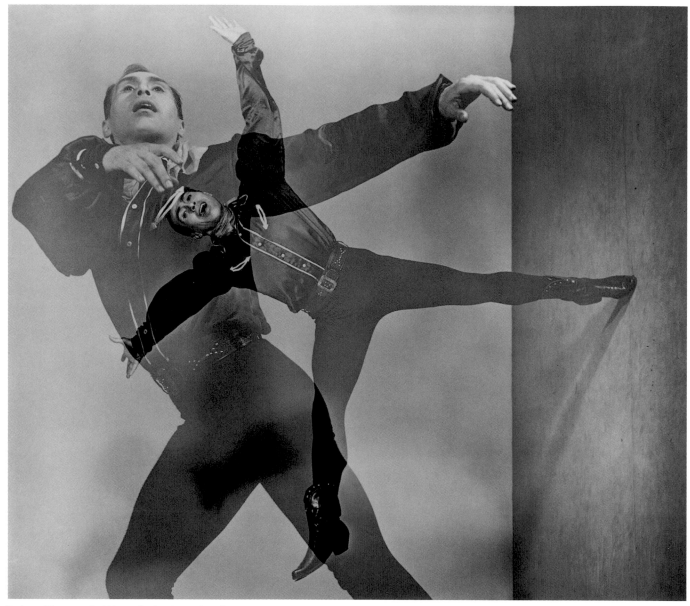

Barbara Morgan *José Limon: Cowboy Song* (1944)

8 · Experimentation / Innovation

From its earliest days, the world of photography has been characterized by rapid and extraordinary technical advances. This, after all, is the medium in which all the basic means of picture-taking were put into place within its first fifty years. Just as important, the medium has been marked by the presence of photographers willing to push the envelope, eager to explore ways of creating new approaches and new types of images.

Among these photographers have been women who have taken the lead in exploring the medium in all its capacities. Some, like Ruth Bernard, undertook new approaches while continuing to work within their main field of concentration. Others, like Lotte Jacobi, became almost totally involved in experimentation after leaving their mark on other areas of the medium. Still others, like Carlotta Corpron, devoted their entire careers to pursuing innovative techniques. Indeed, Berenice Abbott closed out a multifaceted career in the medium by pioneering the close relationship between science and photography.

What is most striking when examining these experimentations and innovations is the way photographers such as Consuelo Kanaga and Barbara Morgan pursued new approaches not only to achieve technical and artistic breakthroughs but, most important to them, to find the most effective ways possible to express their deep spiritual feelings.

Lotte Jacobi's work is particularly exemplary in its experimentation. In the late 1940s, in a dramatic departure from the portrait photography that had gained her acclaim, she began producing photograms, the form of cameraless picture-making

Lotte Jacobi *Dimensions 3* (c. 1946)

Virna Haffer *New Sprouted Ferns* (1960s)

paper in front of the light source. What emerged were unique images, sometimes soft or ethereal, sometimes dramatic, often sensual, and always suggestive. Upon seeing Jacobi's creative abstractions, her friend and mentor Leo Katz gave them the name "photogenics," a label Jacobi quickly embraced. "The experience was a marvel," she wrote of her entrance into a new realm of visual expression. "With the photogenics, I felt young again."

As is often the case with compelling works of art in any medium, Jacobi's photogenics elicit different meanings and different interpretations from each viewer. As photo-historian Thomas Beck has stated, encountering them is akin to "standing in a dark room when all that is beyond one's fingertips is unknown." Above all, the work stands as testimony not only to Jacobi's artistic ability but to her willingness to reach beyond her already significant accomplishments to create a new vision for herself and her audience.

Like Jacobi, Virna Haffer began producing photograms late in her career, and also like Jacobi, brought her own special techniques to her creations. Rather than simply exposing sensitized paper that had been shielded by objects, Haffer placed two tiers of glass between each object in her image and then exposed these objects to light. In conceptualizing and setting up these creations she worked in semidarkness, using only a yellow light.

In yet another innovation, Haffer created three-dimensional images by cutting pieces of paper into different shapes and then hinging them to a large piece of glass. When she printed each image, she first raised and exposed each separate piece of paper and then lowered it back into place. The relatively different time exposures made the planes stand out, creating the three-dimensional effect.

For Haffer, like so many photographic innovators, experimen-

made possible by illuminating objects placed directly on sensitized photographic paper. Unsatisfied with the results, Jacobi took her experimentation a step further, creating variations in the flow of light by moving cellophane, glass, or oddly shaped

tation meant revealing beauty and drama in commonplace objects. A compulsive worker, she found in her photograms an avenue for unlimited expression. "The more one does" she stated, "the more vistas materialize to expand into undreamed horizons."

While Jacobi and Haffer created their images by using light as a source to capture images, another woman photographer, Carlotta Corpron, was carving out an important career by photographing light itself. Of the camerawomen devoted to breaking new ground in photographic technique, none was more imaginative than this woman who combined a career in teaching with a life in photography. It was in fact Corpron's years of interaction with her students and her desire to point them in new directions that inspired her own innovative achievements.

Born in 1901 in Blue Earth, Minnesota, she was raised in India where her father served as a missionary and a surgeon. When the family returned to the United States in 1920, she prepared for a teaching career by earning a degree in art from Michigan State Normal College and a master's degree from Columbia University. In 1933, she obtained a job at the University of Cincinnati where she bought her first camera to use as a teaching aid. Two years later she was hired to teach art history and advertising design at Texas State College for Women, where she would remain for thirty-three years.

In 1936, college officials asked Corpron to begin teaching photography. Considering what she would teach, she realized that it was creative photography that interested her most. This fascination

with photographic experimentation, particularly as it related to the creative use of light, would become the basis for her work with three generations of students and for her own image-making.

At this pivotal time in her life, Corpron was fortunate to have the aid of a photographic giant. Gyorgy Kepes was teaching at a nearby college and she formed what would become an ongoing friendship with the master photographer. It was from Kepes that she learned the nuances of creating images by depicting light as it

Virna Haffer *Into Limbo* (1960s)

Carlotta Corpron *Light Pours Through Space* (1946)

Barbara Morgan *Spring on Madison Avenue* (1938)

followed the contours and penetrated the shadows of natural forms. In the 1940s, she took her experimentation a vital step further by producing abstract images that focused on the intriguing patterns created by light. This approach, evidenced in her photograph *Light Passes Through Space*, would become the hallmark of her work.

As with so many innovators, Corpron's experimentations were not easily understood or fully appreciated during her lifetime. "Through the years as a photographer, I have been neither 'fish not fowl,' " she wrote. "That is, most photographers could not understand what I was doing, and very few artists were willing to accept photography as art." Corpron, on the other hand, was very clear about her place in the medium. She put it simply: "I consider myself a designer with light."

Barbara Morgan's purpose in embracing photographic innovation can also be clearly defined. A woman who came to be regarded as a philosopher as well as a photographer, she adopted imaginative approaches and techniques as a means of discovering the most effective form of expressing herself. She was born Barbara Brooks Johnson in Buffalo, Kansas, in 1900. While studying art at the University of California at Los Angeles she became devoted to Eastern teachings, particularly as they related to the harmony to be found in life. After graduation, she married photographer-writer Willard Morgan, who encouraged her to try her hand at photography.

Her classic images of dancers would gain her wide acclaim, but it was through another form that she established herself as one of photography's premier innovators and found a vehicle for expressing her deepest feelings and beliefs. "As a kid," she later said, "I had always written poems. . . . I realized that my written poetry was a flashback from the visual metaphor that I was seeing in my mind's eye when writing a poem. So when I started photographing it was natural to begin with photomontage, which is image-as-metaphor."

In turning to this form of expression Morgan went beyond the traditional cut-and-paste collage approach that had become popular with other photographers and with abstract artists. Instead, she chose to create her photomontages through multiply exposed or multiply printed images. The technique had been pioneered by László Moholy-Nagy, and to it Morgan brought her own desire to convey the complexities of modern life and her own intensity.

Some of her most powerful montages were created to convey her impressions of life in New York City. Inspired by a gift of tulips, Morgan created *Spring on Madison Avenue* by first taking a picture of people walking on snow-clad streets from her studio window. She then superimposed this picture with a joyous photograph of dancer Eric Hawkins and an image of two of the tulips. The result was a prime example of Morgan's ability to create a unified message through the juxtaposition of seemingly unrelated items.

The receipt of another gift led to the creation of *City Shell*, a photomontage laden with even deeper meaning than *Spring on Madison Avenue*. "I was looking from my fourth story studio window," Morgan wrote, "admiring the 'new' Empire State building, which was then a heroic symbol of 'modern man' when a friend came in with a beautiful shell we placed on the window ledge. Suddenly, viewing the Empire State building and shell simultaneously, I thought, 'This shell is also a Habitat!–the rhythmical creation of an anonymous architect!' So, I was instantly inspired to create the photomontage and to counterplay the Shell with the geometric Empire State building–which I turned upside

down because I felt that the primitive Shell will outlive man-made skyscrapers."

While *Springtime on Madison Avenue* and *City Shell* typify the way that Morgan was able to employ the multiple print to achieve the effects she sought, her depiction of dancer Jose Límon in performance discloses her talent with multiple exposure. The image also reveals her fascination with the dance, particularly that aspect she called "rhythmic vitality."

Toward the end of her career, reflecting upon how her husband was able to convince her to take up the camera, Morgan remembered that she was most persuaded by his belief that photography would become not only the art of the twentieth century but its international language as well. It was a prediction in keeping with her own motivation, for it was in what she regarded as photography's potential to contribute to global harmony that Barbara Morgan found the medium's greatest meaning.

Although they differed in their techniques, Lotte Jacobi, Virna Haffer, Carlotta Corpron, and Barbara Morgan all shared the belief that photography could bring deeper meaning to the commonplace. In exploring new avenues of personal expression they utilized objects with which they and those who viewed their photographs were familiar. Other photographers, though not seeking new ways to create images, nevertheless also pursued imaginative approaches to bringing both beauty and drama to the things they found around them. These photographers created images that went well beyond the traditional still life by focusing on details found in large objects, by playing with light and shadow, and by training their cameras on unique forms created by everyday things.

One such photographer, Sonya Noskowiak, found the subject for a compelling photograph in a lumber yard. Intrigued with

Sonya Noskowiak *Lumberyard* (1937)

the forms created by the way in which long boards were stacked, she waited for the exact light and shadow she desired, positioned herself so she could shoot from a slightly upward angle, and captured an image that epitomizes how, in the hands of an imaginative photographer, beauty can be conveyed through the simplest of objects.

Like Noskowiak, Sybil Anikeef was fond of experimenting with light, shape, and form. In 1937 she took a close-up photograph of a lighthouse lens, highlighting the light and reflections emanating from the object. The result was an almost sur-

Berenice Abbott *Pendulum Swing* (1981)

Berenice Abbott *Beams of Light Through Glass* (1981)

Sybil Anikeef *Lighthouse Lens* (c. 1937)

realistic image, intriguing in the varying patterns that dominate the picture.

One of the most fascinating of the innovative women photographers was Margarethe Mather. Born in the Salt Lake City area in 1885, evidently her parents died when she was very young. She was adopted from an orphanage by a couple named Mather. When she was fourteen or fifteen, unhappy with her adopted parents, she ran away to San Francisco where she became a prostitute. By 1911, she met and entered into a lesbian relationship with a wealthy woman who both supported and educated her.

When she was about twenty-eight Mather met Edward Weston, became his companion, and eventually his partner in his photographic studio. According to Imogen Cunningham, it was Mather who inspired Weston to abandon his highly romanticized images and photograph the "real world," a switch which led to photographs that established Weston as one of the world's photographic giants.

Mather's own photographic career was as intriguing as her personal life. She traveled in the most influential photographic circles, was a member of the prestigious Pictorial Photographers of America organization, and had her portraits and still lifes lauded by some of the nation's most acclaimed photographers. Yet she was never able to find her own niche, and by the 1930s she had all but abandoned her photography.

Mather's greatest contribution to the medium was her innovative focus on parts of the human form, an approach later emulated by scores of other photographers. Of these, the most compelling is the image titled *Billy Justema in Man's Summer Kimono*. Noteworthy at the time for its subject matter, the photograph is distinguished by its sophisticated sense of composition, as seen in the positioning of the subject's hands and in Mather's appreciation of dramatic design.

Sometimes innovation is brought about by personal necessity, as was the case with Berenice Abbott. By the 1950s she had become well known both for her portraiture and her photo-

graphic studies of New York. She had failed to achieve financial success, however, and in the face of what she termed "overwhelming financial difficulties," made a bold decision: "I decided to change my subject. It was an age of science and I decided to know more about the subject itself. I wanted to learn by photographing it."

She began this new venture by attempting to photograph electricity. "I'd seen men who were experts in the field," she said, "and I'd ask them to collaborate on such a project. The general feeling was that it couldn't be done. So I had to decide to try it without them. The result was mixed but I did get valuable experience and a few good pictures."

Though she had learned a great deal, she still wasn't making any money. But she refused to give up. She went to the nationally renowned Bronx High School of Science hoping to find work photographing their experiments in physics, but was told that what she proposed would be impossible to accomplish. Finally, with interest in physics suddenly propelled to an all-time high due to the appearance of the Russian space satellite, *Sputnik*, she was hired to take photographs for a new book on high school physics being prepared by a group associated with the Massachusetts Institute of Technology.

It was the beginning of a better than ten-year endeavor in which Abbott would illustrate the laws of physics through photographs that were unlike any that she or any other photographer had ever taken. Since nothing of this kind had ever been done, there was no photographic apparatus adequate to the task. So Abbott invented her own, becoming the only woman to design her own photographic equipment in order to take a special kind of picture.

The images Abbott produced included photographs of mag-

Consuelo Kanaga *Snow on Clapboard* (n.d.)

netic fields, the swinging of a pendulum, and beams of light through glass. Years after her scientific work was completed she would say, "I loved what I was doing and worked hard at it. I have always wanted to understand why artists don't understand scientists and scientists don't understand artists." Today, in a world where science and photography are linked in ways too numerous to count, it is important to remember that it was Berenice Abbott who pioneered the connection.

Of all the photographers, male or female, who sought to expand the medium's horizons, Consuelo Kanaga may well have had the loftiest motivation. Deeply spiritual, her personal life was driven by her belief in the existence of a divine spirit. Her professional career was profoundly influenced by her conviction that a sense of this spirit could be revealed through photography, which led to the sensitive depictions of the nobility of the human condition that form the main body of her work.

The innovative abstract images that Kanaga produced were based on her conviction that everything involved in the making of a photograph, from the selection of the picture to the making of the print, was a type of mystical experience. At first glance, these abstractions seem to represent a major departure from the rest of her endeavors, but they are related. Her goal was to present everyday things, objects that out of familiarity we often ignore, and give them deeper, spiritual meaning.

It was this ability to add meaning to what at first glance might seem simple that marks her innovative contributions. In the photograph *Snow on Clapboard*, for example, she celebrated nature's power to affect material objects by showing how the irregular design created by newly fallen snow had altered the precise, carefully planned geometric pattern of the building.

Among the most revealing of Kanaga's abstractions are the architectural images of New York City that she began to take in the 1930s. These architectural abstractions are very different from the people-oriented documentary photographs she had taken earlier in New York. They differ also from the industrial images of Margaret Bourke-White or Esther Bubley. These are not photographs designed to pay tribute to progress or the world of work, but rather images created to reveal the presence of a higher order in even the most familiar of manmade things.

This higher order is best seen in *Creatures on the Rooftop*. Kanaga photographed the chimneytops in such a manner as to give them lifelike form. She focused our attention on the light pouring through the "eyes" of the metal structure. Through the aura she created in presenting this simple subject, she hinted at the presence of a force much greater than we can fully understand.

In describing her personal and professional goals, Consuelo Kanaga said, "I am eager to find the truth of this medium—I desire clarity in my photography and realize I must first find it in myself, which is possibly more difficult." This search for clarity in their picture-taking and in their lives was the hallmark of almost all the pioneer women photographers we have met. Through the restlessness, energy, special skills, and sense of purpose they brought to their work, they met the considerable challenges they faced and produced images that resonate today. In the process, they enriched the medium in ways that we are still discovering.

Consuelo Kanaga *Creatures on a Rooftop* (1937)

BIBLIOGRAPHY

Alland, Alexander Sr. *Jesse Tarbox Beals: First Woman News Photographer.* New York: Camera Graphic Press, 1978.

Barnes, Catherine Weed. "Why Ladies Should Be Admitted to Membership in Photographic Societies." *American Amateur Photographer* I (December 1889): 223–24.

Brannan, Beverly W., and David Horvath, eds. *A Kentucky Album: Farm Security Administration Photographs, 1935–1943.* Lexington: University Press of Kentucky, 1986.

Burton, Walt. *Nancy Ford Cones: The Lady from Loveland.* Cincinnati: Walt Burton Galleries, 1981.

Callahan, Sean, ed. *The Photographs of Margaret Bourke-White.* New York: Bonanza; Greenwich, Conn.: New York Graphic Society, 1972.

Cunningham, Imogen. *After Ninety.* Seattle: University of Washington Press, 1977.

Daniel, Pete, and Raymond Smock. *A Talent for Detail: The Photographs of Miss Frances Benjamin Johnston, 1889–1910.* New York: Harmony, 1974.

Daniel, Pete, et. al. *Official Images: New Deal Photography.* Washington, D.C.: Smithsonian Institution Press, 1987.

Dater, Judy. *Imogen Cunningham: A Portrait.* Boston: New York Graphic Society, 1979.

Ewing, William A. *Flora Photographica.* New York: Simon and Schuster, 1991.

Featherstone, David. *Doris Ulmann: American Portraits.* Albuquerque: University of New Mexico Press, 1985.

Fleischauer, Carl, and Beverly W. Brannan, eds. *Documenting America, 1935–1943.* Berkeley and Los Angeles: University of California Press, 1988.

Fleming, Paula Richardson, and Judith Luskey. *Grand Endeavors of American Indian Photography.* Washington, D.C.: Smithsonian Institution Press, 1993.

Fleming, Paula Richardson, and Judith Luskey. *The North American Indians in Early Photographs.* New York: Barnes and Noble Books, 1992.

Gernsheim, Helmut, and Alison Gernsheim. *The History of Photography: From the Earliest Use of Camera Obscura in the Eleventh Century up to 1914.* New York: McGraw–Hill, 1969.

Gilpin, Laura. *The Enduring Navaho.* Austin: University of Texas, 1968.

Gilpin, Laura. *The Rio Grande: River of Destiny.* New York: Duell, Sloan, and Pearce, 1949.

Glauber, Carole. *Witch of Kodakery: The Photographs of Myra Albert Wiggins.* Pullman, Washington: Washington State University Press, 1997.

Glenn, James R. *Guide to the National Anthropological Archives.* Washington, D.C.: National Anthropological Archives, 1996.

Goldberg, Vicki. "Louise Dahl–Wolfe." *American Photographer* 6 (June 1981): 38–47.

Goldberg, Vicki. *Margaret Bourke-White: A Biography.* New York: Harper and Row, 1986.

Goldberg, Vicki. *Photography in Print: Writings from 1916 to the Present.* New York: Simon and Schuster, Touchstone, 1981.

Gover, C. Jane. *The Positive Image: Women Photographers in Turn of the Century America.* Albany: State University of New York, 1988.

Hall–Duncan, Nancy. *The History of Fashion Photography.* Rochester, N.Y.: International Museum of Photography; New York: Alpine, 1979.

Harrison, Martin. *Appearances: Fashion Photography since 1945.* New York: Rizzoli, 1991.

Hartman, Sadakichi. *The Valiant Knights of Daguerre: Selected Critical Essays on Photography and Profiles of Photographic Pioneers.* Edited by Harry W. Lawton and George Knox. Berkeley: University of California Press, 1978.

Hurley, F. Jack. *Industry and the Photographic Image.* New York: Dover, 1980.

Hurley, F. Jack. *Marion Post Wolcott: A Photographic Journey.* Albuquerque: University of New Mexico Press, 1989.

Klute, Jeanette. *Woodland Portraits.* Boston: Little Brown, 1954.

Lange, Dorothea, and Paul Taylor. *An American Exodus: A Record of Human Erosion.* New York: Reynal and Hitchcock, 1939.

Lange, Dorothea. *Dorothea Lange: Photographs of a Lifetime.* Millerton, N.Y: Aperture, 1996.

Lufkin, Liz. "Ruth Bernhard." *American Photographer* 20 (April 1988): 60–66.

Lucey, Donna M. *Photographing Montana: The Life and Work of Evelyn Cameron.* New York: Alfred A. Knopf, 1990.

Mann, Margery. *Imogen Cunningham: Photographs.* Seattle: University of Washington Press, 1974.

Mann, Margery, and Anne Noggle. *Women of Photography: An Historical Survey.* San Francisco: San Francisco Museum of Modern Art, 1975.

Margolis, Marianne Fulton. *Camera Work: A Pictorial Guide.* New York: Dover, 1978.

McCausland, Elizabeth, and Berenice Abbott. *Changing New York.* New York: E. P. Dutton, 1939. Revised and reprinted as *New York in the Thirties, as Photographed by Berenice Abbott.* New York: Dover, 1973.

Meltzer, Milton. *Dorothea Lange: A Photographer's Life.* New York: Farrar, Straus and Giroux, 1978.

Michaels, Barbara I. *Gertrude Käsebier: The Photographer and Her Photographs.* New York: Harry N. Abrams, 1992.

Millstein, Barbara Head, and Sarah M. Lowe. *Consuelo Kanaga: An American Photographer.* Brooklyn: Brooklyn Museum: Seattle: University of Washington Press, 1992.

Mitchell, Margaretta K. *Recollections: Ten Women of Photography.* New York: Viking Press, Studio, 1979.

Morgan, Barbara. *Barbara Morgan: Photomontage.* Dobbs Ferry, N.Y.: Morgan and Morgan, 1980.

Newhall, Beaumont. *The History of Photography from 1839 to the Present Day.* New York: Museum of Modern Art, 1982.

Novotny, Ann. *Alice's World: The Life and Photography of an American Original: Alice Austin.* Old Greenwich, Connecticut: The Chatham Press, 1976.

Palmquist, Peter E., ed. *Camera Fiends and Kodak Girls: Fifty Selections by and about Women in Photography, 1840–1930.* New York: Midmarch Arts, 1989.

Partridge, Elizabeth, ed. *Dorothea Lange: A Visual Life.* Washington, D.C.: Smithsonian Institution Press, 1994.

Peladeau, Marcus B. *Chansonetta: The Life and Photographs of Chansonetta Stanley Emmons, 1858–1937.* Waldoboro, Maine: Maine Antique Digest, 1977.

Peterson, Christian A. *Alfred Stieglitz's Camera Notes.* New York: W. W. Norton, 1993.

Plimpton, George, introduction. *Toni Frissell: Photographs 1933–1967.* New York: Doubleday, 1994.

Rosenblum, Naomi. *A History of Women Photographers.* New York: Abbeville Press, 1994.

Rosenblum, Naomi. *A World History of Photography.* New York: Abeville Press, 1987.

Sandweiss, Martha A. *Carlotta Corpron: Designer with Light.* Austin and London: University of Texas Press: Fort Worth: Amon Carter Museum, 1980.

Sandweiss, Martha A. *Laura Gilpin: An Enduring Grace.* Fort Worth: Amon Carter Museum, 1986.

Stryker, Roy, and Nancy Wood. *In This Proud Land: America as Seen in the FSA Photographs.* New York: Gallahad Books, 1973.

Sullivan, Constance, ed. *Women Photographers.* New York: Harry N. Abrams, 1990.

Tucker, Anne, ed. *The Woman's Eye.* New York: Alfred A. Knopf, 1973.

Wise, Kelly, ed. *Lotte Jacobi.* Danbury, N.H.: Addison, 1978.

Witkin, Lee, introduction. *Invisible in America: An Exhibition of Photographs by Marion Palfi.* Lawrence: University of Kansas Museum of Art, 1973.

INDEX

PHOTO CREDITS

Addison Gallery: 92, 130, 133, 135, 168, 173, 176, 177, 179; Ball State University Museum: 175, 178; Brooklyn Museum: 44 left, 44 right, 126, 127, 144 left, 178, 179, 181; Walt Burton, Cincinnati: 18; Camera Notes: 54; Camera Work: 34 left, 55, 56, 57 right, 58 right, 62 right; Community Service Society of Columbia University: 142, 143; Dayton Art Institute: 60, 61, 137; George Eastman House: 153; Fashion Institute of New York: 167; Indiana Art Museum: 135, 136; Library of Congress: frontis, 2, 4, 15, 16 right, 17 left, 17 right, 19, 32, 33, 34 right, 35, 37, 38, 39, 41, 42, 43, 46, 47, 48, 50, 53, 57 left, 58 left, 59, 63, 64 left, 64 right, 65 left, 65 right, 67, 68 left, 68 right, 70, 73, 74, 75, 77, 78, 79, 80, 81, 82, 83, 86, 89, 98, 100 left, 102 left, 106 left, 106 right, 109, 111, 112, 113, 117 right, 121, 124, 128, 129, 140, 144 right, 145, 147, 148, 151, 152, 154, 155, 158, 159, 161, 163, 164, 166, 168; University of Louisville Photographic Archives: 155, 160, 162, 167; Minneapolis Institute of Arts: 90, 91; Montana Historical Society: 6, 7, 8, 116, 117 left; Museum of American History: 64 left, 102 right, 131, 132, 133, 168 right, 173, 181; Museum of Northern Arizona: 105; National Anthropological Archives: 100 right, 101, 103; National Archives: 107; Naylor Collection: 14 left, 14 right, 16 left, 137, 146; University of New Hampshire Photographic Archives; 40; New York Public Library: 62 left, 87; New Orleans Museum of Art: 172; North Carolina Department of History and Archives: 24, 25; Oakland Museum: 108; Portland Art Museum: 121; St. Louis Art Museum: 30, 93, 94, 114, 122, 125, 150, 153, 158, 171; Sandler Collection: 95, 96, 149; Society for the Preservation of New England Antiquities: 23; Stanley Museum: 20, 21, 22, 36, 76; State Historical Society of North Dakota:10, 11, 12, 13, 118, 119; Staten Island Historical Society: 26, 27; Tacoma Public Library: 134, 170, 171, 173; Frederick Weismann Museum, University of Minnesota: 84, 85, 88; Wellesley College Art Museum: 52.